BRITISH ART

from Holbein to the present day

Simon Wilson **BRITISH ART**

from Holbein to the present day

The Tate Gallery & The Bodley Head

British Library Cataloguing
 in Publication Data
 Wilson, Simon
 British art.
 1. Painting, British 2. Sculpture, British
 I. Title
 759.941 ND464
ISBN 0 370 30034 3

© 1979 Simon Wilson
Printed in Great Britain for
The Bodley Head Ltd
9 Bow Street, London WC2E 7AL and
The Tate Gallery Publications Department
Millbank, London SW1P 4RG
by Balding & Mansell, London & Wisbech
Set in Monophoto Photina
First published 1979

Contents

Author's Note

The intention of this book is to provide a compact, basic introduction to the mainstream of fine art in Britain since the Reformation, and I hope that it may provide a useful basis for the general reader to begin an exploration of the immense riches of British art both ancient and modern contained in the country's national and provincial collections and in the many country houses that are open to the public.

The book is a history, not an encyclopaedia, and like all histories it is to some extent a personal view. Furthermore it covers a period of some four and a half centuries and is thus necessarily highly synoptic and selective. The problem of tracing a dominant historical pattern becomes particularly acute in the twentieth century, and especially when dealing with the period post-1945, during which there has been a vast expansion of art activity, largely fuelled by greatly increased state patronage and during which also traditional approaches to the making of fine art have been increasingly modified and extended in new directions. The final chapters of the book and the last chapter in particular should be seen as an attempt only to pick out what seem to be the major trends and their most representative exponents during the period covered.

This is not an academic book so I have not burdened it with footnotes although I have quite often given sources in the text. Any errors are entirely my responsibility as are of course my opinions. No one can write a general work of this kind without depending heavily on existing histories and monographs. The list of suggestions for further reading at the back of the book can also be read as an acknowledgment of the previous literature.

I should like to thank the following people who helped to make this book: first, all artists who appear in its pages; then, the Trustees and Director of the Tate Gallery, who authorised its publication; the entire curatorial staff of the Tate including my colleagues in the Education Department most of whom allowed me to pick their brains for specialised knowledge or advice, and in particular Martin Butlin and Richard Morphet who read the manuscript in draft and made many valuable corrections and suggestions; Lynn Lewis and Mollie Luther of the Tate Gallery Publications Department for all their work in obtaining the illustrations; Pauline Key who designed it; Penny Beadon who valiantly typed the manuscript; all the public institutions, private owners and living artists who generously gave permission to reproduce works in their possession or of which they were the copyright holders; and finally my wife without whose love and support it would never have been written at all.

SIMON WILSON 3 October 1978

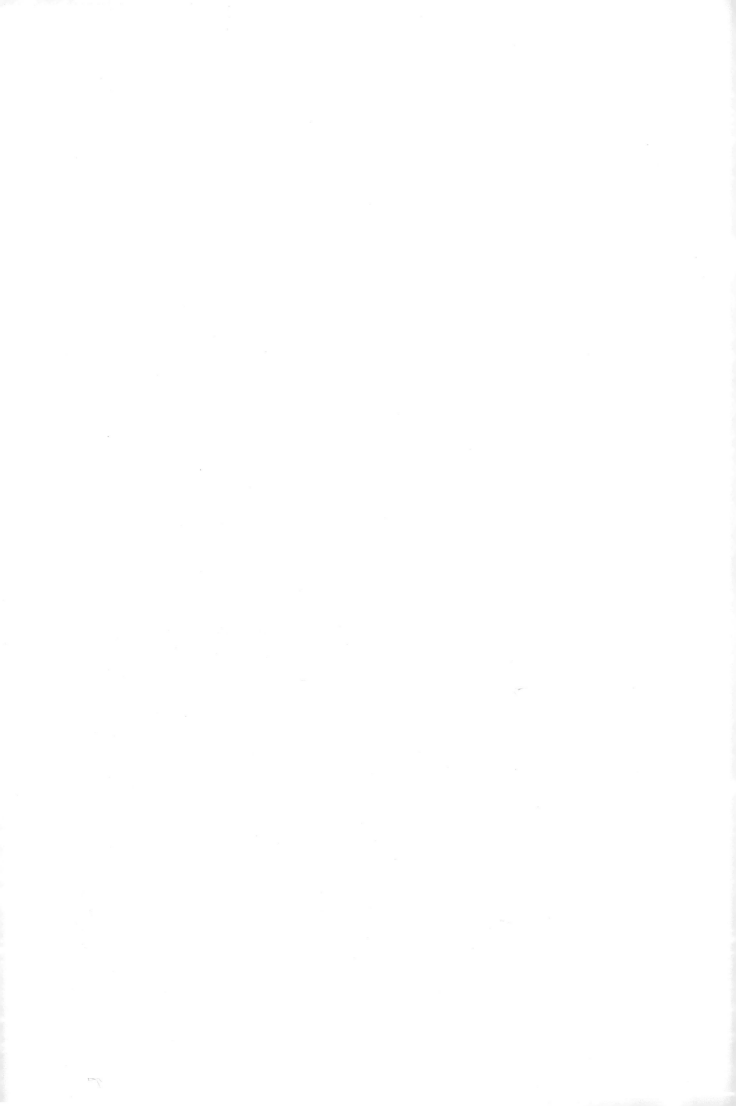

Chapter 1
Tudor and Jacobean Painting

In 1534 Henry VIII of England (reigned 1509–47) broke with the Pope and established the Anglican Church with himself as its head, an act which formally marked the beginning of the Reformation in England. It also marked the beginning of the end of England's rich medieval religious art, for the Protestant reformers were intensely hostile to religious images of all kinds. This hostility culminated in the appalling iconoclasm unleashed in 1548, under Henry's son Edward VI, when an Order of the Privy Council brought an abrupt end not only to an enormous quantity of art objects of various kinds but also to the industry of painters, sculptors, embroiderers and gold- and silversmiths which had produced them for the Catholic Church. From the time of Henry VIII onwards pictorial art in England was to be secular rather than religious. Its most important form by far became the independent easel painting rather than the wall painting, altarpiece or illuminated manuscript, and for nearly two hundred years, until the early eighteenth century, its subject matter consisted almost entirely of portraiture. Furthermore, during that period most of the major painters working in England were to be foreigners.

The most important single influence on the development of post-Reformation British art was Hans Holbein the Younger (1497–1543) of

Hans Holbein the Younger
The Ambassadors, 1533
Oil on panel,
$81\frac{1}{2}$ x $82\frac{1}{2}$ in/207 x 209.6 cm
National Gallery, London

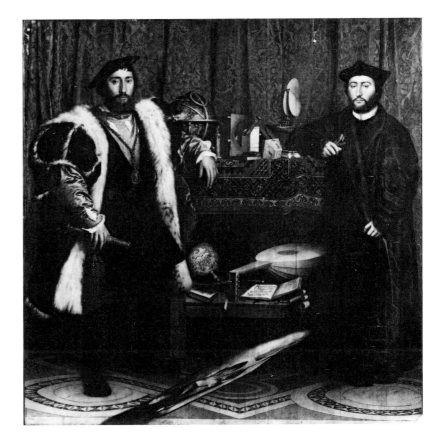

Basle. He spent two years in London from 1526–8, then in 1532 returned to live there until his death.

Holbein's greatest surviving masterpiece from his English period is the painting known as 'The Ambassadors'. This work possesses all the qualities that made Holbein the outstanding genius of northern European art in his time: an extraordinary and outstanding realism in the painting of the figures and the objects in the picture; a complete technical mastery which enabled him to achieve this realism and also to paint strange inventions like the mysterious form in the foreground; and finally a rich and complex symbolism which tells us who and what these men are and, beyond that, makes a philosophical statement about the nature of human existence.

The two men are Jean de Dinteville, on the left, a French nobleman who spent much of his time as ambassador in London, and his close friend Georges de Selve, Bishop of Lavaur and a brilliant classical scholar. The picture was painted to commemorate Selve's visit to London in the spring of 1533. Their different characters are clearly brought out: Selve the introverted ecclesiastic in dark clothing and with slightly hooded eyes; Dinteville the worldly extrovert in sumptuous and richly coloured robes, wearing a sword and dagger and gazing steadily at the spectator. The range of their knowledge and achievement is represented by the objects on the table between them; on the top shelf, the Turkish rug shows wealth and connoisseurship and the globe and other instruments demonstrate their up-to-date knowledge of science. Below, their worldwide commercial interests are represented by a globe and textbook of *Arithmetic for Merchants*. The hymn book in a modern version by Martin Luther indicates their knowledge of the latest developments in religion and the musical instruments show their accomplishment in music. All this in men still extraordinarily young: Dinteville was twenty-nine and Selve twenty-five at the time. They are almost supermen, but Holbein does not allow this splendid image of man's pride and magnificence to stand alone: the painting is full of symbols of death which the sitters cannot see: the crucifix on the wall behind them, the broken string on the lute and especially the strange form in the foreground which is in fact a human skull painted in distorted perspective – it can be seen properly by looking along the diagonal line of the object from close to the picture. Holbein is reminding us that for all their magnificence these men will die: that, in the words of St. Peter's First Epistle (1.24), 'All flesh is as grass, and all the glory of man as the flower of grass. The grass withereth and the flower thereof falleth away.'

The achievement of this painting was not to be matched in art in England until the arrival of Anthony Van Dyck exactly a century later. Much more immediately influential was the portrait style Holbein developed for his royal sitters after he began to work for Henry VIII in about 1536. One of the first and finest examples of this style is the famous portrait of Queen Jane Seymour. The face is treated with Holbein's usual unblinking realism, but the pose is formal and rigid and in particular the dress and head-dress and magnificent jewellery have been treated as flat, linear patterns so that the whole work tends to take on a richly decorative and quasi-religious character. This became a principal quality in English painting over the next century, so much so that Dr Roy Strong, when he came to write what is now the standard book on the art of that period, gave it the title *The English Icon.*

It is perhaps above all for his portraits of the King himself that Holbein is popularly remembered, and especially for that awesome image of Henry, bearded, bulky, hand on dagger, feet firmly planted astride which, overwhelmingly, has come down to posterity. Holbein originally created

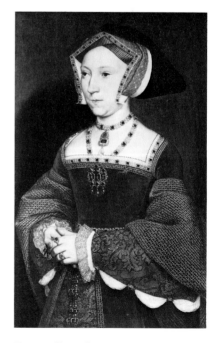

Hans Holbein the Younger
Jane Seymour, 1536
Oil on panel, 25¼ x 16 in/64.1 x 40.6 cm
Kunsthistorisches Museum, Vienna

Hans Holbein the Younger
Henry VIII, c. 1536–7
Ink and watercolour,
101½ x 54 in/
257.8 x 137.2 cm
National Portrait Gallery,
London

William Scrots
Mary I, c. 1550
Oil on panel,
80 x 44 in/203.2 x 111.8 cm
Private collection

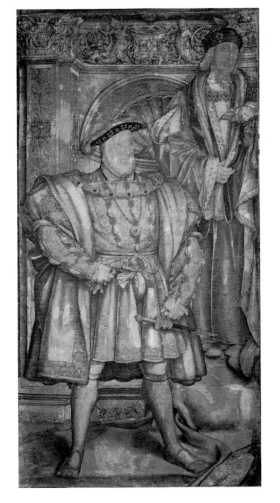

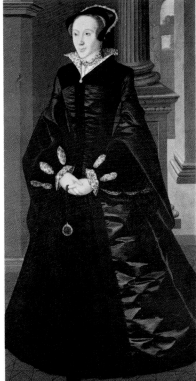

this picture of the King as part of a large wall painting of the Tudor dynasty (Henry VII, his queen, Elizabeth of York, Jane Seymour and Henry VIII) done in 1536–7 in the King's Privy Chamber in the Palace of Whitehall. It was destroyed by fire together with the whole palace in 1698 and there remains only a small copy in oils by an artist called Leemput in the Royal Collection to tell us what it was like. Fortunately, however, the most important part of Holbein's preparatory cartoon, the picture of Henry, survives. This marvellous life-size drawing can be seen in the National Portrait Gallery in London. A number of full-length versions in oil exist of the portrait of the King but none of them are thought with certainty to be by Holbein himself. Indeed, apart from miniatures, the only surviving portrait of Henry VIII by Holbein's own hand is the half-length in the Thyssen Collection, Switzerland.

Among Holbein's immediate followers in England the outstanding figure was John Bettes (active 1531–*c.*1576). He is presumed to be native-born since the reverse of his only certainly attributed work, the 'Unknown Man' of 1545 in the Tate Gallery, is inscribed 'faict par Jehan Bettes Anglois'. He is thought to have actually worked and been trained in the studio of Holbein, a view based both on the closeness of his style to that of Holbein and the very high quality of his work.

The move away from naturalism and an interest in the sitter's character towards a sophisticated style of courtly glamour was accelerated by the painter William Scrots (active 1537–53/4), a Netherlander who was Holbein's official successor from 1545 until he either left England or died in 1553 or 1554. Little is known of Scrots except that he had been court

painter to Elizabeth of Hungary, the Regent of the Netherlands, before entering the service of Henry VIII and that he received from Henry the exceptionally high salary of £62-10s a year, more than any painter to the Royal Household had received before. It seems clear that Henry was determined to spare no expense to get the most up-to-date and fashionable artist available. Scrots is best known for his State portraits of Edward VI (reigned 1547–53), but his portrait, thought to be of Mary I (reigned 1553–8), painted in about 1550 before she came to the throne, is a splendid example of the cool glossy elegance of his court pictures, especially in the rendering of her black silk dress and accessories.

The accession of Mary I coincided with the death or emigration of Scrots, who was replaced as court painter by Hans Eworth (active 1540–73). Eworth is now accepted as the dominating figure in English painting in the mid-sixteenth century. Little is known about his life although he probably came from Antwerp and is first recorded in England in 1549. Fortunately, unlike most of his contemporaries, he signed many of his pictures with his monogram and his œuvre is therefore exceptionally well documented. He worked for Mary during her brief reign but fell out of royal favour under her half-sister Elizabeth I (reigned 1558–1603).

Eworth continued to develop the trend towards a decorative, flatly patterned portrait as can be seen in his 'Mary FitzAlan, Duchess of Norfolk', painted in about 1555 and recently revealed in all its glory by cleaning and restoration. The emphatic flatness and frontality of the figure, the fantastic elaboration of the embroidered sleeves and panels of the dress, the sumptuous colour scheme of green and plum, the enamel-like quality of the paint, the highly focused precision of the style and finally the face, pale, smooth and hard as ivory with its remote, withdrawn expression, all combine to make a gorgeous, glittering and somewhat inhuman image. This was a kind of painting which was to find its fullest expression in the reign of Elizabeth I and particularly in the State portraits of the Queen herself.

Not all Eworth's portraits were of this type. One of the strangest of all Tudor paintings is his allegorical portrait of Sir John Luttrell, a soldier and trader, done in 1550. This picture is in fact in the highly sensual and symbolic style of the School of Fontainebleau then at its height at the French court. Sir John is depicted as a fighting sea god rescued from the storms of war by Peace, represented by the nude figure carrying an olive branch.

The gap created by Eworth's fall from favour after Elizabeth's accession in 1558 was filled by various lesser talents, mostly from the Netherlands, and it was not until the 1570s that another outstanding artist appeared. This was Nicholas Hilliard (1547–1619), the first native-born genius of English painting. It is worth noting that until her discovery of Hilliard, Elizabeth could find no satisfactory court painter. So unsatisfactory indeed were the portraits of her that, in 1563, the Queen's councillors drafted a proclamation forbidding the painting of portraits of the Queen until 'some special persons . . . shall have first fynished a portraiture thereof, after which fynished, her majesty will be content that all other payntors, or gravers . . . shall and maybe at ther plesurs follow the said patron [pattern] or first portraiture.'

Hilliard was born in Exeter in 1547, the son of a successful goldsmith, and, after spending most of his childhood in Geneva, it was as a goldsmith that he eventually trained. In 1562 at the age of fifteen he was apprenticed to Robert Brandon, a leading member of the Goldsmiths' Company in London and goldsmith and jeweller to the new Queen Elizabeth I. After the usual seven years Hilliard set up as a professional goldsmith with his

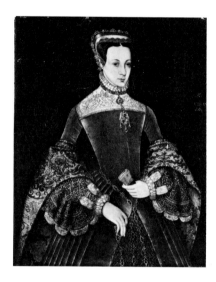

Hans Eworth
?Mary FitzAlan, Duchess of Norfolk,
?1555
Oil on panel, 35 x 28 in/88.9 x 71.1 cm
Private collection

Hans Eworth
Sir John Luttrell, 1550
Oil on panel,
42¼ x 32¾ in/108 x 82.2 cm
Lee Collection, Courtauld Institute
Galleries, London

brother John, but he was from the outset of his career also a painter or, more correctly, a limner. Limning was a specialised form of miniature portrait painting founded in England by Holbein and taken to its highest pitch of perfection by Hilliard during the reign of Elizabeth. The miniature took on great significance in court circles, becoming a form of personal jewellery, worn in elaborate jewelled 'picture boxes' or in lockets, hung on jewelled chains or framed in carved ivory cases. Hilliard's two professions, of goldsmith and limner, were thus intimately linked.

The importance of the place held by the miniature in Elizabethan court life, revolving as it did round political and amorous intrigue and flattery of the Queen, is illustrated by the following anecdote quoted by the nineteenth-century Prime Minister Disraeli in his *Curiosities of Literature*. It comes from a letter of the period: 'Lady Derby wore about her neck and in her bosom a portrait. The Queen espying it, inquired about it but her ladyship was anxious to conceal it. The Queen insisted on having it and discovering it to be the portrait of young Cecil, she snatched it away and, tying it upon her shoe, walked along with it; afterwards she pinned it on her elbow and wore it some time there. Secretary Cecil hearing of this composed some verses and got them set to music; this music the Queen insisted on hearing. In his verses Cecil sang that he repined not, though Her Majesty was pleased to grace others. He contented himself with the favour she had given him by wearing his portrait on her feet and elbow!'

Hilliard's fame rests not just on his supreme achievement as a practising artist but on his book, *Treatise on the Art of Limning*, which he compiled between 1597 and 1603. Although this is primarily a technical treatise dealing with Hilliard's working methods it also includes glimpses of the prominent people he came in contact with from Elizabeth herself to the French poet Ronsard, as well as his reflections on aesthetics.

It is in the *Treatise* that Hilliard explicitly reveals the influence of Holbein on the formation of his style – he probably first has access to Holbein miniatures during his childhood in Geneva: '...the most excellent painter and limner Hans Holbein, the greatest master truly in both those arts after the life that ever was... Holbein's manner of limning I have ever imitated and hold it for the best...' As well as drawing directly on the linear style of Holbein, Hilliard also admired the engravings of Holbein's great predecessor in Northern Renaissance painting, Albrecht Dürer, and he inherited the formalising decorative manner developed, as we have seen, by painters who came after Holbein such as Scrots and Eworth. To this, however, he added a high degree of naturalism and a keen interest in the mood and character of the sitter. He always painted from life and there is no doubt that much of the power of his images has its source in Hilliard's strong responsiveness to physical beauty in both men and women. In the *Treatise* he went so far as to elevate this response to the level of aesthetic theory, claiming the human face as the absolute model of beauty: '...of all things the perfection is to imitate the face of mankind...' Furthermore, he responded most strongly to specifically English kinds of beauty: '...rare beauties are...more commonly found in this isle of England than elsewhere, such surely as art must give place to. I say not for the face only but every part, for even the hand and foot excelleth all pictures that yet I ever saw. This moved a certain Pope to say England was rightly called Anglia, or Angely, as the country of Angels, God grant it.'

A third element in Hilliard's style was the influence of the Queen herself and her ideas about painting. In the *Treatise* is an account of Elizabeth's first sitting to him, a reminiscence he brings up as an example to drive home a lesson on the importance of line. The Queen, who was knowledgeable about

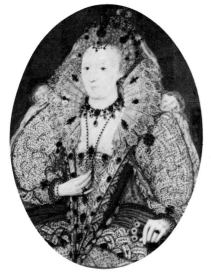

Nicholas Hilliard
*Elizabeth I, c.*1600
Miniature, $3\frac{3}{8} \times 2\frac{5}{8}$ in/8.6 x 6.7 cm
Ham House, London

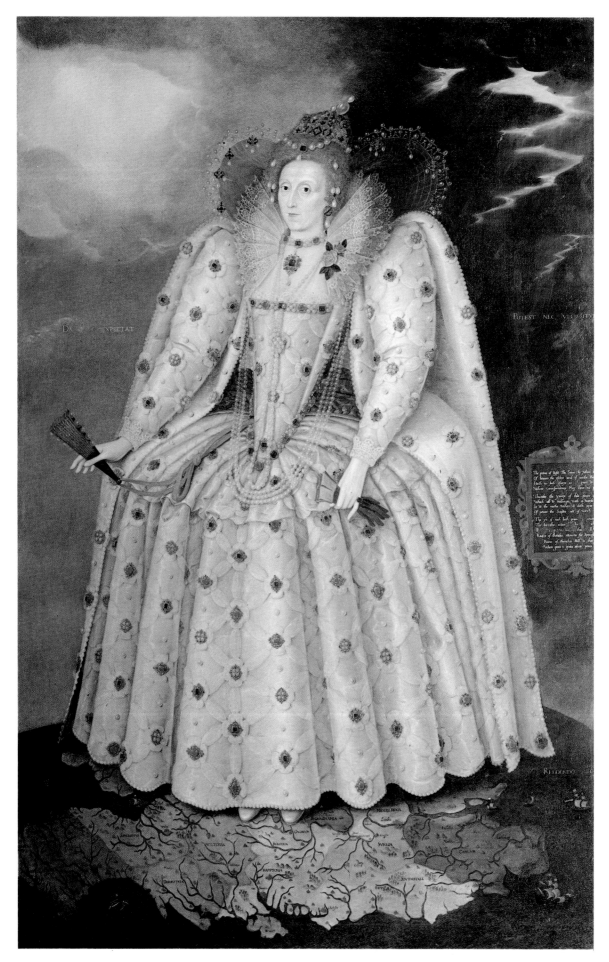

Marcus Gheeraerts the Younger
Elizabeth I, 1592?
Oil on canvas, 95 x 60 in/
241.3 x 152.4 cm
National Portrait Gallery, London

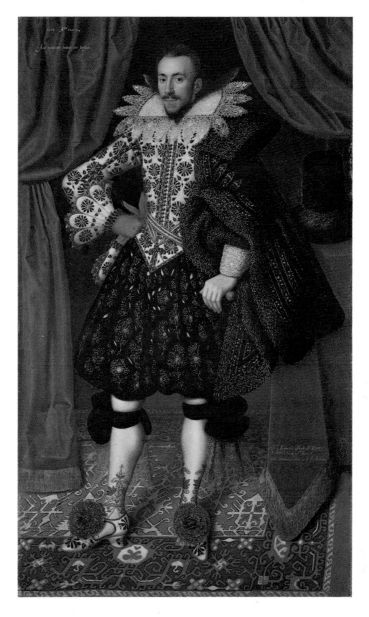

William Larkin
Richard Sackville, Third Earl of Dorset,
1613
Oil on canvas,
80 x 47 in/203.2 x 119.4 cm
Ranger's House, Blackheath (Greater
London Council)

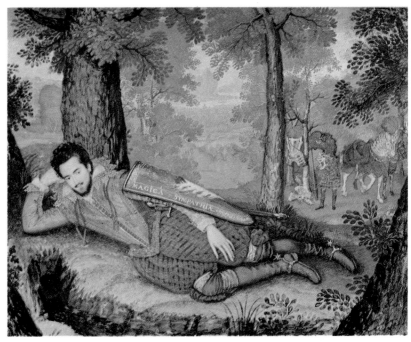

Isaac Oliver
Lord Herbert of Cherbury, c.1610–15
Miniature, 7⅛ x 9 in/18.1 x 22.9 cm
The Earl of Powis

art, remembered that the best painters did not use shadow and asked Hilliard why: 'I granted and affirmed that shadows in pictures...give unto them a grosser line...Here her Majesty conceived [understood] the reason and therefore chose her place to sit in for that purpose in the open alley of a goodly garden, where no tree was near, nor any shadow at all...' The result of this sitting was almost certainly the miniature of 1572 now in the National Portrait Gallery.

Elizabeth here was clearly encouraging the flat linear quality already present in Hilliard's art and this as we have seen tends to produce an iconic character. This is precisely what the Queen wanted: an image of herself as an object of worship, and she strongly reinforced the effect of god-like majesty in her portraits by deploying a wardrobe and jewellery of awesome richness.

Hilliard's portraits of Elizabeth reached their peak in those works, like the marvellous three-quarter length in Ham House, described by Roy Strong as 'formalised votive images in which the splendour of her jewels and dress is reduced to a pattern reminiscent of a Byzantine mosaic'.

Apart from his portraits of the Queen Hilliard developed in his art a remarkably wide and rich range. The 'Unknown Young Man Among Roses' and 'George Clifford, Third Earl of Cumberland' are two strongly contrasting works which mark the full dazzling climax of Hilliard's art in the 1590s.

George Clifford has been described as 'a typical Elizabethan sailor-courtier, gambler and buccaneer' and he was in high favour with the Queen. Hilliard's portrait shows him as Queen's Champion at her annual tilt or tournament. The Elizabethan court had a romantic obsession with medieval chivalry, and the Queen had a dual role as sovereign claiming the loyalty of her knights and as the adored idealised lady in whose honour the knights entered the lists at the tournament. Clifford is wearing the Queen's diamond-studded glove on his head-dress and has just flung down his gauntlet as a challenge.

The portrait of the unknown young man is concerned with a very different preoccupation of the Elizabethan court – the cult of melancholy. It is also different from the Cumberland portrait in that it depicts a psychological state, a mood, rather than being an icon of power and achievement. The Elizabethan concept of melancholy is a complex one, fully explored in Robert Burton's famous *Anatomy of Melancholy*, published in 1621, a few years after Hilliard's death. Briefly, the state of melancholy was taken as an indication of intellectual depth and particularly of artistic, poetic and philosophic sensibility. It was also very much associated with lovers, and the young man with his hand on his heart is clearly suffering from unrequited love. This interpretation is reinforced by the roses which apparently symbolised chastity and the motto *Dat Poenas Laudata Fides* which has been translated 'My praised faith causes my sufferings'.

After Hilliard established the type, votive images of the Queen abounded. Spectacular examples are George Gower's 'Armada Portrait' in the Duke of Bedford's collection, a glorification of Elizabeth after the defeat of the Armada, seen sailing towards England on one side of her and being wrecked on the other; Robert Peake's picture, now in a private collection, of her being carried in procession for the adoration of her subjects, and the Flemish-born Marcus Gheeraerts the Younger's huge canvas (originally even bigger than it now is) depicting Elizabeth standing on a globe of the world. On a smaller scale, the portrait attributed to John Bettes in the National Portrait Gallery is a perfect example of the extreme degree of icon-like abstraction reached in the Queen's portraits during the period of open war with Spain about 1585–90.

Nicholas Hilliard
George Clifford, Third Earl of Cumberland,
*c.*1590
Miniature, 10 x 7 in/25 x 18 cm
(approx)
Greenwich Hospital Collection,
National Maritime Museum, London

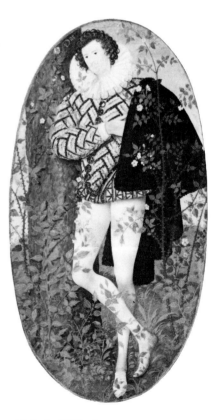

Nicholas Hilliard
An Unknown Young Man Among Roses,
*c.*1588
Miniature, 5⅜ x 2¾ in/13.7 x 7 cm
Victoria and Albert Museum, London

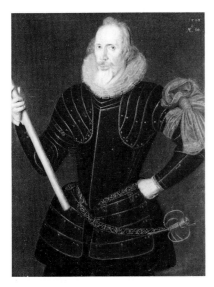

Robert Peake
Unknown Military Commander, 1593
Oil on panel, 44½ x 35½ in/
113 x 90.2 cm
The Lord Rootes

George Gower (1540–96) and Robert Peake (active 1575–1623) were the two leading Elizabethan portraitists apart from Hilliard. Gower was appointed Sergeant Painter to the Queen in 1581 and three years later combined with Hilliard in an attempt to gain a monopoly of royal portraiture. The younger Robert Peake established a flourishing practice in the 1580s and his career continued well into the reign of James I whose Sergeant Painter he became. The 'Unknown Military Commander', his only fully signed and dated work, is a fine example of his art and particularly reveals the much greater realism in the depiction of character Elizabethan portraitists could permit themselves when their sitters were not royal.

One of the last great exponents of the high Elizabethan style established by Gower and Peake was William Larkin (active 1610–20), an obscure figure until his œuvre was recently reconstructed by Roy Strong. He is famous for the 'Redlynch Long Gallery Set' of seven full-length portraits of ladies commissioned about 1614 to commemorate the marriage of the First Earl of Berkshire. There is no space here to reproduce this remarkable group, but Larkin's portrait of the Third Earl of Dorset of 1613 fully conveys the almost oriental splendour of his style.

By the time this picture was painted James I (reigned 1603–25) was on the throne and Hilliard had been succeeded as the dominant painter by two younger men, Marcus Gheeraerts the Younger (1561–1635) and the French-born miniaturist Isaac Oliver (1556(?)–1617). Oliver actually learnt the art of limning from Hilliard himself in the 1580s and by 1595 or so had become his great rival. The main difference in his style from that of Hilliard is the use of shadow and darker colour to create both a more naturalistic, more three-dimensional effect and often a more sombre mood. He came into his own as court painter to James and his large miniature of Henry Prince of Wales, done not long before Henry's premature death in 1612, is one of his masterpieces. Another is the marvellous portrait of Lord Herbert lying under a tree by a stream. Here the outdoor setting has naturally led to the use of the clear light and colour more characteristic of Hilliard. This picture is another image of melancholy, although in this case it is not upon love but upon some intellectual matter that the subject is brooding; Herbert was the author of a philosophical treatise, *De Veritate*.

Marcus Gheeraerts was Isaac Oliver's brother-in-law and like Oliver he firmly established his reputation in the last decade of Elizabeth's reign and flourished in the first decade of that of James. In his portraits other than those of the Queen, Gheeraerts established a style of great charm in which, although the Elizabethan emphasis on decoration is retained, the figures are no longer flat but convincingly three-dimensional and stand in three-dimensional settings. From about 1616 Gheeraerts was eclipsed by the Dutchman Paul Van Somer (c.1576–1622) whose richer style brought him extensive court patronage, but he in turn was rapidly put in the shade by another Dutchman, Daniel Mytens (sometimes pronounced mittens) c.1590–1647, who remained the dominant figure in English painting until the arrival of Van Dyck.

Mytens came to London in 1618 having already gained aristocratic patronage. In 1624 James granted him an annual pension, and when Charles I came to the throne in 1625 he appointed Mytens for life as one of his official 'picture drawers of our Chamber in Ordinarie'. Mytens's portraits are distinguished by the naturalism and solidity of the figures and particularly by their simple grandeur of composition and cool restrained elegance of colour and tone, beside which the work of his predecessors tends to look gaudy and over-elaborate. His picture in the Tate Gallery, thought to be of the First Duke of Hamilton as a boy, is a miracle of sensitive

relationships of muted colour, blacks and silvery greys, brought to life by the brilliant red of the stockings.

Mytens remained in high favour well into the reign of Charles I, but when Charles in 1632 secured the services of the immeasurably more gifted Anthony Van Dyck, Mytens was rapidly eclipsed and a new chapter opened in the history of painting in Britain.

Daniel Mytens the Elder
The First Duke of Hamilton as a Boy?,
1624
Oil on canvas,
79 x 49¼ in/200.7 x 125.1 cm
Tate Gallery, London

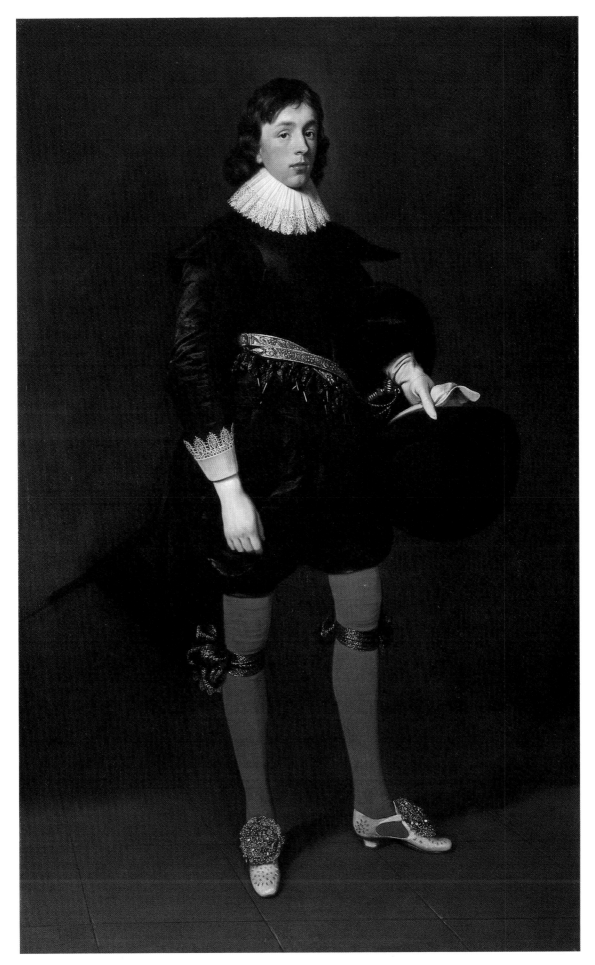

Chapter 2
Painting under the Stuarts

Charles I (reigned 1625–49) was by far the greatest and most perceptive collector and patron of the arts in the history of the British monarchy. By the time of his accession he already owned, or had ordered the purchase of, an impressive collection of pictures by great European masters past and present, including Raphael (the great cartoons now on permanent loan from the Queen to the Victoria and Albert Museum), Titian, Tintoretto, Holbein and Rubens, as well as by domestic talents such as Mytens, and this collection was vigorously expanded through his reign. The Flemish painter, Peter Paul Rubens (1577–1640), with whom Charles had been in touch for some years before his accession, seems to have admired Charles almost as much as Charles admired him and called him 'the greatest amateur [collector, connoisseur] of painting among the princes of the world'. When Rubens finally came to England from June 1629 to March 1630 Charles knighted him and finalised the arrangements for Rubens to paint ceiling decorations for the new Banqueting Hall designed by Inigo Jones in Whitehall. These decorations, painted on canvas in Brussels and installed in March 1676, are miraculously still in place, the only one of Rubens's decorative schemes still to survive in its original setting, and since the dispersal and partial destruction of Charles's collection after his death, the most complete and intact evidence of the flowering of the arts which took place in England during his reign.

It was not Rubens, however, but his great pupil Anthony Van Dyck (1599–1641) who made the most important contribution to pictorial art in England during the age of Charles I. Van Dyck made his first brief visit to England in 1620 and entered the service of James I. At this time, although only twenty-one, he was already a highly accomplished artist – it has been suggested that he left Antwerp, his and Rubens's home town, because of a growing rivalry with the older painter – but seems to have felt the need to further his education in Italy. He obtained eight months' leave from James for this purpose but in the event did not return to England until 1632. He was now fully mature: the most dazzlingly talented court portrait painter in Europe. This time he stayed, not surprisingly since Charles treated him with extraordinary favour. He was appointed 'principalle Paynter in ordinary to their majesties' with a pension of £200 a year, given a house and knighted. He died in London in 1641 at the outbreak of the Civil War.

Sir Oliver Millar, Surveyor of the Queen's pictures, has written of Van Dyck: 'His training enabled him to design on a large scale with an assurance which no earlier painter established in England had attempted. He was master of a beautiful technique, a variety of touch and a delicacy of tone far more sophisticated than his predecessors in royal service could display.' What Van Dyck did with this basic equipment can be seen in pictures like the 'Charles I on Horseback' of 1633 and the double portrait of 'Lord Digby and Lord Russell'.

The huge equestrian portrait of Charles was originally hung at the end of

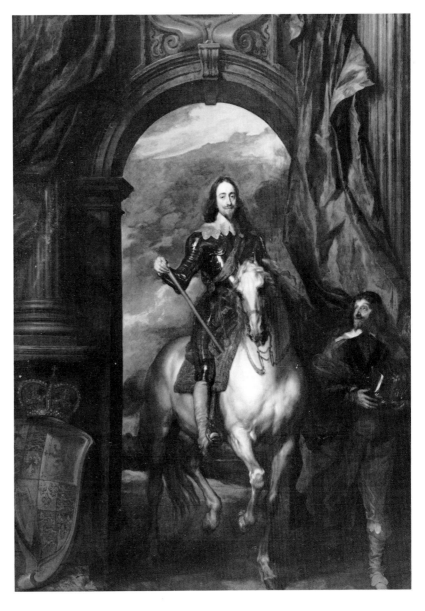

Sir Anthony Van Dyck
Charles 1 on Horseback, 1633
Oil on canvas, 145 x 106 in/
368.3 x 269.2 cm
Royal Collection (reproduced by
gracious permission of Her Majesty
the Queen)

the Long Gallery in the Palace of St. James. Since the horse and figures are life-size it would have created the impression on visitors entering the other end of the room that the King was riding towards them through the arch. As Oliver Millar has also pointed out, Van Dyck has 'so skilfully brought him to life with his brush that if our eyes alone were to be believed they would boldly assert that the King was alive in the portrait so vivid is its appearance'. This intense naturalism combines with the grandeur of design, the feeling of weight and power in the very forms and rhythms of the picture, to produce an image unmistakably that of a great monarch. There is another equally imposing life-size equestrian portrait of Charles by Van Dyck, with a landscape setting, now in the National Gallery.

The design of the portrait of Lord Digby and Lord Russell is also imposing, but without the overwhelming monumentality of that of the King. Here Van Dyck is doing what he perhaps did best of all in his English works, creating gorgeous, immensely glamorous and elegant images of the cavalier aristocracy. These marvellous paintings were, of course, unashamedly propagandist. Charles, we know from contemporary accounts, was physically unprepossessing, and no king who plunges his country into civil war and is subsequently executed by his subjects can be called great. Doubtless, too, Digby and Russell were not in reality the

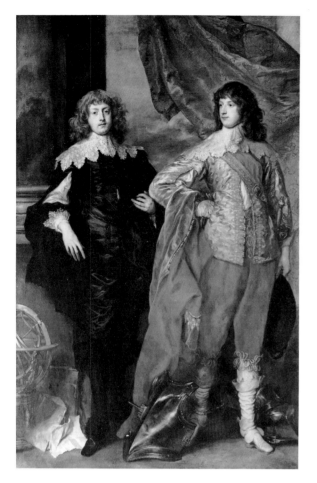

Sir Anthony Van Dyck
Lord Digby and Lord Russell
Oil on canvas, 99⅞ x 62¾ in/
253.7 x 159.4 cm
The Earl Spencer, Althorp

magnificent creatures of Van Dyck's painting. But it should also be added
that the glamourising function was fundamental to the theory of
portraiture of the time. This theory was best stated rather later by the
eighteenth-century writer and critic Jonathan Richardson: 'A good portrait
(is one) from whence we conceive a better opinion of the beauty, good sense,
breeding and other good qualities of the person than from seeing
themselves.' It is true that he went on to say that we should not be able to
see 'in what particular it is unlike, for nature must be ever in view', but this
part of the theory was never taken too seriously by either portrait painters
or their fashionable sitters.

The simultaneous outbreak of civil war and the death of Van Dyck
brought to an end the civilisation of the Caroline court. But that civilisation
and the influence of Van Dyck produced one last flowering – the art of
William Dobson (1611–46), the only native-born genius of seventeenth-
century British painting.

Little is known of Dobson's life and all the surviving works by him date
from between 1642, when Charles set up his wartime court in Oxford, and
1646, the year of Dobson's death at the age of thirty-five. Among these his
masterpiece is the portrait of Endymion Porter, probably painted in Oxford
about 1643–5. This picture is an outstanding example of the type of
portrait Dobson is best known for: the so-called allegorical portrait in which
various elements, especially classical busts and friezes, are introduced to
illustrate the character, tastes and circumstances of the sitter.

Porter was Charles's Groom of the King's Bedchamber and devoted to
both literature and the visual arts. He acted as an agent of the King in
scouring Europe for works of art for the royal collection, taking part, for
example, in the hard bargaining which in 1627 secured the magnificent

William Dobson
Endymion Porter, c.1643–5
Oil on canvas, 59 x 50 in/
149.9 x 127 cm
Tate Gallery, London

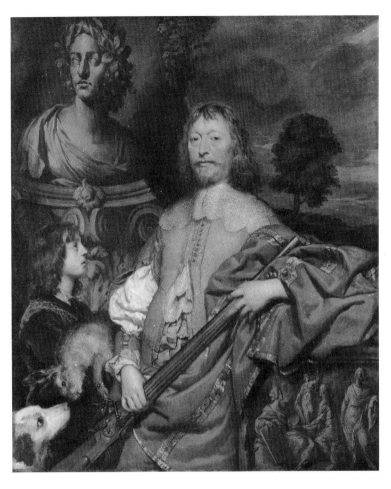

Sir Peter Lely
Sleeping Nymphs, c.1650–5
Oil on canvas, 50¾ x 57 in/
128.9 x 144.8 cm
Alleyn's College of God's Gift, Dulwich
College, London

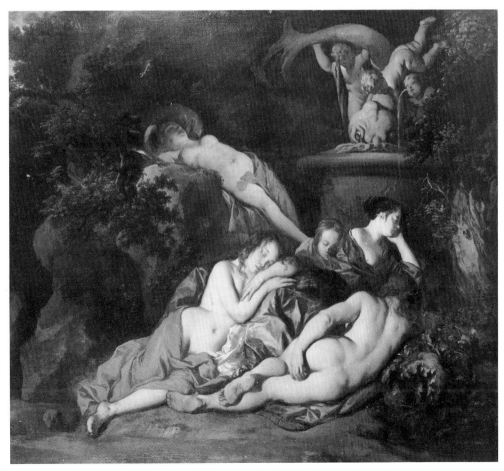

collection of the Duke of Mantua for Charles at a low price. This side of Porter's character is reflected in Dobson's portrait in the bust of Apollo, Greek god of the arts, in the top left corner, and the frieze at the bottom right of three figures representing painting, sculpture and poetry. The pose of the figure of Porter is based on a painting by Titian of the Roman Emperor Vespasian at that time in the royal collection. Porter probably suggested this himself as an indirect reference to his love and knowledge of Italian art, but the richness and beauty of Dobson's colour, here a particularly pleasing harmony of dark golds, reveals his own admiration for Titian and his ability to profit from it. The costume (hunting dress), wheel-lock sporting rifle, page boy, dog and dead hare present an image of Porter as country squire to balance and complement that of the connoisseur.

The period from the restoration of the monarchy in 1660, when Charles II (reigned 1660–85) came to the throne, up to the rise of Hogarth in the 1720s is dominated by two portrait painters, the Dutchman Peter Lely (1618–80) and his successor, the German-born Godfrey Kneller (1646–1723).

Lely was trained in Haarlem in Holland and came to England probably in 1643 although the exact date is not known. He quickly found important patrons and his first datable portrait is of Charles I and his son the Duke of York, now at Syon House, painted in 1647 for the Duke of Northumberland in whose custody Charles was at Hampton Court after the end of the Civil War.

Ironically, Lely did extremely well during the Commonwealth and was a rich man by the time of the Restoration. His success came not from portraits but oddly enough from rather erotic subject pictures like the 'Sleeping Nymphs' or 'Susanna and the Elders' at the Tate Gallery. Perhaps his Puritan patrons felt that vanity was a greater sin than voluptuousness, although an important factor would also have been that subject pictures of this kind were what was known as 'history painting' or 'high art'. History painting was the invention of the great Renaissance masters exemplified by Raphael, and from the Renaissance until the middle of the nineteenth century was universally accepted as the noblest form of art, outranking all others such as portraiture and landscape. The aim of history painting was the imaginative expression of important intellectual ideas or great human passions and emotions through subjects drawn from either classical history, classical mythology or the Bible. These categories of subject matter were strictly adhered to until the end of the eighteenth century when they were extended to include great imaginative literature such as the works of Shakespeare and Milton.

The collection of Charles I consisted largely of history painting – the Raphael cartoons, for example – and like Charles most English patrons who came after him went to the original source, Italy, to buy their history pictures. This meant that artists in England got little chance to practise 'high art' and when they did the results, as in the case of Lely, were rarely of the highest quality. It was not until the late eighteenth century that, encouraged by the newly formed Royal Academy, a number of interesting painters of history were to appear using particularly the new literary subject matter.

Lely's history pictures, even if not very great art, form an important element of relief among the portraiture of the period. Unfortunately, after the Restoration demand for them ceased and Lely became completely preoccupied with the production of fashionable portraits.

Probably because he had shrewdly kept in touch with the Royal Family in exile, Lely was immediately made Principal Painter to Charles II and was

eventually knighted just before his death in 1680. The range of Lely's art under the Restoration can be seen in two series of portraits, the Admirals in the Queen's House at Greenwich, done in about 1666–7, and the Windsor Beauties now kept at Hampton Court. The Admirals are severe images of the guardians of British sea power, none more so than the remarkable picture of Sir Jeremiah Smith. This work, with its astonishingly realistic and powerful depiction of character combined with an austere beauty of colour, has rightly been picked out as one of Lely's greatest portraits.

The Windsor Beauties are at the opposite pole of sensibility, being outstanding examples of Lely's power to render the sleepy, pop-eyed voluptuousness so fashionable at the court of Charles II. They were commissioned by the Duchess of York who, according to the Comte de Grammont in his famous memoirs, 'wished to have a gallery of the fairest persons at Court: Lely painted them for her. In this commission he expended all his art; and there is no doubt that he could scarcely have had more beautiful sitters.' There are ten of them altogether, hanging now in the Communication Gallery at Hampton Court like a harem, five on either side of a portrait of Charles II which shows him at his most sensual and rakish. They are all luscious, but one of the most fetching is the delicious Frances Brooke, Lady Whitmore with her enormous eyes, knowing look and ripe mouth. It is worth emphasising that these portraits are more Lely's creations than true representations of the sitters: as Samuel Pepys commented when he saw them in 1668, 'they are good but not like'.

Godfrey Kneller settled in England in 1676 after training in Holland and Italy. His early career remains obscure but by 1685 the diarist Evelyn was calling him 'the famous painter' and in 1688 he and the painter John Riley were appointed jointly to the post of 'chief painter', replacing the Italian Verrio who held it briefly after Lely.

On Riley's death in 1691 Kneller assumed the whole office and remained the major artistic figure in England until his own death in 1723. He was knighted in 1692 and made a baronet in 1715, an extraordinary honour

Below left:
Sir Peter Lely
Admiral Sir Jeremiah Smith, c.1666
Oil on canvas, 50 x 40 in/
127 x 101.6 cm
Greenwich Hospital Collection,
National Maritime Museum, London

Below right:
Sir Peter Lely
Frances Brooke, Lady Whitmore, 1662–5
Oil on canvas, 49 x 40 in/
124.5 x 101.6 cm
Royal Collection (reproduced by
gracious permission of Her Majesty
the Queen)

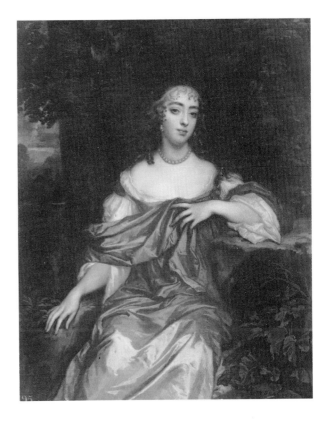

for an artist and an index of how well he served the society he lived in.

As with Lely, Kneller's achievement can now best be seen in certain series of portraits. There is a series of admirals, successors to Lely's at Greenwich, and a series of beauties at Hampton Court, but his greatest is generally agreed to be that of the Kit Cat Club now in the National Portrait Gallery. The Kit Cat was a political dining club of the Whig Party. Kneller himself was a member and between 1703 and 1717 he painted portraits of forty-two of its members. The outstanding qualities of these portraits are directness, sobriety and a solid realism which makes them the direct ancestors of the portraiture of Hogarth. They are also an important historical and social document.

It would be wrong to leave the impression that painting in Britain before Hogarth consisted entirely of portraiture. In the second half of the seventeenth century some variety began to appear. We have seen that Lely painted subject pictures in the 1650s and at that time he proposed an ambitious scheme for a series of historical paintings to hang in the Houses of Parliament. It was unfortunately never carried out. The beginnings of that important and characteristically English art, the painting of nature, can be seen in the landscapes of painters like Jan Siberechts (1627–1700) and Wencelaus Hollar (1607–77), in the marvellous animal paintings of Francis Barlow (1626–1704) and in the growth of marine painting.

Most landscape painting at this time was of poor quality and unrelated to the English scene. Siberechts' 'Henley-on-Thames' of 1690 in the Tate Gallery is remarkable both for its subject and especially for its naturalism – particularly in the observation of weather conditions.

Relatively few paintings by Barlow have survived, but works like the frieze of hounds of 1667 reveal an impressive combination of earthy naturalism with a strong sense of formal design – very much the qualities to be found in Stubbs a century later.

From 1673, when the Dutchman William Van de Velde settled in England, there was a vigorous development of marine painting by him, his son William the Younger and their English successors Charles Brooking (1723–59), Peter Monamy (1682–1749) and Samuel Scott (1702–72), whose work can be seen in great quantities in the National Maritime Museum in the Palace of Greenwich.

Finally there was a certain amount of decorative ceiling and mural painting. Its outstanding English exponent was Sir James Thornhill (1675/6–1734), Hogarth's father-in-law, whose art can best be seen in the famous Painted Hall at Greenwich. His predecessor Antonio Verrio (1639–1707) did extensive work at Hampton Court. However, the best baroque decoration in Britain remains, of course, the Rubens ceiling in the Banqueting Hall at Whitehall.

Sir Godfrey Kneller
Jacob Tonson, 1717
Oil on canvas,
36 x 28 in/91.4 x 71.1 cm
National Portrait Gallery, London

Sir Godfrey Kneller
Sir John Vanbrugh, c.1704–10
Oil on canvas,
36 x 28 in/91.4 x 71.1 cm
National Portrait Gallery, London

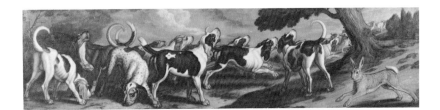

Francis Barlow
Southern Mouthed Hounds, c.1690
Oil on canvas, 35 x 140 in/
88.9 x 355.6 cm
Clandon Park (National Trust)

William Hogarth

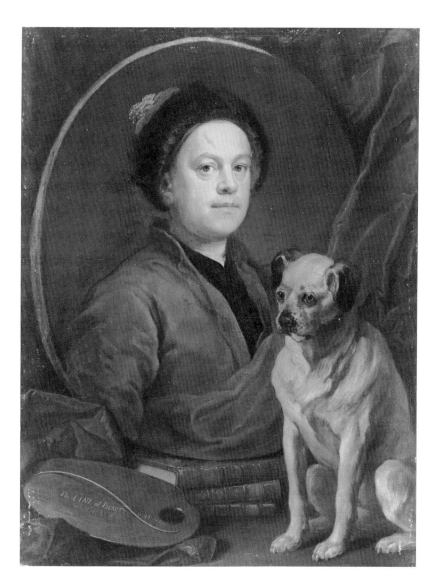

William Hogarth
The Painter and his Pug, 1745
Oil on canvas, $35\frac{1}{2}$ x $27\frac{1}{2}$ in/
90.17 x 69.9 cm
Tate Gallery, London

William Hogarth (1697–1794) dominated English art during the first half of the eighteenth century and his career marks the beginning of a great flowering of painting in Britain. Hogarth extended the existing tradition of portraiture with distinction and originality, but perhaps his main achievement was to go beyond portraiture to create for the first time a variety of types of painting rooted in English life and English culture.

Hogarth's character and the range of his artistic and intellectual interests are vividly expressed in his famous self-portrait of 1745. Here Hogarth's own image rests on three books by great British writers, Shakespeare, Swift and Milton, and these writers reflect a range of interests and concerns that appear in his art.

The palette in the lower left corner is an emblem of the sitter's profession, but on it is a curved line accompanied by the words 'The line of beauty'. This idea was fully explored in Hogarth's important book *The Analysis of Beauty* which he eventually published in 1753. The first purely theoretical treatise in the history of British art, it points up the impressive intellectual dimension of Hogarth's artistic personality. There was nothing new, of course, in the idea of beauty residing in a curved line: Hogarth in his autobiographical notes, now preserved in the British Museum, wrote of 'the inimitable curve of beauty of the "S" undulating motion line, admired and inimitable in the ancient great sculptors and painters'. What was novel was a painter theorising about it, and when the self-portrait was published as an engraving in 1749 Hogarth was delighted by the interest aroused by the serpentine line: '. . . no Egyptian Hieroglyphic ever amused more than it did for a time. Painters and sculptors came to me, to know the meaning of it . . .'

Hogarth's pet pug, Trump, prominently placed in the foreground of the portrait, would probably have been equally remarked upon since among other things it was a breach of the rules of art and taste as laid down by the aristocratic collectors, sometimes known as Connoisseurs, upon whom all ambitious artists at that time depended for their livelihood. Hogarth quarrelled with them all his life and the placing of Trump in the self-portrait was almost certainly intended as a deliberate provocation. His chief disagreement with the collectors was over the vexed question of history painting (see p.24). Hogarth, as an ambitious artist possessed of great and original creative powers, naturally wished to paint history. As we have seen, however, British patrons were reluctant to commission history pictures from British artists. Hogarth only had one such commission, which was a fiasco, the patron refusing in the end to accept the painting, 'Sigismonda'. It is now in the Tate Gallery but, it must be said, is not among the most admired of Hogarth's works. Besides 'Sigismonda' there are a number of other history paintings by Hogarth, mostly done for charity or for his own satisfaction, but with one exception these, like 'Sigismonda', are not considered to be successful works. The very important exception is 'Satan, Sin and Death' of 1735–40 which is discussed on page 34.

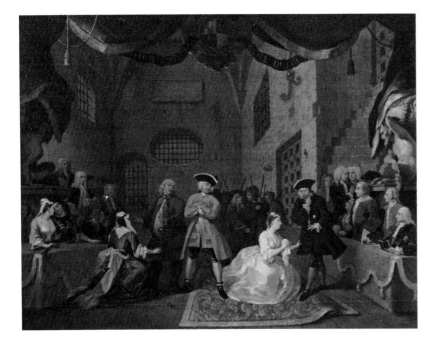

William Hogarth
A Scene from 'The Beggar's Opera',
1729–31
Oil on canvas, 22½ x 29⅞ in/
57.15 x 75.9 cm
Tate Gallery, London

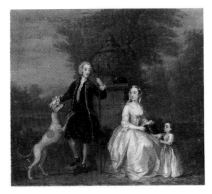

William Hogarth
*Ashley Cowper with his Wife and
Daughter*, 1731
Oil on canvas, 21 x 23⅞ in/
53.3 x 60.6 cm
Tate Gallery, London

William Hogarth
A Rake's Progress (Plate 3), 1735
Engraving, 12½ x 15¼ in/31.8 x 38.7 cm
Tate Gallery, London

Hogarth was born in the heart of London, the son of a schoolteacher who for some years in Hogarth's childhood ran a Latin-speaking coffee-house. The failure of this coffee-house and his father's subsequent imprisonment for debt scarred Hogarth for life, and he repeatedly introduced prisons, debtors and gaolers into his art. It also delayed his education, as well as no doubt contributing to his rebelliousness. Eventually at seventeen he was apprenticed as a silver engraver and in about 1720 he set up on his own and also learned to engrave on copper. It was with 'The Taste of the Town', a copper engraving satirising the Connoisseurs, that he first achieved some notice around London. Hogarth's early training and practice as an engraver is of great significance. He later engraved and published many of his own works, thus reaching a wider audience than that for painting and achieving a large degree of independence from aristocratic patronage.

During the 1720s Hogarth taught himself to paint, and towards the end of that decade, in about 1728–9, he suddenly blossomed as a painter. He also, in 1729, eloped with the daughter of Sir James Thornhill.

The main kind of picture Hogarth was doing at the time of his marriage he described as 'portrait figures from ten to fifteen inches high, often in subjects of conversation'. In practice this meant small, informal group portraits, often of great charm and elegance, of which 'Ashley Cowper with his Wife and Daughter' (1731) is a good example. This type of portrait, known as a 'conversation piece' was based on Continental models, but in England, as Hogarth remarked, 'it had some novelty'. Hogarth had

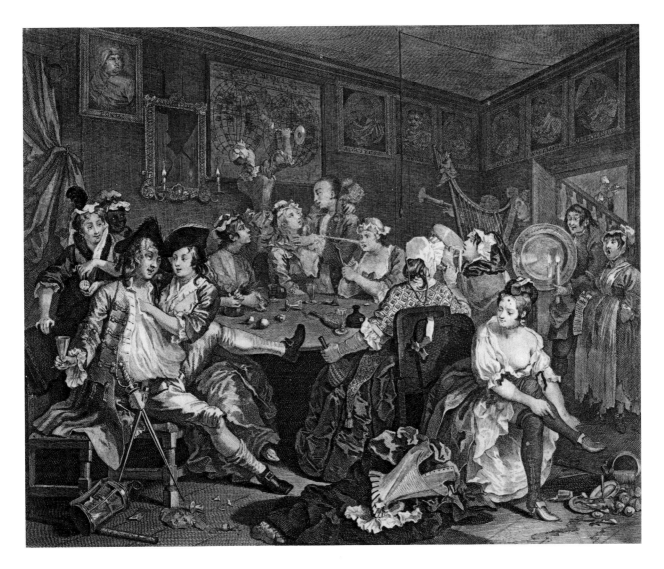

considerable fashionable success with these pictures and the conversation piece remained for half a century one of the most popular and vital kinds of painting in Britain. But, from the beginning, Hogarth developed important variants of the conversation piece, taking it beyond pure portraiture and extending it into a broader depiction of the life of his time.

One of the first works in which this happens is 'The Beggar's Opera', of which Hogarth did six versions between 1729 and 1731. John Gay's *Beggar's Opera* was first produced in 1728 by John Rich at the Lincoln's Inn Fields Theatre. It seems likely that the play was of special interest to Hogarth since it was notorious for its blunt social and political satire, cynical matter-of-fact realism and accurate observation of the criminal underworld. Hogarth has chosen the dramatic moment in which Polly Peachum (on the right) and Lucy Lockett entreat their fathers to save the life of Macheath, the highwayman, whom each supposes to be her husband. Hogarth has not so much illustrated this scene as recorded the actual situation on stage, with the actors in the centre and the wealthier members of the audience sitting on the edge of the stage. All the main figures are recognisable portraits, but a major part of his purpose must have been simply to depict an aspect of London life with which he was particularly engaged – the theatre. He has also taken over as part of the content of his picture the social and political satire of Gay's work and finally added a piece of personal satire of his own: in its final form – here illustrated on page 28 – Hogarth introduced a significant change: he broadened the view so that more of the audience and stage and the whole of the proscenium arch come into the picture. The proscenium is supported by the prominent figure of a satyr, which represents lechery and is pointing a finger at the young Duke of Bolton, the figure sitting in sash and star of the Order of the Garter immediately below it. It was well known that Lavinia Fenton, the actress playing Polly Peachum, was his mistress and Hogarth is here commenting on the sexual irregularities of the aristocracy.

Hogarth was now poised to develop, out of the conversation piece, a new form of art in which not just one but a series of paintings would depict and comment upon the contemporary world. These would be made available to a wide public through the publication of Hogarth's own engravings of them and they were called by Hogarth 'modern moral subjects'. His motive in turning to this form of painting was partly economic: the very success of the conversation pieces made them, Hogarth wrote, '...a kind of drudgery...that manner of painting was not sufficiently paid to provide what my family required. I therefore recommended those who came to me for them to other painters and turned my thoughts to a still newer way of proceeding Viz painting and engraving modern moral subjects, a field unbroke up in any day or any age.' The first was 'A Harlot's Progress', published in April 1732, a simple tale in six engravings of a country rector's daughter who comes to London ostensibly to enter domestic service but quickly becomes first a rich man's mistress, then a common whore, is imprisoned and finally dies in misery. The success of this series was instant, huge and lasting: the diarist Vertue recorded that, during the period when Hogarth was advertising for subscriptions, before the plates were actually engraved, 'daily subscriptions came in, in fifty or in hundred pounds in a week – there being no day but persons of fashion and Artists came to see these pictures'. In fact Hogarth gathered nearly two thousand advance subscriptions at a guinea each, a very considerable sum of money.

The modern moral subjects constitute the core of Hogarth's achievement and are the works on which his fame ultimately rests. Immediately after the publication of the 'Harlot' he began a sequel, 'A Rake's Progress', eight

canvases this time, telling the story of a young man who inherits a fortune, squanders it on drink, whores and fashionable pursuits and ends, first in a debtors' prison and, finally, in the madhouse. 'The Tavern Scene', third in the series, is a splendid evocation of London low life. Its composition, with the drunken rake and the pretty young harlot framing the riotous gambling table, has a symmetry and monumentality that, taken with the permanent relevance of its theme, helps to lift this picture to a high level of art.

The enormous success of 'A Harlot's Progress' had brought its own problems, notably that of piracy: Hogarth's engravings were copied and sold at prices undercutting his. The artist's response to this was characteristic: he sponsored a Parliamentary Bill to protect engravers and, as the Engravers Act, this became law on 15 June 1735, the day of publication of 'A Rake's Progress'. 'Hogarth's Act', as it is sometimes known, formed the basis of copyright law and was ultimately of enormous importance to writers as well as artists. At the same time Hogarth founded an academy in St. Martin's Lane to provide for young artists both training and a social and professional focus.

About 1743 Hogarth painted the six canvases of 'Marriage à la Mode', which attacked the institution of arranged marriage by tracing the disastrous course of a marriage purely of economic convenience between

William Hogarth
The Graham Children, 1742
Oil on canvas,
63¾ x 71¼ in/161.9 x 181 cm
Tate Gallery, London

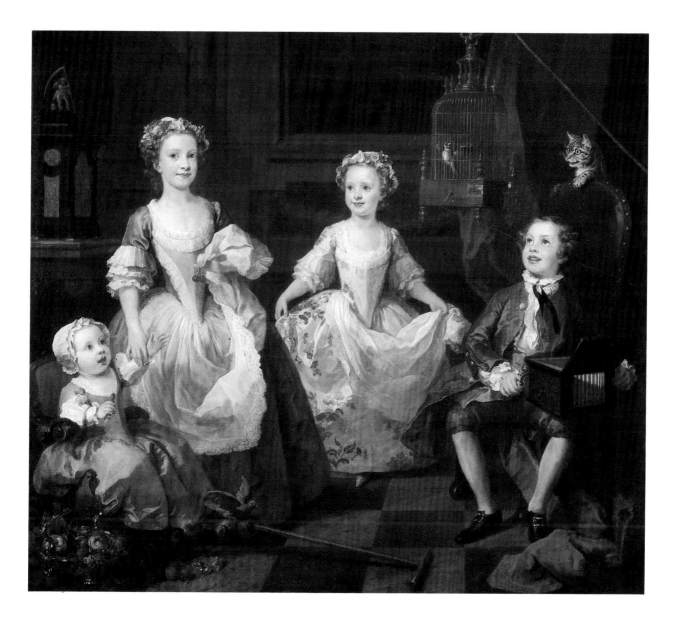

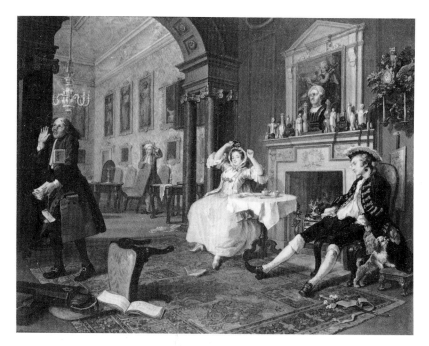

William Hogarth
*Marriage à la Mode: 'Shortly after
the Marriage',* 1743
Oil on canvas,
$27\frac{1}{2}$ x $35\frac{3}{4}$ in/69.9 x 90.8 cm
National Gallery, London

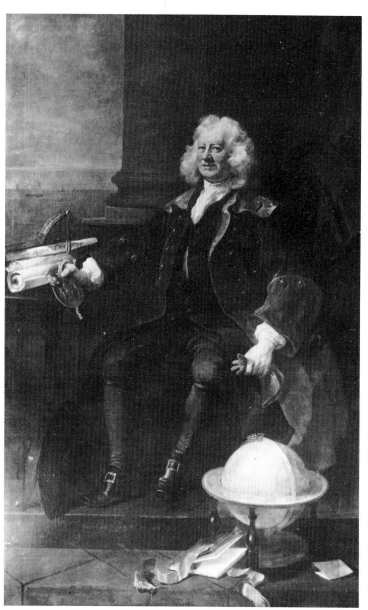

William Hogarth
Captain Coram, 1740
Oil on canvas, 94 x 58 in/
238.8 x 147.3 cm
Thomas Coram Foundation for
Children, London

the son of an earl and the daughter of a wealthy city alderman. The painterly accomplishment and especially the breadth and richness of the social comment of these paintings makes the series Hogarth's masterpiece among the modern moral subjects. 'Marriage à la Mode' fully deserves its place in the National Gallery, London, where it splendidly represents Hogarth among the European masters he sought to rival.

The second canvas of 'Marriage à la Mode', 'Shortly after the Marriage', vividly charts the rapid decline of the young couple: it is breakfast time; tired servants are clearing up after the Countess's card and music party of the night before, while she yawns and stretches, looking sideways at the Earl, perhaps in the hope of attracting his amorous attention. He, however, appears exhausted and the lace cap in his pocket, being sniffed at by a small excited dog, and the broken sword on the floor indicate that he has probably spent the night in a brothel. On the walls, the paintings, a Cupid among ruins over the fire and the one in the next room which, covered by a special curtain, must be of an erotic subject, further symbolise their dissolute life.

Although he disliked the business of conventional portrait painting, 'phiz-mongering' as he contemptuously called it, Hogarth was an occasional formal portraitist of genius. His greatest portrait, a full-length of his friend Captain Thomas Coram, was painted under the stimulus of foreign competition, specifically that of the Frenchman Van Loo who was getting all the best commissions in London in the later 1730s. Hogarth tried to rally his colleagues: 'I exhorted the painters . . . to oppose him with spirit. But was answered "You talk! Why don't you do it yourself?" Provoked by this I set about this mighty portrait and found it no more difficult than I thought it.'

'Captain Coram' has all the qualities of Hogarth's best portraits, especially those he made of men he knew and who were, like him, intellectual, hard working, believing in the solid virtues and values of the then burgeoning professional middle classes. The image of Coram expresses all these things. But the painting has much more; immense grandeur, a bravura quality in the actual handling of paint and great richness of colour.

'The Graham Children', another of Hogarth's masterpieces, is a rather different kind of portrait. Here he has achieved the remarkable feat of

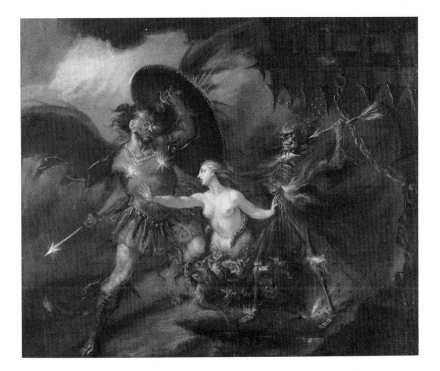

William Hogarth
Satan, Sin and Death, c.1735–40
Oil on canvas, 24⅜ x 29⅜ in/
61.9 x 74.6 cm
Tate Gallery, London

scaling up the conversation piece to full portrait size (the figures are life-size) without losing any of the charm and informality which were such vital ingredients of the conversation piece. Once again he is dealing with friends or, rather, the children of a friend, Daniel Graham, apothecary to Chelsea Hospital. In this painting Hogarth goes beyond simple individual portraiture to create one of the most memorable images in art of the gaiety and innocence of childhood. The boy plays a musical box for his sister to dance to, the other girl holds some cherries, symbolising youth, which the baby, in its splendid gilt baby carriage, is reaching for with one hand; in its other is a half-eaten biscuit and Hogarth has here created an affectionate picture of childish greed. But he has also introduced an element of sinister allegory: in the left background is a clock topped by a figure carrying a scythe, a symbol of death, and on the right, in a brilliantly painted vignette, a fierce-looking cat attempts to reach the caged bird. Hogarth is reminding us of the ephemeral nature of human existence, the vanity of human pleasure and, more specifically, of the brevity of childhood innocence and happiness before we enter the jungle of the adult world.

In about 1735-40 – the exact date is not known – Hogarth painted his only really significant history painting, one of his most extraordinary and fascinating works, 'Satan, Sin and Death'. Although it is a biblical subject, Hogarth's immediate source was Milton's *Paradise Lost*, one of the books that appear in the self-portrait, and one of the most important aspects of this painting is that it marks that extension of history subject matter into the area of imaginative literature already mentioned on page 24. The painting illustrates the moment in *Paradise Lost* Book II when Satan arrives at the gates of Hell to find his exit barred by Death, the skeletal guardian of the gate. Satan prepares to fight his way out and the scene is thus set for a clash of supernatural forces. At this moment Sin, the half-woman, half-writhing-serpent creature who is the keeper of the key of the gate, intervenes and prevents the fight. She does so by reminding Satan that she is his daughter and that Death is his son by her. Hogarth's treatment matches the subject: the two combatants confront each other in poses of great tension while Sin thrusts out between them towards the spectator to make a dramatic and dynamic composition of complex criss-crossing diagonals. The fitful lighting with its extremes of light and darkness completes the disturbing effect.

'Satan, Sin and Death' was engraved, and through the engravings and perhaps to some extent the original (which passed into the collection of the great actor-manager David Garrick) it was to be a crucial source of inspiration to romantic history painters two decades later.

Chapter 4
Reynolds and the Foundation of
the Royal Academy

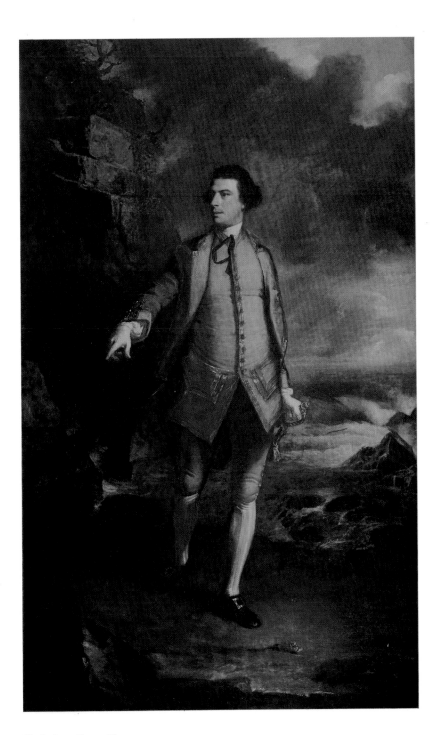

Sir Joshua Reynolds
Augustus, Viscount Keppel, Admiral of the White, 1753
Oil on canvas, 94 x 58 in/238.8 x 147.3 cm
National Maritime Museum, Greenwich, London

In the second half of the eighteenth century painting in Britain became increasingly rich and varied, although it should be said that Hogarth had no real successors for his most original invention, the modern moral subject. Portrait painting, of course, continued to flourish and threw up two outstanding geniuses, Reynolds and Gainsborough. Indeed, in quantity it still outstripped all other forms and was the livelihood of most painters. However, the period also saw the rise and spread of landscape and sporting painting, the development of history painting, a novel and increasing interest in subjects taken from contemporary life and the establishment in 1768 of the Royal Academy of Arts with Reynolds as its first President.

Joshua Reynolds (1723–92) was born in Devon, trained for four years in London from 1740–4 with the portrait painter Thomas Hudson, returned to Devon to practise and then in May 1749 set sail for Italy where he stayed in Rome until 1752. In Italy Reynolds steeped himself in classical and Renaissance art and by the time he returned to England his artistic and intellectual formation was complete. Early in 1753 he settled in London and was an immediate success. By 1755 he had a hundred sitters a year and began to employ studio help. From this time on most of Reynolds's portraits were largely executed by assistants, an important difference between his practice and that of his rival Gainsborough. By 1760 the number of sitters had risen to a hundred and fifty a year and Reynolds raised his prices simply to reduce the volume of business. He nevertheless had to raise them again in 1764 and was to do so once more before the end of his life. The explanation of this success takes us to the core of the nature of Reynolds's art and can be found by examining the painting which made him his reputation and remains his greatest masterpiece, the portrait of Commodore (later Admiral and Viscount) Keppel.

It was Keppel, a fast-rising young naval commander, who had given Reynolds a passage to Italy on his ship in 1749. Back in London in 1753, the portrait must have been Reynolds's first major undertaking and the Commodore could hardly have wished for a more magnificent gesture of gratitude: Keppel is shown striding forward along a storm-wracked seashore making an imperious gesture of command to some unseen person. It is an intensely heroic and dramatic image of a kind that no other portrait painter in England at that time was capable of producing, and Reynolds's ability to do so is one of the two major ingredients of his success. The other is that right from the beginning he inserted into his pictures references to or quotations from the great masters of the Renaissance tradition and their classical predecessors. In the case of Keppel the pose of the figure is based very closely, although in reverse, on the antique sculpture known as the Apollo Belvedere which, in Reynolds's day, was one of the most famous and admired works of art in the world. This reference has the effect of raising the intellectual level of the work and this, combined with the dramatic content of the image, removes the whole thing into the realm of history painting and 'high art' – it becomes a high art portrait. It should be added that a large part of the impact of this painting stems, too, from Reynolds's revolutionary use of light and shade to blend the figure convincingly into its stormy surroundings and its outstandingly beautiful colour – steely blue-greys tinged with purple in the sky – and rich texture. It was, of course, painted before Reynolds went over to a studio system and there is no doubt that a great deal of the purely sensuous element of his painting was lost when he did so. However, it should be stressed that with Reynolds it was always the idea of the picture that counted most. As Gainsborough once jealously remarked, 'Damn him, how various he is!'

Reynolds brought the high art portrait to its fullest pitch of development

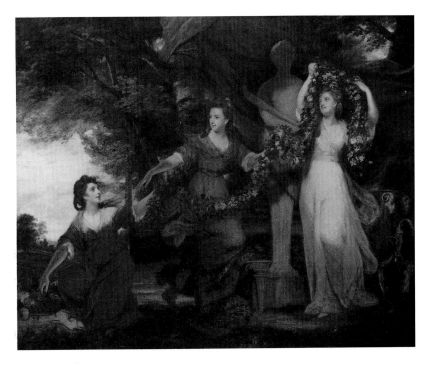

Sir Joshua Reynolds
Three Ladies Adorning a Term of Hymen
(The Montgomery Sisters), 1773
Oil on canvas, 92 x 114½ in/
233.7 x 290.8 cm
Tate Gallery, London

in the early 1770s in works like 'The Montgomery Sisters' of 1773. Here the sitters become part of a complete classical mythological scene, Reynolds depicting them as priestesses sacrificing to Hymen, Greek god of marriage. This is a marvellous example of Reynolds's ability to find a classical reference appropriate to the personality or circumstances of the sitter, for the work was commissioned by the fiancé of the sister in the centre of the picture just before their marriage.

The high art portrait was a crucial invention for Reynolds. It enabled him to compromise between his intellectual ideals and his commercial good sense – he was well aware of the reluctance of British patrons to buy history painting from British artists – and it carried two great advantages, purely commercial success on the one hand and on the other the establishment of Reynolds as something more, in terms of social and professional status, than an ordinary portrait painter, however successful. This new status was of great importance to Reynolds. A famous anecdote recounts how in his youth he announced to his father that he 'would rather be an apothecary than an *ordinary* painter', and he carefully chose as his friends men of letters such as Dr Johnson, his most famous friend, rather than his own colleagues. All this made him the natural choice for the first Presidency of the Royal Academy of Arts at its foundation in 1768 by a group of artists, with the encouragement of the King. The final touch to his prestige was added the following year when George III conferred a knighthood upon him.

As the art historian Ellis Waterhouse has pointed out, Reynolds's ambition was not only personal but for his whole profession – 'Raising the status of the British artist was the political objective of Reynolds's life,' and the creation of the Royal Academy with himself as President gave him the means with which to accomplish this by adding his own prestige and intellectual attainments to the other advantages the Academy brought. These included royal patronage, a school offering a proper professional training and annual exhibitions of a much higher standard than those of the Academy's forerunner, the Society of Artists, which had started in 1760 and marked the beginning of the public exhibition of art in Britain.

Reynolds's chief intellectual contribution to the Academy was undoubtedly the fifteen Discourses (lectures) which he composed and

delivered at intervals from 1769–90 and in which he consistently preached the virtues and importance of high art, with the aim of founding a great British school of history painters. The preaching took effect and, in spite of the notorious resistance of the British collector to the home product, a considerable quantity of history painting began to be produced, some of it even finding buyers, although artists who believed in it too wholeheartedly paid dearly for their faith – James Barry died in poverty, John Hamilton Mortimer went mad, Benjamin Robert Haydon (1786–1846) committed suicide, Henry Fuseli had to be supported by the Academy and William Blake lived most of his life in poverty and obscurity.

Two phases of history painting in England can be distinguished, the first or neo-classic, and the second or romantic. The first phase was relatively brief and minor, but the second, dating from about 1780, was much more interesting and complex. It included Blake, one of the greatest of British artists, and will be dealt with in a later chapter.

The principal exponents of the earlier neo-classic phase were Benjamin West (1738–1820) and Gavin Hamilton (1723–98). They were the practitioners of a particularly pure form of history painting based in style on Greek relief sculpture and taking its subjects, often very obscure, from the ancient Greek poets – hence the term neo-classic. Their works, even when depicting, as history paintings were supposed to do, moments of great heroism or drama, were cool, restrained, ordered, balanced and static. A perfect example is West's 'Cleombrotus Ordered into Banishment by Leonidas II, King of Sparta' of 1768, a subject taken from Plutarch and treated exactly like a painted frieze.

Benjamin West
Cleombrotus Ordered into Banishment by Leonidas II, King of Sparta, 1768
Oil on canvas, 54½ x 73 in/
138.4 x 185.4 cm
Tate Gallery, London

Chapter 5
Thomas Gainsborough

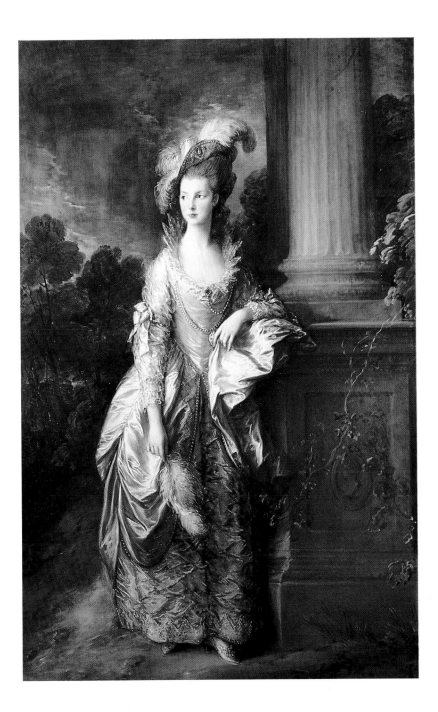

Thomas Gainsborough
The Hon. Mrs Graham, 1775–7
Oil on canvas, $93\frac{1}{2}$ x $60\frac{3}{4}$ in/
237.5 x 154.3 cm
National Gallery of Scotland,
Edinburgh

Although the names of Reynolds and Gainsborough are indissolubly linked in the history of eighteenth-century British painting, they were diametrically opposed both as artists and as men and the differences between them are highly illuminating.

Thomas Gainsborough (1727–88) was a countryman, born and bred in Sudbury in Suffolk, and although he painted some of the most ravishing portraits in the entire history of European art he always privately attached more importance to the landscape painting so despised by Reynolds. He spent most of his career in Suffolk and Bath, only moving to London in 1774, fourteen years before his death. He was an enthusiastic amateur musician and was possessed of a warm, sensual temperament which, we know from remorseful letters, made him liable to be led astray by convivial companions on trips to London. Reynolds by contrast was the cool, socially ambitious, metropolitan intellectual.

Gainsborough's character and attitudes to art are particularly vividly evoked in a witty letter, written from Bath to his friend the composer and musician William Jackson, who gave him lessons in music in return for lessons in drawing. Gainsborough opens with some discussion of his own progress in music, then turns to the topic of one of Jackson's pupils in the town:

'...I dined with Mr Duntze in expectation (and indeed full assurance) of hearing your scholar Miss Floud play a little, but was for the second time *flung*. She had best beware of the third time lest I *fling* her, and if I do I'll have a kiss before she is up again. I'm sick of Portraits and wish very much to take my Viol de Gamba and walk off to some sweet Village where I can paint landskips and enjoy the tag End of Life in quietness and ease. But these fine Ladies and their Tea drinkings, Dancings, *Husband huntings* and such will fob me out of the last ten years, and I fear miss getting husbands too. But we can say nothing to these things you know Jackson, we must jogg on and be content with the Jingling of the Bells, only d—m it I hate a dust, the kicking up of a dust and being confined *in Harness* to follow the track, whilst others ride in the waggon, under cover, stretching their legs in the straw at ease and gazing at Green Trees and Blue Skies without half my *Taste*, that's damn'd hard.'

Unlike Reynolds, Gainsborough employed no studio help at all until 1772 when he took on his nephew, Gainsborough Dupont, and even then, as the art historian John Hayes has written, '...generally speaking and in total contrast to most of his contemporaries, Gainsborough executed the whole of a picture with his own hand; for an artist as passionately absorbed in the business of painting as he, drapery, accessories and background all involved exciting passages he had no wish to delegate...his dedication to his art was absolute.'

The wholly autographic nature of Gainsborough's art is particularly significant since he was supremely naturally gifted in the handling of paint: the long feathery brush strokes of his maturity create surfaces and textures which are beautiful in themselves. And these surfaces have mostly survived in fine condition due to the soundness of Gainsborough's technique, particularly his use of well-thinned paint, whereas the surfaces of many of his contemporaries' paintings, including those of Reynolds, have cracked and blackened. More than any other eighteenth-century painter Gainsborough created an art of pure sensuousness and visual delight.

He trained in London from 1740–8 with the Frenchman Gravelot, so that his apprenticeship was in the lightness and charm of the French rococo style. In 1748 he returned to Suffolk and settled in Ipswich where he spent the next ten years painting portraits of the local gentry, mostly conversation

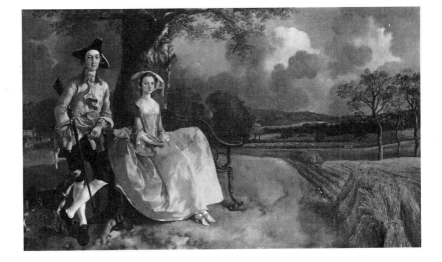

Thomas Gainsborough
Mr & Mrs Andrews, c.1750
Oil on canvas, 27½ x 47 in/
69.9 x 119.4 cm
National Gallery, London

pieces with landscape backgrounds in many of which the landscape setting is more strongly asserted than hitherto, often playing as important a part in the picture as the people themselves rather than simply being a backdrop. This is very much the case in the portrait of 'Mr and Mrs Andrews', a vision of the English country gentleman at home in his native landscape. It implies a view that was new to the eighteenth century of the relationship of man and nature which Gainsborough was to work out fully in his pure landscapes. 'Mr and Mrs Andrews' has something of the awkward charm of immaturity and as Ellis Waterhouse has written, 'There is a dewy freshness about this picture, a friendly naturalness of vision of an artist as yet untainted by any preoccupation with fashionable taste which makes it one of the eccentric masterpieces of English painting.'

The preoccupation with fashionable taste came, as his letter to Jackson indicates, with his move to Bath in 1760. Here his portrait style matured and commissions came in a steady flow until in 1774 he finally made the move to London. Gainsborough, like Nicholas Hilliard, responded strongly to physical attractiveness, especially in women, and this was an important part of his painter's armoury for there is no doubt that the greatest achievements of his maturity are his full-length portraits of beautiful women. Among these, that of the Honourable Mrs Graham, painted in London in 1777, is outstanding. Indeed, it is probably Gainsborough's most dazzling production, overwhelming in the sheer visual impact of its exquisite soft luminous tones of silver grey and pale rose pinks (perhaps the most elegantly sensuous of all possible colour combinations) and delicate paint textures. Not since Van Dyck had portraiture in England reached quite such heights nor was it ever to do so again.

Gainsborough's pure landscape paintings have proved to be much more than just the relaxation from the demands of society portrait painting implied by the artist in his letter to Jackson. They constitute a contribution of great significance to the growth and development of landscape painting in Britain in the second half of the eighteenth century and are more fully discussed in the next chapter.

Chapter 6
The Rise of Landscape and Sporting Painting

The history of the development and growth of landscape painting in Britain in the eighteenth century is highly complex, and from the late seventeenth century a number of different but interrelated strands or traditions can be traced in both oil and watercolour painting. However, the two main landscape traditions to emerge clearly in the first half of the eighteenth century were the classical and the topographical. Classical landscape meant essentially paintings based on the style of the great seventeenth-century French painter Claude Gelée le Lorrain, known in England simply as Claude. Classical landscapes incorporated 'history' subjects and were usually largely invented, while topographical landscape was, as the name implies, based on actual scenes or aspects of nature rendered for their own sake and was the creation of the seventeenth-century Dutch painters, chief among them Jacob van Ruysdael. These two kinds of landscape as they appeared in Britain are admirably illustrated by two pictures by George Lambert (1700–65), the first substantial figure in British landscape painting.

His 'Classical Landscape' of 1745, although it has no history subject, corresponds perfectly to the basic pictorial formula invented by Claude which has been admirably summarised by the art historian Michael Kitson: '...an open foreground, like a stage...framing trees on one side balanced by an answering motive on the other, and a circuitous path taking the eye by easy and varied stages to a luminous distance'. In Lambert's picture the 'answering motive' is, as almost always in classical landscape, another clump of trees and the varied stages on the path include several groups of figures, a lake and buildings and a distant town on a hill. Claude had developed his art in Italy and classical landscape is always strongly Italian in feeling. Lambert's very un-English buildings and shepherds are a case in point.

'Landscape near Woburn Abbey' of 1733 is very different. Indeed, it is remarkable even within the topographical tradition for the degree to which it depicts a real landscape for its own sake. It is also remarkable, as Luke Herrmann points out in *British Landscape Painting of the Eighteenth Century*, for its 'true understanding of the colours, light and atmosphere of an English summer's day'.

However, this painting is somewhat exceptional and there is no doubt that imaginative, classical Italianate landscape painting was more popular in Lambert's time than topography. Not until Constable, nearly a century later, did a fully naturalistic landscape art substantially emerge and even then it was not generally popular. But the idea of naturalism, of what Constable was to call 'a natural painture' of the English scene, was always present: Horace Walpole, in his introductory remarks to the section on Lambert in his *Anecdotes of Painting in England*, wrote:

'In a country so profusely beautiful with the amenities of nature, it is extraordinary that we have produced so few good painters of landscape...our painters draw rocks and precipices and castellated

George Lambert
Classical Landscape, 1745
Oil on canvas, 40¾ x 46 in/
103.5 x 116.8 cm
Tate Gallery, London

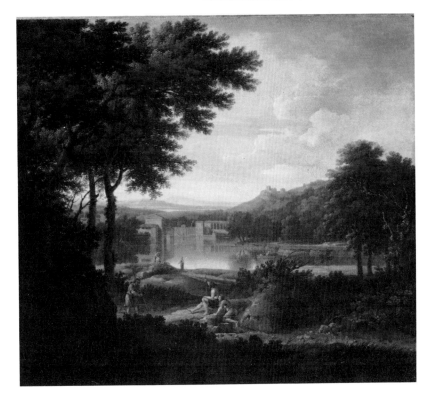

George Lambert
*Landscape near Woburn Abbey,
Bedfordshire*, 1733
Oil on canvas, 35¾ x 72½ in/
90.8 x 184.1 cm
Tate Gallery, London

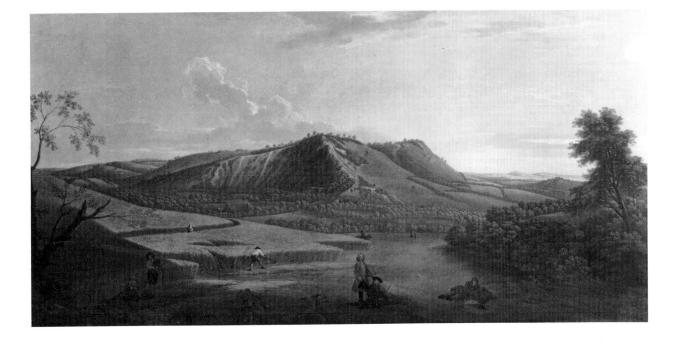

mountains because Virgil gasped for breath at Naples and Salvator [Rosa, the Italian seventeenth-century painter] wandered amid Alps and Apennines. Our ever verdant lawns, rich vales, fields of haycocks and hop grounds are neglected as homely and familiar objects...'

The classical tradition was reinforced in the 1740s and 50s when British artists began to go regularly to Italy. Here they grafted the formulas of Claude onto actual Italian landscapes and, crucially, back at home, in some cases onto British scenes. At the same time the topographical tradition received a boost from the arrival in England in 1746, for a stay that lasted with two short breaks for ten years, of the already enormously admired Venetian painter Canaletto and from the foundation of a flourishing

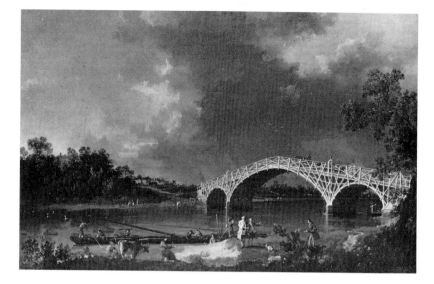

Giovanni Antonio Canal (Canaletto)
Old Walton Bridge, 1754
Oil on canvas, 19¼ x 30⅛ in/
48.9 x 76.5 cm
Alleyn's College of God's Gift, Dulwich
College, London

topographical tradition in watercolour by Paul Sandby. Canaletto's English paintings, particularly such straightforward views as 'Old Walton Bridge' with its emphasis on lighting, atmosphere and weather, were extremely influential.

Canaletto had one English follower, Samuel Scott (1702–72), who although primarily a marine painter, produced a number of topographical works of such quality and originality that he should be mentioned. One of these is 'An Arch of Westminster Bridge' in which he daringly isolates a section of the bridge using an almost photographic close-up, cut-off composition to give the scene a 'classic' monumentality without resorting to traditional pictorial devices.

It was the Welsh-born Richard Wilson (1713–82) who managed to create the first satisfactory blend of the classical tradition and native British landscape. He was by far the most important of those painters who went to Italy and learned first to apply Claude to Italian scenes and then to do the same for the British landscape. Wilson's great achievement was that he ultimately went further than any other painter of his generation towards

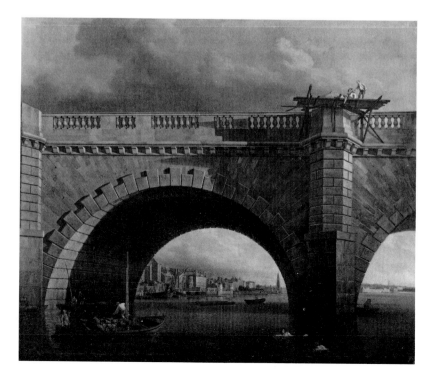

Samuel Scott
An Arch of Westminster Bridge
Oil on canvas, 53¼ x 64½ in/
135.3 x 163.8 cm
Tate Gallery, London

nature, creating in the end what might be called a classical naturalism which, in the view of John Ruskin for one, made him the true forerunner of Turner and Constable: 'With the name of Richard Wilson the history of sincere landscape art, founded on a meditative love of Nature, begins for England.'

Wilson stayed in Italy from 1750 to 1757 or 1758. A fine example of the landscapes he painted there is the distant view of Rome, 'Rome and the Ponte Molle', which can be seen in the National Museum of Wales in Cardiff. This has all the trappings of classical landscape but is notable for its subtle and sensitive representation of evening light and for its evocation of the atmosphere and mood of a particular time of day. On his return he painted British scenes, like the pair in the National Gallery, 'Holt Bridge on the River Dee' and 'The Valley of the Dee', in the same way. He gave them a more or less obvious classical structure, but an increasing naturalism can be detected which reached its fullest expression in his Welsh landscapes. One of the most successful of these is the large canvas of 'Pistyll Cain, Merioneth', which combines truthfulness of colour and light in its greens and pale luminosity with a grandeur of effect that does not depend on classical formulas.

The third great pioneer of landscape painting in Britain in the eighteenth century was Thomas Gainsborough. As a young man he made an important contribution to the topographical tradition with a small but very high quality group of paintings done around 1750, but in maturity he developed a completely original form of imaginative landscape which was nevertheless based on, and dealt with, the English rural scene. In both cases

Richard Wilson
Holt Bridge on the River Dee, ?exh.1762
Oil on canvas, 58½ x 76 in/
148 x 193.7 cm
National Gallery, London

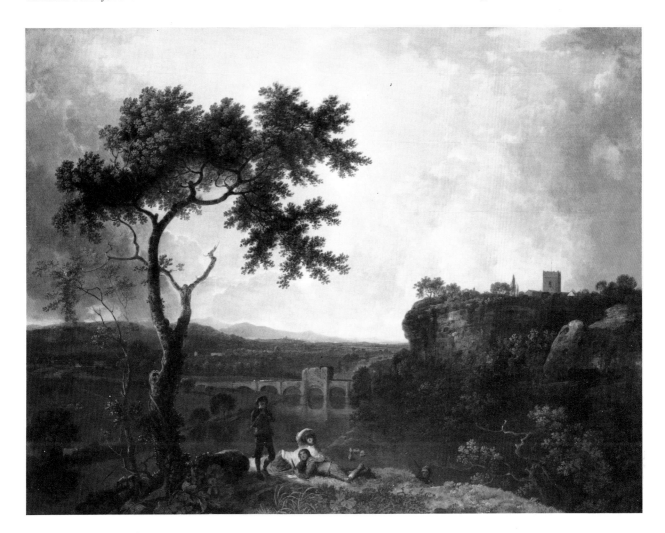

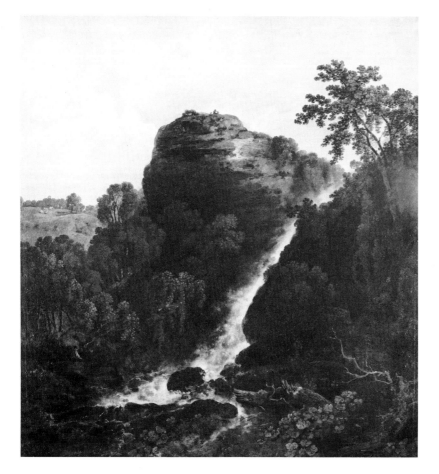

Richard Wilson
*Pistyll Cain, Merioneth, c.*1770–5
Oil on canvas,
68×66in/172.7×167.6cm
National Museum of Wales, Cardiff

Gainsborough was hardly touched by Italian influence, looking in his early works to the example of Dutch seventeenth-century naturalism, especially to the work of Jacob van Ruysdael, and later looking to an earlier phase of Dutch painting, the rich landscapes of Rubens, as well as reflecting, as in his portraits, the warmth, lightness and charm of the French rococo style.

'Cornard Wood' is rightly the most famous of Gainsborough's early landscapes and it was one he remained attached to all his life. In 1788 he mentions it in a letter:

'Mr. Boydell [a well-known picture dealer of the period] bought the large landscape you speak of for 75 guineas last week. It is in some respects a little in the *schoolboy stile* – but I do not reflect on this without a secret gratification; for as an early instance how strong my inclination stood for landskip, this picture was actually painted at Sudbury in the year 1748; it was begun *before I left school* – and was the means of my father's sending me to London. It may be worth remarking that though there is very little idea of composition in the picture, the touch and closeness to nature in the study of the parts and *minutiae* are equal to any of my latter productions.'

Gainsborough is being falsely modest about the composition: with its naturalism of detail and, especially, of colour and light it also combines a notable and original adaptation of the rules of classical composition. The main clump of trees slightly right of centre is balanced by clumps on each side while to its left winds the path taking us into the distance. Although Gainsborough always had difficulty selling his landscapes the price paid by Boydell for 'Cornard Wood' and the fact, recorded by Gainsborough, that it had been in the hands of twenty dealers up to that time, indicates that this early masterpiece was recognised as such. Sudbury, where it was painted, is of course in Suffolk, and it was probably this kind of picture by

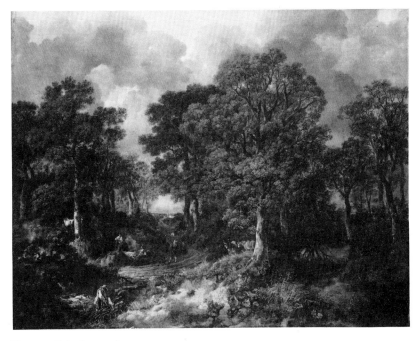

Thomas Gainsborough
Gainsborough's Forest (Cornard Wood),
*c.*1748
Oil on canvas, 48 x 61 in/
121.9 x 154.9 cm
National Gallery, London

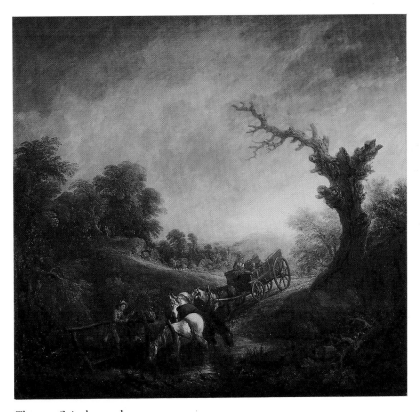

Thomas Gainsborough
Sunset: Carthorses Drinking at a Stream,
*c.*1760
Oil on canvas, 56½ x 60½ in/
143.5 x 153.7 cm
Tate Gallery, London

Gainsborough that John Constable had in mind when he made his celebrated remark in a letter written from Suffolk, 'Tis a most delightful country for a landscape painter, I fancy I see Gainsborough in every hedge and hollow tree.'

In his maturity Gainsborough clearly came to believe that landscape painting should have an imaginative quality, that it should make some kind of statement not just about nature but about man's relationship to it and place in it. Thus from the early 1750s he painted invented landscapes which express an intensely poetic vision of man as an integral part of the natural world, of man in harmony with the fruitful earth. Two examples, one early (about 1760) and one late (1786), are the 'Sunset: Carthorses Drinking at a Stream' and 'The Market Cart'. 'Sunset' is a paradisal image of the farmer at the end of the day's toil taking his rest. His horses drink under his benevolent eye and his wife breastfeeds her baby. The group of horses and figures nestles in a dell framed by feathery trees on one side, by a picturesque blasted oak on the other. The whole scene is bathed in a warm golden light. The landscape, though artificial, is recognisably English and so are the people.

'The Market Cart' depicts another facet of Gainsborough's idyllic vision of rural life. The theme of fruitfulness is overt: the cart is a cornucopia crammed with produce, and the theme is echoed in the soaring, swelling forms of the trees and billowing cumulus clouds beyond them. These trees, with the cart tucked in at their base, taken with the markedly vertical format (rare in landscape painting) and large scale (the painting is nearly two

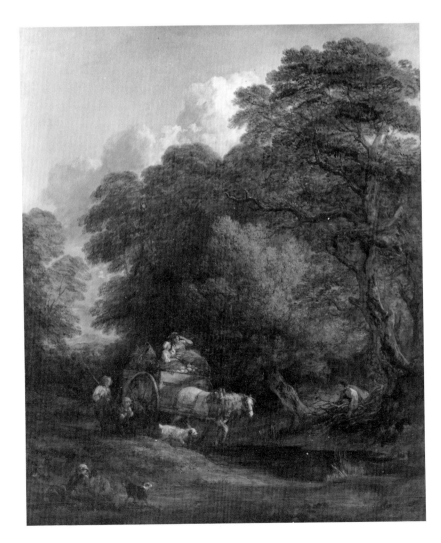

Thomas Gainsborough
The Market Cart, 1786–7
Oil on canvas, 72½ x 60¼ in/
184.2 x 153 cm
Tate Gallery, London

John Wootton
The Death of the Stag, 1737
Oil on canvas,
77¾ x 78¾ in/197.5 x 200 cm
Royal Collection (reproduced by
gracious permission of Her Majesty
the Queen)

metres high), make a composition of great monumentality and grandeur.

'The Market Cart' marks the full-blown maturity of Gainsborough's landscape style and, indeed, the climax of English landscape painting before Turner and Constable. In it Gainsborough firmly established landscape at the very highest level of art, no longer just as a decorative thing to be hung over doors and chimney pieces as it had always been in the past, but as a vehicle for the poetic expression in picture form of important feelings and ideas.

Like landscape, sporting painting – the painting of hunting and other rural sporting scenes – grew in popularity through the late seventeenth and early eighteenth centuries. Its rise can be attributed to the growth of the country-house style of life among the aristocracy and gentry and the central place in that life of sport. The most important was fox-hunting, which largely replaced stag-hunting at the end of the seventeenth century. Of the famous hunts the Quorn was founded in 1698, the Belvoir in 1740, the Pytchley in 1750. One result of the growth of fox-hunting was a corresponding development in horse breeding and horse racing, and racing, hunting and fine horses form the major subject matter of the sporting painters.

Among the early sporting painters Francis Barlow has already been mentioned (see p.26). He was succeeded by John Wootton (?1686–1765), whose splendid pair of large hunting scenes, 'The Death of the Stag' and 'The Return from the Chase' of 1737, can be seen at Windsor Castle. The landscape backgrounds of Wootton's hunting scenes are more often than not given as much prominence as the hunt, and there is no doubt that he made a considerable contribution to the growing practice of landscape painting. The backgrounds of the Windsor pictures, for example, depict the actual scenery of Windsor Forest composed in a classical mould.

A third early master of sporting painting was James Seymour (1702–52),

one of the first purely specialist horse and hunting painters, whose art, like that of his many successors through the century after his death, often has an awkward quality which comes from lack of academic training. As can be seen in Seymour's large fox-hunting scene, 'A Kill at Ashdown Park', this gives his pictures an unsophisticated charm to which typical touches, such as the horse urinating on the right, add a vivid evocation of the pungent flavour of eighteenth-century rural life.

James Seymour
A Kill at Ashdown Park, 1743
Oil on canvas, 71 x 94 in/
180.3 x 238.8 cm
Tate Gallery, London

Chapter 7
George Stubbs, Joseph Wright and the Extension of Subject Matter

George Stubbs
Mares and Foals in a Landscape,
*c.*1760–70
Oil on canvas, 40 x 63¾ in/
101.6 x 161.9 cm
Tate Gallery, London

Charming though Seymour and his specialist successors are, their work is not great art. But at exactly the same time as Gainsborough was elevating landscape to the very highest levels of art so an artist emerged to do the same for sporting painting. This was George Stubbs (1724–1806), like Gainsborough one of the great innovators and original geniuses of eighteenth-century British art.

A large part of Stubbs's achievement can be understood by considering one of the series of nine paintings of mares and their foals done in the 1760s for various aristocratic patrons – Earl Grosvenor, the Duke of Grafton and the Marquis of Rockingham – which marks one of the high points in English painting in the eighteenth century. In 'Mares and Foals in a Landscape' the horses stand before us more naturalistically than ever before in the history of art. This unprecedented naturalism was primarily the fruit of Stubbs's long and arduous anatomical studies of horses and other animals, and of human beings as well. The earliest evidence of these studies are the etchings of the human embryo Stubbs did for a book on midwifery published in 1751, but his most important early anatomical work was the dissection of horses he carried out for about a year from 1758–9 in the isolated Lincolnshire village of Horkstow and the book he subsequently published in

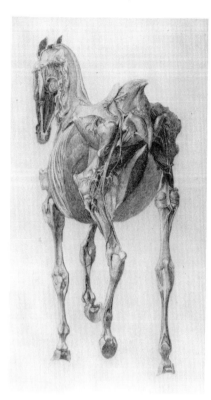

George Stubbs
Anatomical Study of a Horse (finished
study for 'Tab. x v'of *Anatomy of the
Horse*), *c.*1756–60
Pencil, 14¼ x 7½ in/36.8 x 19 cm
Royal Academy, London

1766, the famous *Anatomy of the Horse*. Stubbs was a natural scientist as much as an artist and he put science in the service of art. However, he studied the living animal too, and his horses are as naturalistic in their poses and behaviour as they are anatomically. He also had a gift for individualising animals, for capturing their particular character.

But intensely naturalistic as Stubbs's images of animals are, a second glance reveals them to be carefully composed into highly ordered pictorial structures which reveal a thorough knowledge and understanding of classical and Renaissance art, gained on a trip to Italy in 1754. In the 'Mares and Foals in a Landscape' the animals are precisely arranged into a pyramidal or conical formation, a structure of great coherence and stability which gives the group the 'classic' qualities of balance, harmony and monumentality.

Naturalism and ordered, stable compositional structures are common to all Stubbs's art, but an important part of his genius is that he developed a very wide range of types of picture. This included not only pictures like the mares and foals, and hunting, racing and other sporting scenes, but individual horse and dog portraits, marvellously observed portraits of a wide variety of wild animals, pictures of aspects of rural life like the pair of 'Reapers' and 'Haymakers' of 1783, now in the Tate Gallery, and, of course, portraits of people – usually on horses or in horse-drawn conveyances of some sort. Stubbs thus encompassed in his art the whole life of the English countryside. But he went beyond this in what was perhaps his most original pictorial invention, called by Basil Taylor, whose life's work was the study of Stubbs, the 'animal history picture', by which he meant the depiction of dramatic episodes from the life of wild animals. This was a direct equivalent for animal painting of the high art, human drama, history picture. Stubbs was thus, in subject matter as well as in treatment, bringing the painting of nature into the realms of high art.

The most famous of Stubbs's animal histories are the nine versions (seven in oil, one in enamel, one mezzotint engraving) of a lion frightening and

then attacking a wild horse. There is a story, possibly apocryphal, that Stubbs actually witnessed such an attack in North Africa where he stopped off on his way back from Rome. Whether he did or not, what is interesting is that, as Taylor has shown, the basis of the composition of the group in those versions showing the lion on the horse's back is almost certainly a famous piece of classical sculpture which in Stubbs's day was on public view in Rome in the courtyard of the Palazzo Senatorio and which he would certainly have seen. This points up with particular force Stubbs's central achievement of investing a new, fresh and vital subject matter with the lasting qualities of the great tradition of Western art.

The version of the horse and lion episode reproduced here (one of two in the Tate Gallery) is the one that Stubbs made in enamel. Enamel was normally used for miniatures, snuff boxes and other decorative purposes, but from about 1769 Stubbs developed it as a medium for picture-making and eventually produced a substantial group of enamel paintings. He seems to have been attracted by the quality of colour of enamel and particularly by its permanence. Unlike oil painting, enamels do not decay and Stubbs's enamels are probably unique among eighteenth-century pictures in looking now exactly as they did when they were made. Initially a number of difficulties had to be overcome: a suitable range of colours did not exist and Stubbs found that for technical reasons it was not possible to make enamels on copper (the normal support) larger than about 15x18 inches (38.1x45.7cm). It is entirely characteristic of Stubbs's questing and scientific turn of mind that he solved the first problem by doing his own experiments with colour and the second by setting up a collaboration with Josiah Wedgwood, the first great industrial potter, to develop a ceramic base on which large enamel pictures could be painted. After lengthy and costly research Wedgwood and Stubbs were eventually able to produce enamel paintings on ceramic plaques up to three-and-a-half feet (1.07m) across.

This episode reminds us that the second half of the eighteenth century was the age of the scientific and industrial revolutions which created the world we live in today and that Stubbs, with his scientific interests and contacts with industrialists like Wedgwood, was one of the new men of that age, his finger on the pulse of the most vital social currents of his time. So too was his contemporary Joseph Wright of Derby (1734–97) who was, to quote from Francis Klingender's pioneering book *Art and the Industrial Revolution*, 'the first professional painter directly to express the spirit of the industrial revolution'. Wright, like Stubbs, knew Wedgwood, who bought his pictures, and he painted for the first great cotton manufacturers, Arkwright, Strutt and Crompton. He was in contact with the scientists Erasmus Darwin and Joseph Priestley, with amateur intellectuals like Brooke Boothby and with the scientific Lunar Society and the Philosophic Society to which most of them belonged.

Wright of Derby, as the name by which he is always known implies, except for a trip to Italy and a brief period in Bath, lived all his life in the north Midlands at the very source of the ideas and in the midst of the scenes which provided his most important inspiration. In 1766 at the age of thirty-two Wright exhibited at the Society of Artists – one of the several exhibiting Societies which were forerunners of the Academy – his first major scientific and philosophical subject, now in Derby City Art Gallery, 'A Philosopher Giving that Lecture on the Orrery, in which a Lamp is Put in the Place of the Sun' (an orrery is a clockwork model of the planetary system). The extreme descriptive precision of the title is symptomatic of Wright's own scientific turn of mind. In 1768 he followed it with the picture which is his masterpiece and one of the masterpieces of English painting, 'An

George Stubbs
Horse Being Attacked by a Lion, 1769
Enamel on metal,
$9\frac{1}{2}$ x 11$\frac{1}{8}$ in/24 x 28.2 cm
Tate Gallery, London

Experiment with the Air-Pump'. The air-pump, by means of which a vacuum can be created, is a fundamental scientific instrument invented in the seventeenth century and more or less perfected by Wright's time. The one in his picture is accurate in every detail. The experiment, here being used as an instructional entertainment, is to demonstrate the effects of a vacuum on living things. The scene probably represents very much the sort of gathering, half social, half scientific, which took place in the houses of members of the Lunar Society.

As Klingender has pointed out, Wright was a natural scientist himself in his obsessional investigation of light in his art. In the 'Air-Pump' two kinds of light, moonlight and candlelight, mingle, but primarily the light is used to pick out the reactions of the spectators to the experiment and reveal a human drama which focuses on the fears of the little girls for the bird's life and the precise timing required to demonstrate the effect without killing the subject. The man in the left foreground studies a watch, the experimenter waits for the signal to turn the valve, the boy lowers the bird cage, the philosopher at the table with another instrument in front of him, a pair of hemispheres, broods about the significance of it all. The young couple on the left are clearly contemplating experiments other than scientific! The work thus has rich human as well as scientific and philosophical content and Wright has set all this in a compositional framework taken from high art. The figures are life-size (as the strict rules of history painting demand) and they form, like Stubbs's mares and foals, a pyramidal group which is given even greater coherence by the use of light. Wright is thus monumentalising in the classic forms of art an aspect of the contemporary world and bringing yet another new kind of subject matter into the realm of high art. He did the same for the industrial scene in paintings like the two studies of an iron forge, an interior and an external view, of 1772 and 1773. The first is in a British private collection, the second was bought by Catherine the Great of Russia and is now in the Hermitage Museum in Leningrad. Wright painted other industrial scenes, all of which reveal his interest in light, including blast furnaces, glass-blowing houses and views of early factories like Arkwright's cotton mills.

Joseph Wright of Derby
*An Experiment with the
Air-pump*, 1768
Oil on canvas, 72½ x 96 in/
184.2 x 243.8 cm
Tate Gallery, London

Joseph Wright of Derby
An Iron Forge, 1772
Oil on canvas, 48 x 52 in/
121.9 x 132.1 cm
Broadlands Collection,
Hampshire

The tendency to look at the immediate, real world for inspiration evident in Stubbs, Wright and the landscape painters found its counterpart from about 1770 in an important extension of the traditional subject matter of history painting to include contemporary historical events. This innovation was pioneered by Benjamin West in his painting of the 'Death of Wolfe' of 1771 but it was the American-born John Singleton Copley (1738–1815) who made this new kind of painting particularly his own in a series of often very large paintings done between 1779 and 1799. Outstanding among these is the vivid and dramatic 'Death of Major Peirson, 6 January 1781' of 1783.

John Singleton Copley
The Death of Major Peirson,
6 January 1781, 1783
Oil on canvas, 99 x 144 in/
251.5 x 365.8 cm
Tate Gallery, London

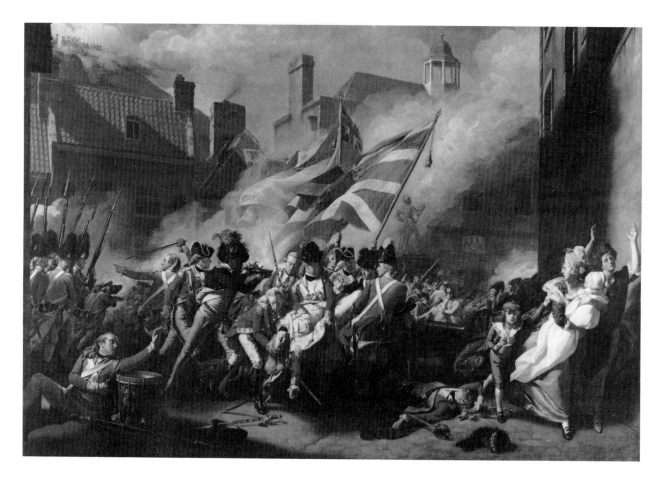

Chapter 8
Romantic History Painting and William Blake

In the 1770s and 1780s history painting in England changed in character, shedding the cool classical restraint of West or Hamilton (see p.38) and becoming increasingly imaginative, emotive, dramatic and dynamic, in a word, romantic. Not surprisingly, given this change, painters turned more and more to imaginative literature as a source of subjects, and particularly to the works of Shakespeare and Milton. However, it was choice of subject more than the source itself which was important to these artists and they continued to draw freely on the more lurid portions of the Bible and classical history and mythology.

Four artists dominated romantic history painting in the later eighteenth and early nineteenth centuries. First, making their mark in the 1770s, were James Barry (1741–1806) and John Hamilton Mortimer (1740–79). Then from 1781 Henry Fuseli (1741–1825), the quintessential romantic history painter, took over. Finally, in the 1790s William Blake (1757–1827), the great eccentric genius of English art, took history painting and used it as the vehicle for the expression of a unique and extraordinary vision.

Barry was born in Ireland and seems to have been self-taught. In 1763 he took a group of historical compositions to Dublin and showed them to the politician, philosopher and connoisseur Edmund Burke. Burke was impressed and took Barry to London in 1764 where he was introduced to Reynolds who encouraged him. Burke was the author of *A Philosophical Enquiry into the Origin of our Ideas of the Sublime and Beautiful*, first published in 1757, which both reflected and contributed to the change in artistic sensibility evidenced in romantic history painting. His central notion was that the sublime was an aesthetic emotion *superior* to the traditional feeling of beauty. He defined the sublime as an artistic effect productive of the strongest emotion the mind is capable of feeling and, he wrote, 'whatever is in any sort terrible or is conversant about terrible objects or operates in a manner analogous to terror is a source of the sublime'.

Barry went to Italy in 1766 where he stayed until 1771, saturating himself in the art of Ancient Greece and Rome, in the work of Raphael and especially in that of Michelangelo, the dynamism and excessiveness of whose art always made him the favourite of the romantics. On his return he devoted the rest of his life to history painting, but lack of patronage embittered him and although he was made Professor of Painting at the Academy in about 1783 he became unbalanced, was expelled in 1799 and died a few years later.

His great surviving monument is the decorative scheme he did for the Society of Arts in 1777–83, a series of huge canvases (two of them are each 42 feet, 12.8 m, long) on the theme of 'The Progress of Human Culture'. However, Barry's art can probably best be appreciated from the impressive engraving of his own version (clearly inspired by Hogarth's) of the Milton subject 'Satan, Sin and Death', and from his picture of 1786, 'King Lear Weeping over the Dead Body of Cordelia'.

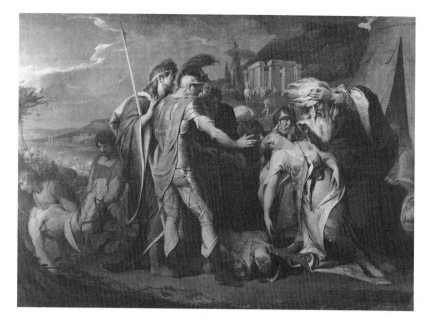

James Barry
*King Lear Weeping over the Dead Body of
Cordelia*, 1786–8
Oil on canvas, 23½ x 19½ in/
59.7 x 49.5 cm
Tate Gallery, London

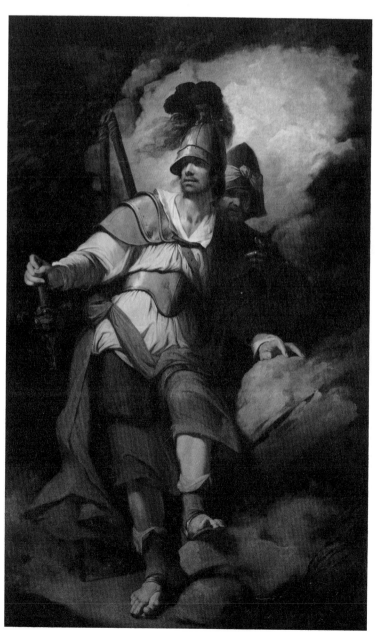

John Hamilton Mortimer
*Sir Arthegal, the Knight of Justice, with
Talus, the Iron Man*, 1778
Oil on canvas, 98 x 54 in/
248.9 x 137.2 cm
Tate Gallery, London

In its general style and composition this dramatic painting is inspired by Raphael's great cartoons in the royal collection (see p. 24) which Barry would have seen or known from engravings. But it has a very un-Raphaelesque tension and morbidity about it which is typically romantic, as is Barry's choice of a moment of extreme emotion, a good example of the sublime, Lear's speech over Cordelia's body:

> Howl, howl, howl, howl! O! you are men of stones:
> Had I your tongues and eyes, I'd use them so
> That heaven's vaults should crack. She's gone for ever.

The short-lived John Hamilton Mortimer is a complex and still somewhat obscure figure, the range of whose art included a great deal of portraiture, landscape painting and various kinds of genre besides history. Few of his major history pictures have survived but one of these, recently rediscovered and now in the Tate Gallery, is the very impressive and dramatic work, the central figure well over life-size, exhibited at the Royal Academy in 1778 under the title 'Sir Arthegal, the Knight of Justice, with Talus, the Iron Man'. The source is the Elizabethan poet Spenser's Arthurian fantasy *The Faerie Queene*, although the costume and armour are very like those of the contemporary European bandits who appear in a number of Mortimer's etchings and paintings.

The most striking of Mortimer's romantic works, 'Death on a Pale Horse', has come down to us only in the form of an engraved copy which, however, is itself a splendid thing. The original was exhibited at the Society of Artists in 1775 and was probably a large drawing rather than a painting. The subject is from the Book of Revelation and has an obvious appeal to the romantic imagination: 'And I looked, and behold a pale horse: and his name that sat on him was Death, and Hell followed with him...' Mortimer's version is authentically nightmarish, terrifying and macabre in the extreme, a perfect expression of the idea of the sublime.

Apart from Blake who is a special case, the greatest, the most celebrated or perhaps more correctly, the most notorious, of the romantic history painters is Henry Fuseli. Notorious because, as his disenchanted follower

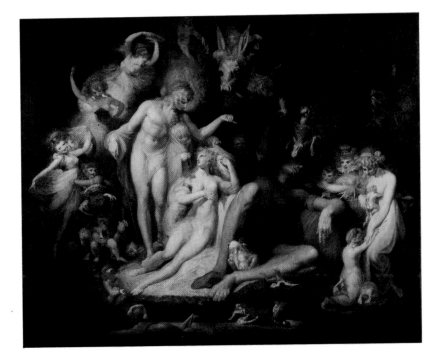

Henry Fuseli
Titania's Awakening (A Midsummer Night's Dream), 1785–9
Oil on canvas,
87⅜ x 110¼ in/222 x 280 cm
Kunstmuseum, Winterthur

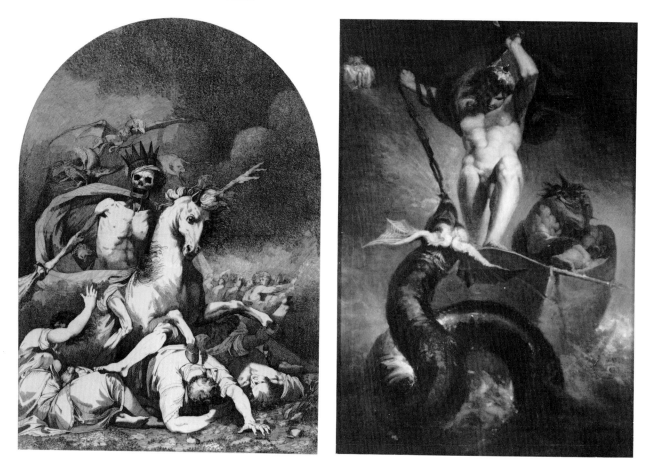

Benjamin Robert Haydon put it, 'The engines in Fuseli's Mind are Blasphemy, lechery and blood.'

Henry Fuseli was born in Zurich, the son of the artist and art historian Johann Füssli (Henry later changed the spelling of his name) who gave him a good grounding in both subjects before deciding his son should become a minister of the Zwinglian Church. Fuseli trained in Zurich under the great Swiss scholar Jacob Bodmer whose aesthetic ideas had an important influence on him. Bodmer stressed the importance in art of the bizarre, the horrifying and the miraculous and he introduced Fuseli to literary sources where these could be found – Homer, Dante, the German medieval legends known as the *Niebelungenlied* and, of particular fascination for Fuseli, Shakespeare and Milton.

Ordained a priest in 1761, Fuseli soon found himself in trouble with the authorities on political grounds and left Zurich for good, eventually settling in London in 1764. Although he was already a brilliant draughtsman Fuseli did not at this time paint. He functioned, as he was to continue to do all his life, as a writer and thinker, and later his drawings and paintings, while appealing powerfully to the emotions, always remained complex intellectual constructions full of literary, historical and philosophical allusions. In 1768 he met Reynolds who, as he had done with Barry, encouraged this potential history painter. Fuseli then went off to Italy to train and remained there from 1770 to 1778, where he was deeply affected by Michelangelo, whose Sistine Chapel paintings formed the basis of Fuseli's mature figure style.

On his return to London he quickly made a name in artistic and intellectual circles and achieved fame in 1781 when he exhibited 'The Nightmare' at the Royal Academy. From 1786–9 and from 1790–9 Fuseli devoted his energies mainly to two major artistic enterprises. The first was

the 'Shakespeare Gallery', a set of illustrations to the complete works commissioned from leading artists by John Boydell, the print publisher and picture dealer and also at this time Lord Mayor of London. The pictures were exhibited together in 1789 and an edition of the works containing engravings of them was published. The success of the 'Shakespeare Gallery', to which Fuseli had contributed nine canvases (although he painted and drew many other Shakespeare pictures), inspired him to start a 'Milton Gallery', this time to be painted entirely by himself. He eventually produced forty-seven Milton paintings but, although they were approved by his Academy colleagues when he first exhibited them in 1799, the public was indifferent and the scheme was a financial disaster. Fuseli, who had been elected a full member of the Academy in 1790, was now elected Professor of Painting, a post in which he excelled and kept, with a short break, until his death in 1825. In 1804 he was also made Keeper of the Academy. The respect in which he was held was such that he was buried in St. Paul's Cathedral, an honour normally accorded only to Presidents of the Academy.

A glance at Fuseli's œuvre does reveal, as Haydon noted, an overt preoccupation with on one hand the erotic and on the other violence, conflict and death. These themes are expressed in quite distinct kinds of composition, the first in fantasies of an intensely dreamlike character and the second in works charged with extreme tension and an almost demonic energy.

Fuseli's dreamlike paintings often have actual dreaming figures in them or refer in their titles and sources overtly to dreams. Many of them, for example, are illustrations to Shakespeare's *A Midsummer Night's Dream*. One of the most frequently quoted of Fuseli's pronouncements on art is his aphorism, 'The most unexplored region of art is dreams,' and his conscious interest in the subject gives his work an added significance for us now that modern psychology has revealed the importance of the subconscious mind and of dreams as emanations from it: Fuseli's pictures we can now see are not just literary illustrations but powerful expressions of deep psychological obsessions.

The dream pictures include of course 'The Nightmare', now in the Detroit Institute of Art, still his most famous painting, but his masterpiece of this kind is certainly the amazing fantasy he produced in 1785–9 for the Boydell Gallery illustrating the awakening of Titania from *A Midsummer Night's Dream* (Act IV Scene 1). This is now in the Kunstmuseum, Winterthur, but there is one rather like it, less elaborate and less well preserved – many of Fuseli's paintings have decayed badly – in the Tate Gallery, London.

The other pole of Fuseli's art is well represented by his Diploma picture (the painting every artist has to present on his election to the Royal Academy), 'Thor Battering the Midgard Serpent', a subject drawn from Nordic legend.

William Blake is one of the great original geniuses of British art. He is an extremely complex and many-sided figure, poet and philosopher as well as visual artist, and he and his art in all its aspects are still far from being fully understood. In the context of the history of British painting perhaps the most fruitful approach to Blake is to begin by considering the fact that his art emerged out of the background of history painting in the 1770s and 80s. He was a friend of Fuseli and an admirer of Barry and of his efforts to promote high art. His own style was rooted with perfect orthodoxy in Raphael and Michelangelo (whose work he knew from engravings only, for he never left England), and subjects from the usual sources, the Bible, history, Milton, Shakespeare, Dante, abound in his work. Yet while Barry and Fuseli, even if

Far left:
AFTER John Hamilton Mortimer
Death on a Pale Horse, 1784
Etching, $30\frac{3}{4}$ x $24\frac{3}{4}$ in/78.1 × 62.9 cm
Etched by J. Haynes, 1784, after
Mortimer's drawing of 1775
Victoria and Albert Museum, London

Near left:
Henry Fuseli
Thor Battering the Midgard Serpent,
1790
Oil on canvas, $51\frac{5}{8}$ x $35\frac{3}{4}$ in/131 x 91 cm
Diploma Gallery, Royal Academy of
Arts, London

not generally popular, were fully recognised by the Academy, Blake went completely without official appreciation and had few private patrons either. Most of his life he supported himself primarily by commercial engraving, for, like Hogarth, his first training was as an engraver. This neglect can be taken as an index both of the originality of Blake's personality and of his approach to the great tradition of European art. Put simply, Blake was an anti-rationalist, a visionary and a mystic, intensely other-worldly, a condition which made him an eccentric oddity in a society then, as now, governed entirely by materialistic and rationalistic ideas.

In this respect an illuminating as well as perceptive and sympathetic glimpse of Blake as he appeared to the artistic society of his day is provided by the diary of Lady Charlotte Bury, who in about 1820 found herself at a dinner where, unusually, both Blake and the most successful artist of the day, Sir Thomas Lawrence, President of the Royal Academy, were present:

'Besides Sir T there was also present Mrs M the miniature painter . . . Then there was another eccentric little artist, by name Blake; not a regular professional painter but one of those persons who follow the art for its own sweet sake and derive their happiness from its pursuit. He appeared to me to be full of beautiful imaginations and genius . . . Mr Blake appears unlearned in all that concerns this world. He looks careworn and subdued but his countenance radiated as he spoke of his favourite pursuit . . . I can easily imagine that he seldom meets with any one who enters into his views; for they are peculiar and exalted above the common level of received opinions. I could not help contrasting this humble artist with the great and powerful Sir Thomas Lawrence . . . Mr Blake . . . though he may have as much right from talent and merit, to the advantages of which Sir Thomas is possessed evidently lacks that worldly wisdom and that grace of manner which makes a man sure of eminence in his profession and success in society. Every word he uttered spoke the perfect simplicity of his mind and his total ignorance of all worldly matters.'

Blake's other-worldliness, his complete originality, is apparent as much in the form and medium as in the content of his art. In about 1790 his style, more or less orthodox until then, matured into something entirely personal which, although still recognisably rooted in Michelangelo, is characterised by what might be called a decorative dynamism, a predilection for flowing, curving lines and forms composed into flat, decorative arrangements. In this style Blake worked in a considerable variety of media except, very significantly, that of oil paint on canvas which he disliked and disapproved of. There is no doubt that his refusal to work in what was, and was to remain for a long time, overwhelmingly the most prestigious medium for art, helped to make him invisible to his contemporaries.

It seems that probably from quite early on in his career Blake envisaged his life's work as the production not of a sequence of individual pictures in oil or any other medium but of a series of great illuminated books, written, illustrated, printed and published by himself. The evidence for this intention is to be found in an early (1775–8) manuscript, 'An Island in the Moon', mainly a satire on the intellectual circles in which Blake moved in London as a young man, in which the following fragment of dialogue appears. The first speaker is thought to represent Blake himself:

'. . . thus illuminating the manuscript.'
'Ay,' said she, 'that would be excellent.'
'Then,' said he, 'I would have all the writing Engraved instead of Printed, and at every other leaf a high finished print – all in three volumes folio – and sell them a hundred pounds apiece. They would print off two thousand.'

'Then' said she, 'whoever will not have them will be ignorant fools and will not deserve to live.'

These books would have been splendid objects – by 'high finished print' Blake meant fully and richly coloured, and a folio-size book would stand 15–20 inches (38.1–50.8 cm) high or even more. In the end Blake produced fifteen illuminated books both written and illustrated by himself, and he also illustrated a number of books by other authors, notably *The Book of Job* published in 1820. Of his own books some are tiny, no more than pamphlets, none are folio size. Of the last and most famous of all, *Jerusalem* (1808–20), only one complete coloured copy is known to exist, now in the Mellon Collection in the USA. They were not a success, and perhaps partly because of the difficulties he had with them (apart from anything else they were extremely laborious to produce) Blake made many individual pictures which because of the rarity, inaccessibility and, it must be said, the obscurity of meaning of the books, are his best-known works and the clearest expressions of his vision. These works are mostly in some form of watercolour although Blake also worked in tempera, an archaic medium in which the pigment is mixed with egg yolk, very different in character from oil.

More even than the form, the content of Blake's art created, and still creates, problems. He did not, as for example Fuseli, the artist closest to him, did, choose subjects from 'high art' sources that enabled him to deal with

William Blake
Elohim Creating Adam, 1795
Colour print finished in pen and
watercolour, 17 x 21⅛ in/43.2 x 53.7 cm
Tate Gallery, London

fundamental, universal and immediate human preoccupations such as sexuality or conflict and death. When he did use biblical, historical or literary subjects Blake used them, and adapted them, as the vehicles for his own cosmic vision, a vision, that is, of man's spiritual history, of his place in the universe and of his relationship to God. Furthermore, although Blake was a Christian in the strict sense of being a fervent admirer of Christ, and his work refers extensively to Christian mythology, his view of man's spiritual progress was so radically different from that laid out in the Scriptures that he had to invent his own mythology – 'I must create a system or be enslaved by another man's,' he said. Much of his art, particularly the illuminated books, deals with this personal mythology and its strange protagonists, Los, Orc, Urizen and the rest.

Of Blake's independent pictures those twelve known as the 'Large Colour Prints' of 1795 are outstanding, and are generally considered to constitute, as a group, the most complete and perfect manifestation of Blake's power as a painter. For them Blake used the simplest of all print-making methods, the technique now known as monotype. Basically this involves painting the image onto a smooth hard surface (Blake used millboard) in a thick medium and then immediately laying a sheet of paper over it and pressing it down. Further impressions can be taken before the paint is all absorbed or it can be refreshed. The use of this technique reflects, of course, Blake's continuous experiment with methods of colour printing for his books, but apart from the obvious advantage of enabling him to repeat a design without too much trouble this method particularly lends itself to the production of the glowing colours and rich textures (further worked up by hand after pulling) which are a major factor in the unique visual quality of the Large Colour Prints.

The subjects of these works illustrate some of Blake's most important and fundamental ideas, none more so than the first in the series, 'Elohim Creating Adam'. This reveals more fully than any other single work Blake's view of man and his relationship to the creator of Christian mythology, the God of the Old Testament for whom Elohim is one of the old Hebrew names. Blake's view of the Creation was the exact opposite of the traditional Judaic-Christian one which sees it as a glorious and heroic moment, as it is shown in Michelangelo's celebrated depiction on the Sistine Chapel ceiling. For Blake it was a disaster, a crime perpetrated by God against man. In his picture God appears as an oppressive patriarch and tyrant: Adam screams in agony beneath his weight and flings out an arm in supplication, flinching from the creating hand. Already, before he is complete, a worm has twined itself about his legs, preventing him from moving. It is a powerful expression of Blake's basic view that man was originally a spiritual being, trapped at the time of creation in a material body, placed in a material world and therefore deprived of his freedom – the symbolism of the worm, which also represents evil. In Blake's view, therefore, man's loss of Paradise, the Fall of Christian mythology, took place at his creation, not in the Garden of Eden.

Put very simply, Blake believed that man should strive to regain contact with the spiritual world, usually referred to by him as 'the infinite', which

William Blake
With Songs the Jovial Hinds return from Plow (illustration to Thornton's *Pastorals of Virgil*, 1821)
Woodcut, $1\frac{3}{8}$ x 3 in/
3.5 x 7.5 cm (approx)
Tate Gallery, London

lay beyond the immediate material world and of which Paradise is a part. He also believed that man, or some men, especially artists, possessed a faculty for perceiving this spiritual world which he called the 'prophetic faculty' or 'poetic genius' and in practice equated with the faculty of imagination. This meant that for Blake the purpose of art must be to reveal the spiritual world, and his hatred of Reynolds, whom he saw as a mere materialistic portrait painter, is legendary: 'This Man was Hired to Depress Art,' he wrote of him in the margin of his copy, which has survived, of the *Discourses*, Reynolds's published Royal Academy lectures. When Reynolds states that the basis of art is to be found 'about us and upon every side of us,' Blake angrily writes against it, 'A lie! A lie!' and later gives his own view, 'All Forms are Perfect in the Poet's Mind, but these are not Abstracted nor compounded from Nature but are from Imagination,' and, 'The man who never in his Mind and Thoughts travll'd to Heaven Is No Artist.' Elsewhere, in the preface to the catalogue of the exhibition of his work which he held in rooms over his brother's hosiery shop in Soho in 1809, he wrote:

'Shall Painting be confined to the sordid drudgery of fac-simile representations of merely mortal and perishing substances and not be as poetry and music are elevated to its own proper sphere of invention and visionary conception? No, it shall not be so! Painting, as well as poetry and music, exists and exults in immortal thoughts.'

In the early part of Blake's mature career, the decade of the 1790s, his art tends mainly to encompass the gloomy side of his vision – the Creation and its consequences, as in the Large Colour Prints. But later there are visions that are obviously paradisal, like the lyrical and dreamlike watercolour 'The River of Life' of about 1805 which depicts in a light of unearthly clarity and hue an angelic figure, probably that of Christ, with a child on each hand floating up the stream of time towards the divine sun. And in 1820 Blake made a set of seventeen small woodcuts for an edition of Virgil's pastoral poems which evoke an imaginary world of idyllic peace and calm and were to have a decisive formative impact on Blake's most important immediate follower, Samuel Palmer.

William Blake
The River of Life, c.1805
Pen and watercolour, 12 x 13¼ in/
30.5 x 33.7 cm
Tate Gallery, London

Chapter 9
Samuel Palmer and the Ancients

Samuel Palmer (1805–81) was introduced to Blake in 1824 by the landscape painter John Linnell, who was Blake's chief friend and support during the last decade of his life. Palmer was nineteen at the time, a precociously talented artist (he had been exhibiting at the Academy since 1819) with a strongly mystical temperament, who claimed to have seen visions as a child.

Palmer's own account of his first meeting with Blake has become famous in the annals of British art:

'We found him home in bed, of a scalded foot (or leg). There, not inactive, though sixty-seven years old, but hard working on a bed covered with books sat he up like one of the Antique patriarchs, or a dying Michelangelo. Thus and there was he making in the leaves of a great book (folio) the sublimest designs from his (not superior) Dante. [This is a reference to the illustrations to Dante's *Divine Comedy* which occupied the last years of Blake's life and were left unfinished at his death. They can be seen in the Tate Gallery and elsewhere.] He said he began them with fear and trembling. I said "O! I have enough of fear and trembling." "Then," said he "You'll do!" He designed them (100 I think during a fortnight's illness in bed!) And there, first, with fearfulness did I show him some of my first essays in design; and the sweet encouragement he gave me (for Christ blessed little children) did not tend basely to presumption and idleness but made me work harder and better that afternoon and night. And after visiting him, the scene recurs to me afterwards in a kind of vision; and in this most false, corrupt and genteelly stupid town [London] my spirit sees his dwelling (the chariot of the sun) as it were an island in the midst of the sea – such a place is it for primitive grandeur, whether in the persons of Mr and Mrs Blake or in the things hanging on the wall.'

This passage conveys very vividly Palmer's exalted state of mind and his rejection of the material world, which was, however, less comprehensive than that of Blake. Specifically, Palmer turned away from the increasingly urban and industrial world of his day to unspoiled nature, in this differing crucially from Blake whose Virgil woodcuts (see p.64) are almost the only coherent manifestation of landscape art in his entire œuvre. For a few years, from the time of his meeting with Blake up to about 1834, the time of his marriage to John Linnell's daughter, Palmer painted nature, transforming it through his imaginative powers to create what are undoubtedly the most idyllic and mysterious works in the whole history of English landscape painting: visions of paradise on earth.

The stimulus or inspiration for this phase of Palmer's art came from two sources. One of them was, of course, Blake and his works, particularly the Virgil woodcuts of which Palmer was shown proofs in 1824. He later recorded his reaction:

'I sat down with Mr Blake's Virgil woodcuts before me, thinking to give to their merits my feeble testimony. I happened first to think of their sentiment.

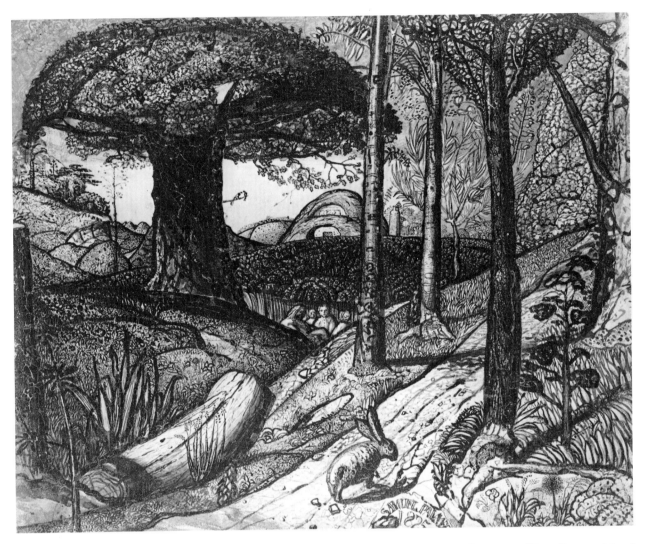

Samuel Palmer
Early Morning, 1825
Pen and brush in sepia, mixed with
gum and varnished,
7⅜ x 9⅛ in/188 x 232 cm
Ashmolean Museum, Oxford

They are visions of little dells, and nooks, and corners of Paradise; models of
the exquisitest pitch of intense poetry. I thought of their light and shade, and
looking upon them I found no word to describe it. Intense depth, solemnity
and vivid brilliance only coldly and partially describe them. There is in all
such a mystic and dreamy glimmer as penetrates and kindles the inmost
soul and gives complete and unreserved delight unlike the gaudy daylight of
this world. They are, like all that wonderful artist's works, the drawing aside
of the fleshly curtain and the glimpse which all the most holy, studious
saints and sages have enjoyed of that rest which remaineth to the people of
God.'

Palmer's second source of inspiration was a place which must almost
have seemed to correspond to the paradise of the woodcuts, the village of
Shoreham in Kent and the fertile valley in which it nestles. It is difficult to
imagine now the Shoreham of Palmer's day, a village essentially
unchanged since the Middle Ages, its inhabitants living a close communal
agricultural existence governed by the rhythm of the seasons and having its
common spiritual focus in the village church.

Palmer first began visiting Shoreham about 1824–5 and finally settled
there after Blake's death in 1827. The earliest major works inspired by
Shoreham are the six extraordinary pictures all dated 1825 in the
Ashmolean Museum, Oxford. They are done in a strange but very successful
technique using a warm brown sepia wash mixed with gum and then
varnished, which gives them a translucent, jewel-like quality, and the look
of something immensely ancient and precious. It conveys the feeling of

[67]

looking through a window into another world. Everything in these works is expressive of a vision of man living in absolute harmony with a fertile and bountiful nature: the rounded, swelling, ripe forms of hills, trees and cottages, the huge harvest moons, the dense fields of wheat with giant heads bursting with grain. In the midst of all this, so much a part of the landscape that they are often difficult to see, are Palmer's farmers and shepherds, their plump sheep and placid cattle.

These first Shoreham pictures remain the best. Palmer never quite matched their amazing intensity, although his response to Shoreham remained strong at least until the early 1830s.

During the years he lived there Palmer gathered about him a circle of young artists who would come to stay and work in the village. They called themselves 'the Ancients', to emphasise their belief in the superiority of ancient man over his modern descendants. The most interesting of them were George Richmond (1806–96) and Edward Calvert (1799–1883), both of whom were strongly influenced by Blake as well as by Palmer himself. Of the two it was Calvert whose art most strongly reflected the paradisal pastoral vision of the Blake woodcuts, of Palmer's early Shoreham works and the influence of Shoreham itself. With these influences, however, Calvert blended an entirely personal element of pagan, rather than Christian, mysticism, giving rise to a vein of lyrical eroticism which sharply distinguishes his art from that of Palmer.

Calvert actually adopted Blake's medium of the woodcut for most of the group of engraved works made between 1825 and 1831 which are his masterpieces of that period and remain the basis of his modern reputation. Known as the 'Early Engravings', there are eleven of them altogether, nine tiny woodcuts and two copper engravings, one rather larger than all the rest. All of them are of great technical perfection as well as inspired content. The loveliest are certainly the woodcut called 'The Chamber Idyll' and the large copper engraving, 'The Bride', in both of which the theme of nature's fertility is reinforced and complemented by a warm celebration of human love.

Edward Calvert
The Bride, 1828
Engraving, 3 x 5 in/7.6 x 12.7 cm
Tate Gallery, London

Edward Calvert
The Chamber Idyll, 1831
Engraving, 1⅝ x 3 in/4.1 x 7.6 cm
Tate Gallery, London

Chapter 10
J. M. W. Turner

Landscape painting in England found its fullest flowering in the first half of the nineteenth century in the art of two very great and very different painters, Turner and Constable. Both men took their point of departure from the landscape tradition as it had been developed in Britain through the eighteenth century, but they also looked beyond it directly to the great European landscape artists of the seventeenth century, the classical Claude and Poussin and the naturalistic Dutch school. Eventually they created a new synthesis, and although both drew on the whole existing range of landscape art it can be said that it was Turner who took the idea of classical landscape, landscape with content, to its ultimate point of development and Constable who finally succeeded in elevating topographical, purely naturalistic landscape to the very highest realms of art.

Joseph Mallord William Turner (1775–1851) was born the son of a barber in Covent Garden, London. His first signed and dated drawings are from 1786 when he was eleven, and his first surviving sketchbook from nature probably dates from 1789, the year he entered the Royal Academy Schools. At the same time he became a pupil of the architectural topographer Thomas Malton and it was as a topographical watercolourist that Turner began his career. He exhibited in watercolour at the Academy for the first time in 1790 and was to exhibit almost every year from then on. In 1792 he made his first sketching tour, to South Wales, and tours in search of material became a regular practice, eventually taking him as far as Rome and Venice. In 1794 his work first attracted attention in the press and in 1796 he exhibited at the Royal Academy his first datable oil painting, 'Fishermen at Sea'. This is a remarkable work, not just for its high degree of skill and accomplishment and because it is Turner's first exhibited oil, but because it already reveals Turner's preoccupation with particular aspects of the natural world. The first of these is with light. Light, as a vehicle of feeling, as an independent pictorial element playing the major expressive role in a painting, was to be Turner's lifelong obsession and this is heralded in 'Fishermen at Sea' in the naturalism and subtlety of the moonlit sky. The total conviction with which he has handled the extremely difficult task of rendering its reflection on the moving water is perhaps without precedent in art.

Turner's other great preoccupation was with the dynamism of the natural world, its innate energy and power, and particularly with the extreme expression of this dynamism in the form of storms and other destructive phenomena. In 'Fishermen at Sea' black clouds scud across the sky and the water humps itself into a dangerous swell – a storm is coming on. Furthermore, the fishermen, their boat wallowing in a trough, picked out by the moonlight, are very deliberately placed in the centre of the painting at the focus of a roughly ovoid compositional structure made up from the pronounced arch of the sky and the corresponding curve of the sea. In the background are the Needles, some of the most dangerous rocks to

shipping off the English coast. The fishermen are thus clearly presented as potential victims of the storm and in this painting Turner is also stating for the first time one of the main philosophical themes of his art, a vision of the frailty and ephemerality of man in the face of the eternal grandeur of nature.

Light plays an important part in all Turner's paintings, but from early on in his career a distinction can be made between works like 'Fishermen at Sea', primarily concerned with the forces of nature, and works like 'Buttermere Lake' of 1798, in which light is the vehicle of an essentially tranquil, lyrical vision of the natural world. In this study of light and changing weather conditions he has captured the precise fleeting moment after a storm when the sun breaks through clouds to produce a rainbow in the last drops of water still hanging in the air. Typically, Turner shows little interest in the topographical detail of the scene, and further evidence of his conscious and exclusive concern with light and weather is provided by the lines of poetry, from James Thomson's celebrated pastoral poem *The Seasons* first published in 1730, that Turner had printed in the Academy catalogue:

Till in the western sky the downward sun
Looks out effulgent – the rapid radiance instantaneous strikes
Th' illumined mountains – in a yellow mist
Bestriding earth – the grand ethereal bow
Shoots up immense, and every hue unfolds.

From this time on Turner made a habit of attaching literary quotations, often his own poetry, to his pictures.

After 1798 Turner's paintings can be divided very broadly into those dominated by natural dynamism and those dominated by light. With pictures like 'Fishermen' and 'Buttermere' and his ever more accomplished watercolours Turner's reputation grew steadily through the 1790s until in 1799 he was elected an Associate of the Royal Academy. He then proceeded to consolidate his position with a dazzling and imposing series of large oil paintings shown at the Academy over the next decade, consisting of turbulent sea pieces and his first major classical landscapes, both pastoral and historical. Because of the prestige still attached by the Academy to high art it was these last in particular that led to the supreme accolade of Turner's election to full membership of the Academy in 1802 at the youngest possible age, twenty-seven. Constable, one year younger than Turner, had to wait over a quarter of a century, until 1829, before he was, grudgingly, made an RA.

Turner's earliest classical landscapes, 'The Fifth Plague of Egypt' (1800)

Below left:
J. M. W. Turner
Fishermen at Sea, 1795–6
Oil on canvas, $36 \times 48\frac{1}{8}$ in/
91.4×122.2 cm
Tate Gallery, London

Below right:
J. M. W. Turner
Buttermere Lake, with part of Cromack Water, exh. 1798
Oil on canvas, 35×47 in/
88.9×119.4 cm
Tate Gallery, London

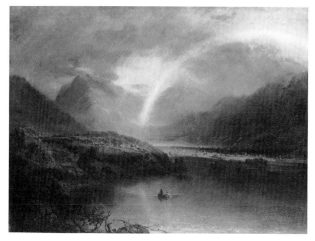

and 'The Tenth Plague of Egypt' (1802) are both based on Poussin. They are both very good examples of the way in which Turner was able to choose 'history' subjects to suit his own deepest interests, for these pictures before they are anything else are representations of the overwhelming of man and his works by enormous natural destructive forces. In both, buildings, whole cities and people are dwarfed into insignificance by the extraordinary billowing formations of storm clouds shot with fire that dominate the painting.

The large sea-pieces range from dramatic representations of stormy skies and seas and wind- and wave-tossed boats like 'Calais Pier' of 1803 in the National Gallery, the outcome of Turner's first visit to France in 1802, to

J. M. W. Turner
The Tenth Plague of Egypt, exh.1802
Oil on canvas, 56½ x 93 in/
143.5 x 236.2 cm
Tate Gallery, London

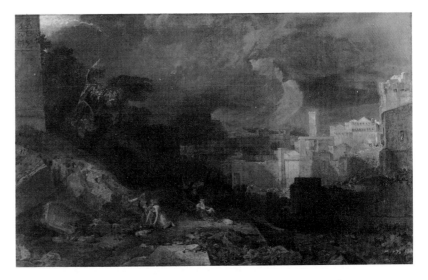

J. M. W. Turner
The Shipwreck, exh.1805
Oil on canvas, 67½ x 95 in/
171.5 x 241.3 cm
Tate Gallery, London

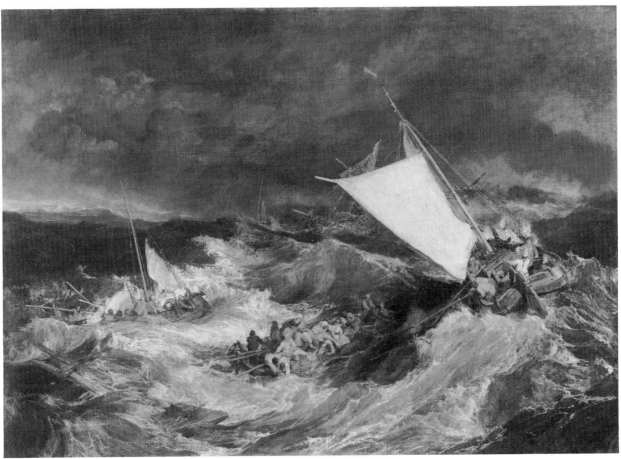

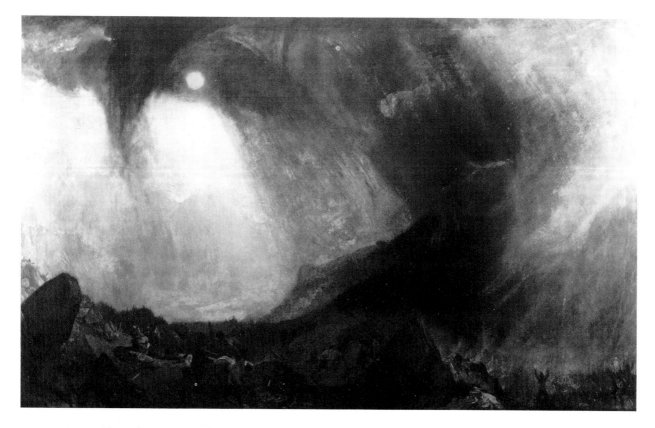

J. M. W. Turner
*Snow Storm: Hannibal and his Army
Crossing the Alps*, exh.1812
Oil on canvas, 57 x 93 in/
144.8 x 236.2 cm
Tate Gallery, London

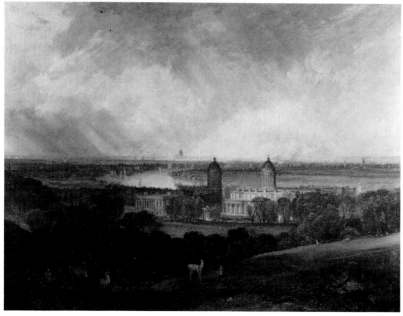

J. M. W. Turner
London from Greenwich, exh.1809
Oil on canvas, 35½ x 47¼ in/
90.2 x 120 cm
Tate Gallery, London

full-blown storm and shipwreck paintings like 'The Shipwreck' of 1805. Here for the first time, in the foaming mass of water around the lifeboat, Turner is using a swirling, distinctly vortex-like structure to express his vision of the storm and its destructive power. These pictures were unprecedented in their dramatic naturalism, their extraordinarily vivid rendering of complex moving masses of cloud and atmosphere and shifting seething water. Turner obtained his effects by using paint with great freedom and from this time his concern for overall visual impact rather than with detail becomes progressively more marked. It was this freedom which gave rise to the first criticisms of Turner on grounds of 'lack of finish', that is, lack of detail and apparent roughness of execution. Turner was to endure a

good deal of hostile criticism throughout his life, but he was greatly praised too, and his reputation as the outstanding genius of British art was never seriously assailed in his lifetime nor has it been since.

The early storm paintings reached a climax in 'Snow Storm: Hannibal and his Army Crossing the Alps' exhibited in 1812. Here the vortex of the great storm cloud is very marked as it arches across the sky and down into the valley to break over Hannibal's hapless troops. Dominated as it is by the storm, this is another example of Turner's ability to choose high art subjects which suited his interests. However, this painting is of special importance because an anecdote connected with it affords a crucial insight into Turner's methods of work. In 1810 he was staying at Farnley Hall in Yorkshire with his patron Walter Fawkes whose son recorded how one day Turner called him out to admire a thunderstorm. Turner was making notes of its form and colour on the back of a letter: 'I proposed some better drawing block but he said it did very well. He was absorbed – he was entranced. There was the storm rolling and sweeping and shafting out its lightning over the Yorkshire hills. Presently the storm passed and he finished. "There," he said, "Hawkey, in two years you will see this again, and call it Hannibal Crossing the Alps".' The use of the back of a letter for recording the storm is typical. Throughout his life the information Turner took direct from nature was almost always of the sketchiest kind: his watercolours and oils were worked up from these sketches, from his prodigious visual memory but especially from his imagination. He recreated in intensified pictorial form those aspects of nature which most deeply moved him.

Throughout this early period Turner also continued to paint the English landscape in the calm, restrained, naturalistic vein of 'Buttermere'. In particular he did a good deal of sketching on the Thames and produced a number of what appear to be oil sketches done direct from the motif, that is, direct from nature, a rare practice with Turner. Some of these can be seen in the Tate Gallery. This activity resulted in a series of luminous, highly atmospheric finished landscapes among which the view of 'London from Greenwich' of 1809 is outstanding and one of the few pictures to which Turner added his signature. But his masterpiece of this phase is undoubtedly the astonishing 'Sun Rising through Vapour; Fishermen Cleaning and Selling Fish' of 1807, his first great imaginative vision of light. No reproduction and certainly no description can remotely do justice to this shimmering, translucent miracle – it is one of his very highest achievements, and can be seen in the National Gallery, London. Hanging beside it there is another of Turner's greatest early works, 'Dido Building Carthage, or the Rise of the Carthaginian Empire' of 1815. This painting reveals that the influence of Poussin, evident in Turner's early classical landscapes, had been supplanted by that of Claude, who was to remain Turner's god among the artists of the past. 'Dido' is based on a type of seaport scene invented by Claude and like 'Sun Rising through Vapour' is dominated by an astonishing sunrise effect, this time of a hotter Mediterranean character as opposed to the coolness and mist of the earlier work. The rising sun is also symbolic of the birth of the Carthaginian Empire and in 1817 Turner exhibited a companion, 'The Decline of the Carthaginian Empire', in which the sun is setting. In these pictures, as in the stormy history paintings like 'Hannibal', Turner is always primarily concerned with visual effect and the depiction of a phenomenon of nature. Awareness of the subject only comes with knowledge of the title. This was often very long – Turner's full title for 'The Decline of Carthage' runs to forty-nine, mostly polysyllabic, words – and the lines of poetry attached to some paintings often reveal even further meanings not immediately

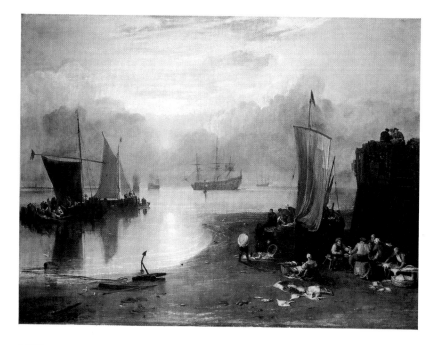

J. M. W. Turner
*Sun Rising through Vapour: Fishermen
Cleaning and Selling Fish, c.*1807
Oil on canvas,
53 x 70½ in/134.6 x 179.1 cm
National Gallery, London

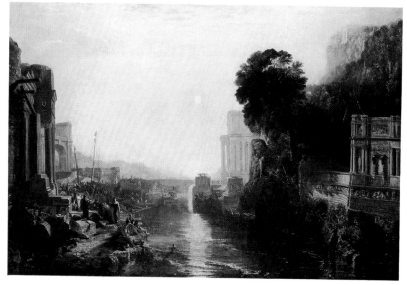

J. M. W. Turner
*Dido Building Carthage, or the Rise of the
Carthaginian Empire,* 1815
Oil on canvas, 61¼ x 91¼ in/
163.2 x 231.8 cm
National Gallery, London

apparent in the painting itself. The detailed titles and explanatory lines make it clear that Turner attached importance to the theoretical subject of his pictures of this type and they should not be forgotten in the face of his dazzling effects.

When Turner first thought of bequeathing works by him to the nation in his will of 1829 (the National Gallery was founded in 1824) it was the two Carthaginian pictures he chose, substituting in 1831 'Sun Rising through Vapour' for the 'Decline of the Carthaginian Empire'. He asked for them to be hung alongside two specified works by Claude, probably because he wished to show that British artists could match the finest achievements of the old masters and thus to encourage the development of the British School.

In 1819 Turner made his first, long-delayed visit to Italy, staying from August 1819 to January 1820. The immediate impact on him of Italian light is recorded in a group of about fifty watercolour studies in which, as the Turner watercolour expert Andrew Wilton has written, 'he catches with breathtaking conviction the luminous atmosphere of Naples, the

Campagna, Venice and Lake Como'. Of them perhaps the loveliest are those of Venice, whose unique combination of sky, water and architecture Turner responded to particularly strongly. One is a view of the Doge's Palace of which Turner's biographer Finberg wrote: 'As a study it was perhaps the most useful drawing Turner made in Venice on this occasion, as it fixed upon his mind for the remainder of his life that vision of a city of gleaming marble rising from the sea which we find in his later paintings.' As this implies, the effect of Italy on Turner's oil paintings was less immediate than on his watercolours. He only exhibited three specifically Italian subjects

J. M. W. Turner
Shipping off East Cowes Headland, 1827
Oil on canvas, $18\frac{1}{8} \times 23\frac{5}{8}$ in/
46 x 60 cm
Tate Gallery, London

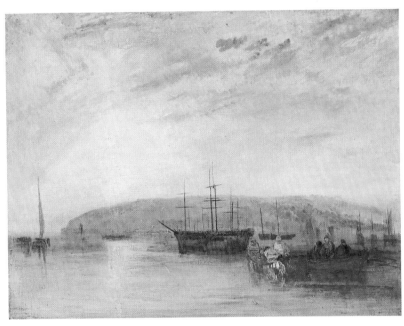

J. M. W. Turner
Ulysses Deriding Polyphemus, 1829
Oil on canvas, $52\frac{1}{4} \times 80$ in/
133.4 x 203.2 cm
National Gallery, London

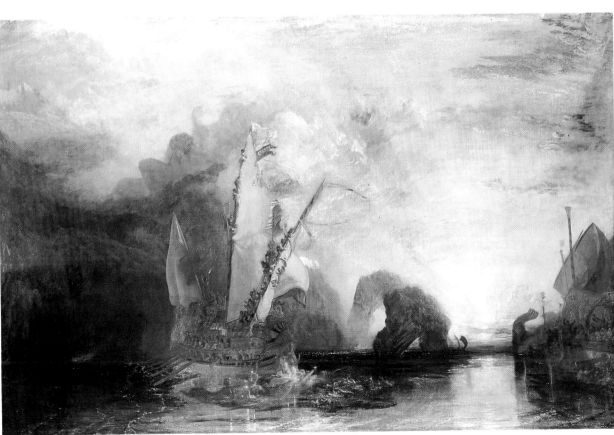

before his second visit in 1828, none of them entirely satisfying works, although one, 'The Bay of Baiae' (1823), was much praised at the time.

Turner devoted most of his energies through the 1820s to a series of projects for book illustrations. His oil paintings of the period other than the big Italian canvases tend to be relatively small-scale and informal English scenes. It is in two groups of such works, done just before his return to Italy, that a new quality of light and colour becomes apparent. They are the nine studies done on two pieces of canvas at Cowes, Isle of Wight, when Turner was staying with the architect John Nash at East Cowes Castle in the summer of 1827; and the five oblong sketches of Sussex scenes done in 1828 for Turner's patron Lord Egremont. All are now in the Tate Gallery, and there are more finished versions of four of the Sussex scenes at Petworth House, Lord Egremont's seat.

The most notable feature of these works is the way in which solid objects are integrated into the overall luminosity and become light and colour themselves. The fishermen in the foreground of 'Shipping off East Cowes Headland', for example, consist of translucent smears of orange, pink and yellow. The ship and island are transparent ghosts amid the yellow haze of the setting sun. The sunset over the lake at Petworth hardly contains an identifiable object. More than ever before in Turner's œuvre these works are pure and unified expressions of light.

The Cowes and Sussex sketches were not the sort of works Turner would have sent for public exhibition. But on his return from Italy in February 1829 he prepared and sent to that summer's Academy a magnificent classical painting inspired by Italy and displaying all his newly heightened awareness of light and colour, 'Ulysses Deriding Polyphemus'. This painting, called by John Ruskin 'the *central picture* in Turner's career', marks the ultimate extension of the classical tradition into the Turnerian realm of light, colour and imagination. It is quite overwhelming in its visual effect, particularly in its extraordinary intensity of colour, '*colouring run mad*', according to the *Literary Gazette*: 'positive vermillion, positive indigo and all the most glaring tints of green, yellow and purple contend for mastery of the canvas'. But, uniquely among Turner's classical works, the imagery is not swamped by all this. Furthermore this imagery, the fairy-tale ship with naked sea nymphs sporting round its bows, the mysterious giant half-concealed in the mist on the mountain, exerts a powerful and immediate appeal purely on the level of fantasy. It is this unusual balance of imaginative content and visual effect which gives 'Ulysses' its peculiar power.

This painting marks the beginning of Turner's full maturity. From then until just a few years before the end of his life he was continuously at the very height of his powers, producing a great series of major exhibition paintings covering a full range of subjects as well as the less finished oil sketches which, unknown in his lifetime, are now among his most appreciated later works. Among all these can be picked out first the oil paintings of Venice that Turner at last began to make in 1833 and that he exhibited at the Academy every year from 1833–7 and from 1840–6. In them he exploits the reflection of light on water and the reflectiveness of the architecture to produce shimmering masses of coloured light, and they mark, together with certain unexhibited oil sketches, the furthest extension of his painting of light for its own sake. Among those sketches, two English scenes, 'Yacht Approaching the Coast' and 'Norham Castle, Sunrise', are outstanding, stripped of almost all external references, his very purest visions of light and colour.

Turner also pursued his naturalistic vision of the storm, that of the early

shipwreck paintings, to its ultimate point in 'Snow Storm: Steam-boat off a Harbour's Mouth Making Signals in Shallow Water and Going by the Lead. The Author was in this Storm on the Night the Ariel Left Harwich.' Here the device of the vortex reaches its fullest and most perfect development, with all the elements revolving in a single dynamic flux around the ship. It is one of Turner's most effective images of man at the mercy of the forces of nature. The exceptional immediacy of this painting derives also from the modernity of the image – a steamship – and the fact stated by Turner in the title that it is based on a real experience, like the famous 'Rain, Steam and Speed'. Ruskin recorded Turner's comment: 'I did not paint it to be understood, but I wished to show what such a scene was like; I got the sailors to lash me to the mast to observe it; I was lashed for four hours and I did not expect to escape, but I felt bound to record it if I did.'

J. M. W. Turner
Snow Storm: Steam-boat off a Harbour's Mouth, exh. 1842
Oil on canvas, 36 x 48 in/
91.4 x 121.9 cm
Tate Gallery, London

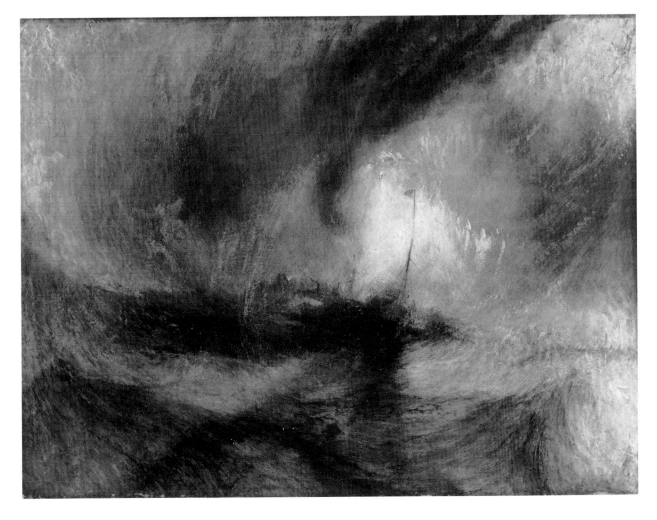

Then at the Academy in 1840 Turner produced his greatest masterpiece of imaginative painting, an extraordinary treatment of a real-life subject combined with blazing colour and the vortex of the storm, 'Slavers Throwing Overboard the Dead and Dying – Typhon Coming On', more popularly known as 'The Slave Ship'.

This is one of the paintings to which Turner attached lines of his own poetry which, as in almost all other cases, purport to come from the manuscript of a great epic poem called *The Fallacies of Hope*, a title which points up Turner's deep underlying pessimism:

Aloft all hands, strike the top masts and belay;
Yon angry setting sun and fierce edged clouds

Declare the Typhon's coming.
Before it sweep your decks, throw overboard
The dead and dying –n'er heed their chains.
Hope, Hope, fallacious Hope!
Where is thy market now?

In 1844 the picture was given to John Ruskin by his father but he later sold it, finding the subject, he said, 'too painful to live with'. Before he parted with it, however, he had written in the first volume of his great book on Turner, *Modern Painters* published in 1843, the following description, perhaps the most remarkable verbal tribute ever paid by a great critic to a great painter:

'But, beyond dispute, the noblest sea that Turner has painted, and, if so, the noblest certainly ever painted by man, is that of the Slave Ship . . . Purple and blue, the lurid shadows of the hollow breakers are cast upon the mist of night, which gathers cold and low, advancing like the shadow of death upon the guilty ship as it labours amidst the lightning of the sea, its thin

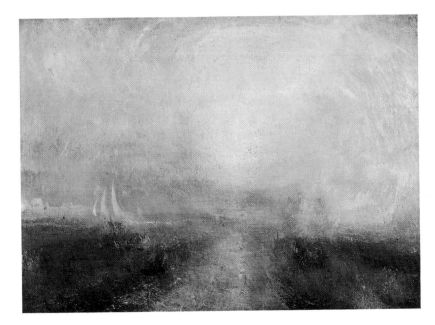

J. M. W. Turner
*Yacht Approaching the Coast, c.*1835–40
Oil on canvas, 40¼ x 56 in/
102.2 x 142.2 cm
Tate Gallery, London

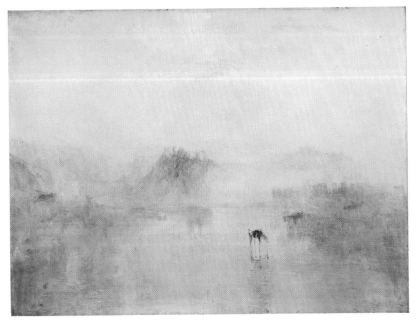

J. M. W. Turner
*Norham Castle, Sunrise, c.*1835–40
Oil on canvas,
35¾ x 48 in/90.5 x 121.9 cm
Tate Gallery, London

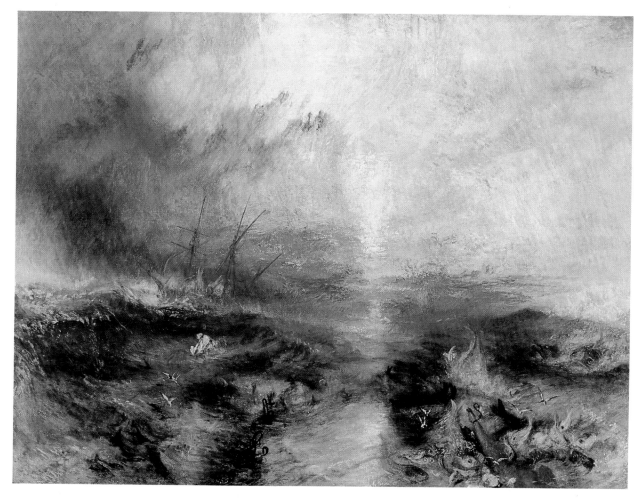

J. M. W. Turner
Slavers Throwing Overboard the Dead and Dying – Typhon Coming on (The Slave Ship), exh. 1840
Oil on canvas, 35¾ x 48 in/
90.8 x 121.9 cm
Museum of Fine Arts, Boston, Mass.

masts written upon the sky in lines of blood, girded with condemnation in that fearful hue which signs the sky with horror, and mixes its flaming flood with the sunlight, and cast far along the desolate heave of the sepulchral waves, incardines the multitudinous sea. I believe, if I were reduced to rest Turner's immortality upon any single work, I should choose this. Its daring conception, ideal in the highest sense of the word, is based on the purest truth, and wrought out with the concentrated knowledge of life; . . . and the whole picture dedicated to the most sublime of subjects and impressions (completing thus the perfect system of all truth, which we have shown to be formed by Turner's works) – the power, majesty, and deathfulness of the open, deep, illimitable sea!'

Chapter 11
John Constable

As we have seen, although landscape painting was still low in the hierarchy of types of painting in the early nineteenth century, from early in his career Turner was able to win the approval of the Academy as well as a large degree of wider popularity by painting historical subjects in a landscape background or depicting inherently dramatic or interesting aspects of the world which he travelled widely to find.

John Constable (1776–1837), however, had no interest in imaginative subject matter of any kind or in seeking out overtly dramatic or exotic scenes. What then did he want to paint? Constable's attitude to landscape is well described by his friend and biographer C. R. Leslie in his account of the only special journey in search of material that Constable ever made, to the Lake District in 1806:

'He spent about two months among the English lakes and mountains where he made a great number of sketches, of a large size, on tinted paper, sometimes in black and white but more often coloured. They abound in grand and solemn effects of light, shade and colour but from these studies he never painted any considerable picture, for his mind was formed for the enjoyment of a different class of landscape. I have heard him say the solitude of mountains oppressed his spirits. His nature was peculiarly social and could not feel satisfied with scenery, however grand in itself, that did not abound in human associations. He required villages, churches, farm houses and cottages and I believe it was as much from natural temperament or from early impressions that his first love in landscape was also his latest love.'

Constable's first and last love, the place in which he found this social landscape, was, of course, his native Suffolk and particularly the village of East Bergholt on the River Stour where his father was a prosperous miller. Many years later, in the introduction to the collection of mezzotints of his work that he published between 1830 and 1832 under the title *English Landscape*, Constable wrote his own evocation of East Bergholt and its surroundings, beginning by quoting briefly from a contemporary book, *The Beauties of England and Wales*:

'"South of the Church is 'Old Mall', the Manor House, the seat of Peter Godfrey, Esq; which, with the residences of the rector, the Reverend Dr Rhudde, Mrs Roberts and Golding Constable Esq., give this place an appearance far superior to that of most villages." It is pleasantly situated in the most cultivated part of Suffolk, on a spot which overlooks the fertile valley of the Stour, which river divides that country on the south from Essex. The beauty of the surrounding scenery, the gentle declivities, the luxuriant meadow flats sprinkled with flocks and herds, and well cultivated uplands, the woods and rivers, the numerous scattered villages and churches, with farms and picturesque cottages, all impart to this particular spot an amenity and elegance hardly anywhere else to be found.'

Amid all this it seems that it was in particular the River Stour and its

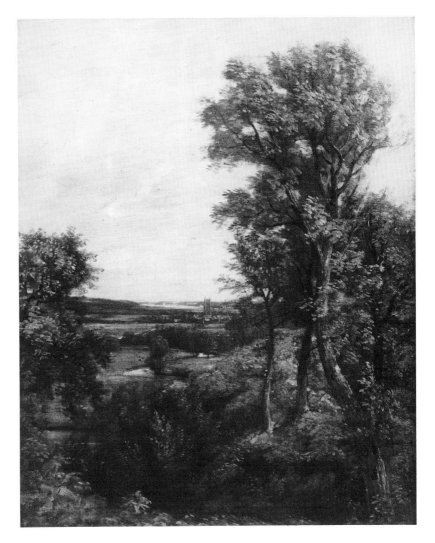

John Constable
Dedham Vale, 1802
Oil on canvas, $17\frac{1}{8}$ x $13\frac{1}{2}$ in/
43.5 x 34.3 cm
Victoria and Albert Museum, London

water mills and barges that provided the core of Constable's inspiration. This he made clear in the celebrated letter written in 1821 to his friend and greatest patron, the Reverend John Fisher:

'How much I can imagine myself with you on your fishing excursion [Fisher was on a trip to Hampshire]. But the sound of water escaping from Mill dams, so do Willows [sic], Old rotten Banks, slimy posts, and brickwork. I love such things... They have always been my delight – and I should indeed have delighted in seeing what you describe... But I should paint my own places best; painting is but another word for feeling. I associate my "careless boyhood" to all that lies on the banks of the *Stour*. They made me a painter (and I am grateful), that is I had often thought of pictures of them before I had ever touched a pencil and your picture is one of the strongest instances I can recollect of it.'

The picture referred to here is almost certainly 'The White Horse', now in the Frick Collection, New York, bought by Fisher in 1819. This was one of the series of 'six-footers' and other large canvases of scenes on the Stour, 'The Hay Wain' among them, sent by Constable to the annual Academy exhibitions from 1817 on, and it was on these works that he pinned his reputation.

Constable's aim was to create what he called in a famous phrase 'a natural painture' – a kind of painting based on such unexceptional, but by Constable deeply loved, scenes that nature itself, trees, leaves, sky, light, water is presented as the subject rather than some dramatic or imagined

effect. And, crucially, this would be achieved without reference to existing pictorial formulas but by direct study of nature.

Constable did, of course, also study the art of the past. Indeed, he had a great love for Claude whose work he knew from the collection of Sir George Beaumont, a great collector, noted amateur artist and an early mentor. It is very important to remember that however close to nature Constable was trying to get, his pictures are, of course, art – they are composed, arranged and organised. His biographer Leslie reports Constable as saying, 'When I sit down to make a sketch from nature the first thing I try to do is *to forget that I have ever seen a picture.*' But, Leslie adds, 'He well knew that in spite of this endeavour his knowledge of pictures had its influence on every touch of his pencil for in speaking of a young artist who boasted that he had never studied the works of others he said, "After all there *is* such a thing as the art".'

When Constable died he left a collection of sixty paintings by old and modern masters, as well as many drawings and about five thousand prints, and copying was for him not just a youthful exercise – he went on doing it all his life. But it was precisely after a visit to Beaumont in 1802, early in his career, that Constable wrote the letter in which he set out what was to be the basis of his approach to painting and in which the term 'a natural painture' occurs:

'I am returned with a deep conviction of the truth of Sir Joshua Reynolds's observation that "there is no easy way of becoming a good painter". It can only be obtained by long contemplation and incessant labour in the executive part . . . for these two years I have been running after pictures and seeking the truth at second hand . . . I am come to a determination to make no idle visits this summer . . . I shall shortly return to Bergholt where I shall make some laborious studies from nature – and I shall endeavour to get a pure and unaffected representation of the scenes that may employ me . . . There is little or nothing in the exhibition [the Academy] worth looking up to – there is room enough for a natural painture.'

Why did Constable think it so important to paint nature for its own sake? Part of the answer can be found in a letter to his wife Maria in which he wrote:

'Every tree seems full of blossom of some kind and the surface of the ground seems quite lovely – every step I take and on whatever object I turn my eye that sublime expression in the Scripture "I am the resurrection and the life" seems verified about me.' And in the draft of the last of his ten lectures on landscape painting given between 1833 and 1836 he says: 'In conclusion I must again repeat the necessity of keeping one's mind alive to that external nature with which we are surrounded, for few there are who seem to be aware of the beauty of the Paradise in which we are placed. We exist but in a landscape and we are the creatures of a landscape.'

These attitudes led him to believe that a pure landscape art such as his could become the vehicle for the kind of elevated feelings which the Academy still believed could only be expressed through history subjects. In a bitterly sarcastic letter written after he failed in the Academy election of 1828 at which the history painter William Etty was elected, Constable attacked those Academicians who preferred *'the shaggy posteriors of a satyr* to the *moral feeling of landscape'*. The reference is probably to the mythological painting by Etty of two satyrs bending over a naked nymph shown at the 1828 Academy. This painting is a very good example of the degraded stage to which, in Constable's view, official art had sunk; it was accepted purely on grounds of its subject which automatically made it 'high art' however mediocre the treatment.

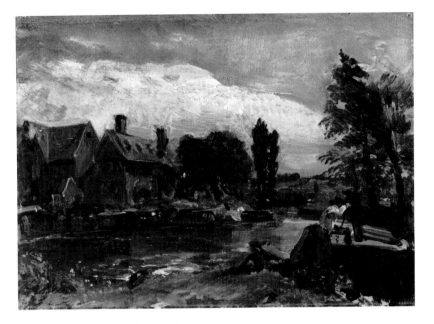

John Constable
Flatford Mill from the Lock, c.1810–11
Oil on canvas laid on board,
6 x 8¼ in/15.2 x 21 cm
Private collection

Constable perceived that the traditional forms and subjects of high art were by his day beginning to be exhausted and he sought to bring about a renewal of art by going to its 'PRIMITIVE SOURCE, NATURE' which will add to art 'qualities...unknown to it before'. Constable did produce an art with qualities 'unknown before' and he did bring about a renewal: his art marks the beginning of a radically new approach to painting which was eventually to lead to modern art.

Constable's evolution as a painter was a long and slow one. At the age of seventeen his father took him into the family milling business, but Constable spent much of his spare time painting with John Dunthorne, the village plumber and a keen amateur artist. In 1795 he was introduced to Sir George Beaumont, who, says Leslie, 'expressed himself pleased' with some drawings he was shown. Beaumont's encouragement and the access Constable had to his collection was crucial at this stage and Constable pursued his art vigorously, forming his first friendship with a professional artist, J. T. Smith, in 1796 and buying books on art. Eventually in 1799 his father consented to him studying full time. Constable was admitted to the Royal Academy Schools and for the next decade and a half divided his time between London and East Bergholt, where from 1802 he kept a small studio, until he settled permanently in London on his marriage in 1816.

For three years from 1799 Constable absorbed all he could learn from an academic training and from the art of the past: we hear of him making copies of Wilson, Ruysdael and, at the Beaumonts where he spent a good deal of time at this period, of Claude. He was, of course, well aware of his Suffolk precursor, Gainsborough, too. Then in 1802 came the letter to John Dunthorne in which he renounced the study of art, 'the truth at second hand', in favour of 'laborious studies from nature'. From this time Constable's career can be seen in a simplified way, in terms first of the development of his practice of sketching in oils in the open air, direct from nature, then of his incorporation of what he learned from this into small or medium sized 'finished' oils done in the studio, that he would exhibit, and finally of the translation of the naturalism he had achieved onto the scale of his grand 'six-foot' Academy exhibition pictures, 'The Hay Wain' and the rest.

The letter to Dunthorne was written in May 1802. In June he returned to East Bergholt and began his 'studies from nature'. Among the surviving oil

sketches he then made are ones dated July, September and October. Two of these are views of Dedham Vale and one is of Willy Lott's cottage (actually a farmhouse and called by Constable the Valley Farm) at the back of Flatford Mill, which were to be recurring and important motifs in Constable's art. These sketches have great freshness, particularly of light and colour, but they also still have a very composed or confected feel about them. Indeed the marvellous Dedham Vale sketch of September 1802 has long been recognised as being based compositionally on Sir George Beaumont's famous Claude, 'Hagar and the Angel' now in the National Gallery, and two other sketches in the Victoria and Albert Museum, possibly also of Dedham Vale, have strong echoes of early Gainsborough, the Gainsborough of 'Cornard Wood' and the Tate Gallery's picture by him of Dedham.

Constable's progress over the next few years seems to have been rather erratic but he continued to develop his sketching and between roughly 1809 and 1812 he produced the now celebrated group of oil studies of Suffolk scenes in which his full mastery of the technique is generally held to be first apparent. These studies, of which 'Flatford Mill from the Lock' is one of the finest, are quite different from the earlier ones. The composed, rather deliberate look has gone and they are less detailed; much is left out in order to record certain essentials of a scene – the quality of light, the structure of the sky, the tonal relationships of the different elements, the shape of a clump of trees and its precise configuration against the sky. Again in contrast with the relatively straightforward handling of the earlier works, these things are captured in vital dabs and whorls and scoops of paint which visibly convey the excitement and tension of the artist confronting and grappling with, more directly than ever before, the raw material of his art. In this respect these sketches look forward to the rich and complex facture of his mature works. There are a number of other sketches of more or less the same view as the 'Flatford Mill' reproduced on page 83, and Constable seems often to have worked in series in order fully to explore and grasp a particular motif.

In 1811 Constable sent to the Royal Academy 'Dedham Vale: Morning', his most substantial exhibited work to date (31 x 51 in, 78.7 x 129.5 cm), a picture to which he evidently attached great importance. David Lucas, his engraver, recorded that Constable 'often told me this picture cost him more anxiety than any work of his before or since that period ... that he had even said his prayers in front of it'. In it Constable is still only partially translating the immediate impressions of the studies into the finished work – the composition has a very classical look and in fact one of the sketches relating to it reveals that the balancing tree on the left is an addition. However, over the next few years he was able to achieve much more direct results in his exhibition pictures, if on a somewhat smaller scale, as in the 'Landscape: Ploughing Scene in Suffolk' he sent to the Academy in 1814 and 'The Millstream', a view of Willy Lott's cottage of the same year which was probably not actually exhibited. His art finally reached its first naturalistic flowering in 1815 in a pair of medium-size exhibition pictures, 'Boat Building', and the 'View of Dedham' which is now in the Museum of Fine Arts in Boston. New in these paintings in relation to earlier finished pictures is an apparent artlessness of composition and particularly an enhanced clarity and sparkle of light and freshness of colour. There is also fairly firm evidence in the case of 'Boat Building' and some evidence in the case of 'Dedham' that they were, partly at least, painted out of doors. There is only one other finished picture, the Hampstead Heath view of 1820 in the Tate Gallery, which bears evidence of being done in the open and it would seem that in order to make his final breakthrough in 1815 Constable simply

John Constable
Landscape: Ploughing Scene in Suffolk (A Summerland), exh. 1814
Oil on canvas,
20¼ x 30¼ in / 51.4 x 76.8 cm
Private collection

John Constable
Boat Building, exh. 1815
Oil on canvas,
20 x 24¼ in / 50.8 x 61.6 cm
Victoria and Albert Museum, London

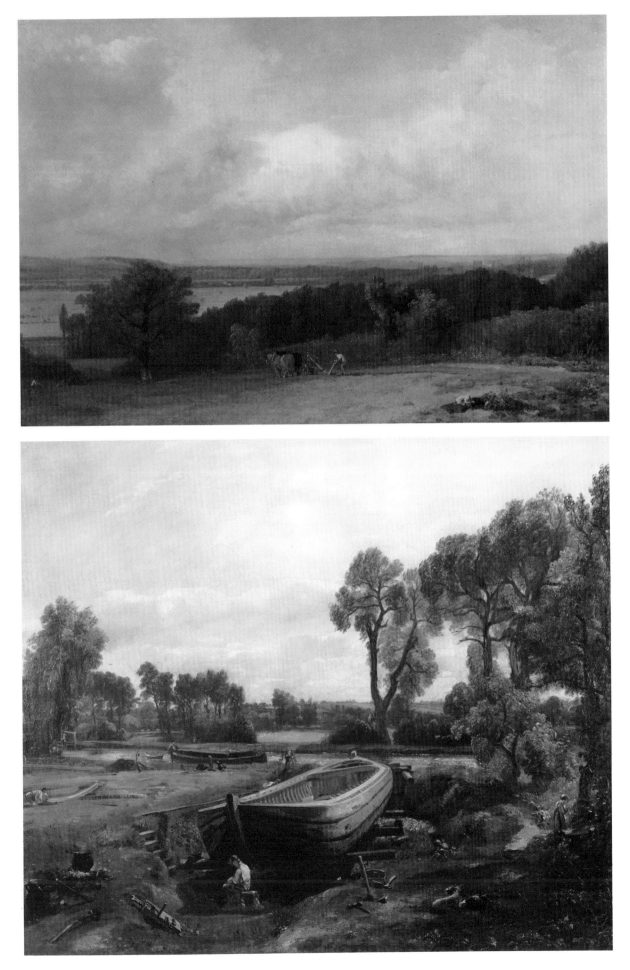

needed this experience. Certainly, after that time he was able to recreate the open-air effect with total conviction in the studio: 'Boat Building' is indistinguishable in this respect from the similar-sized 'Flatford Mill' of 1820 which normally hangs beside it in the Victoria and Albert Museum and which is a studio work.

Constable was now poised to extend the new naturalism of 'Boat Building' and 'View of Dedham' onto a much larger scale. In 1817 he exhibited his largest work to date, the 40 x 50 inch (101.6 x 127 cm) 'Scene on a Navigable River' (Flatford Mill), and finally at the 1819 Academy exhibition unveiled his first six-foot canvas, the first of six large river scenes, 'A Scene on the River Stour' which was bought by his friend Fisher for a hundred guineas and promptly christened 'The White Horse', the name it has gone under ever since. He followed this in 1820 by 'Landscape' (Stratford Mill) and in 1821 'Landscape: Noon' (The Hay Wain). In 1823 he showed 'View on the Stour, near Dedham', in 1824 'A Boat Passing a Lock' (not a six-footer – 56 x 47$\frac{1}{2}$ in, 142.2 x 120.7 cm) and lastly in 1825, 'Landscape' (The Leaping Horse).

It is on these paintings that Constable's fame ultimately rests. In them he has finally fully assimilated the classical tradition into his own simple vision of nature, discarding the form but retaining the essential qualities: order, harmony, grandeur, monumentality. They take their place, as so relatively little British art has ever done, among the outstanding achievements of the European tradition.

Of them 'The Hay Wain' is justly the most famous and can be taken for detailed examination of the ingredients of Constable's mature art.

There are a number of small oil sketches done around 1810–16 showing Willy Lott's cottage from roughly the same angle as in 'The Hay Wain' and a tiny sketch in which the composition is extended to the right to include the opposite bank and meadows, and these may have formed the basis of the full-size sketch done immediately before the large picture in 1820–1, now in the Victoria and Albert Museum. Constable's practice, established for his six-foot canvases, of making a sketch the same size as the finished picture is unique in the history of art and points up the difficulty he had in translating his vision onto a large scale. The sketches vary in their degree of elaboration. The 'Hay Wain' sketch is virtually a monochrome in which no more than the basic elements of the composition and their relationships have been determined.

The intense naturalism of 'The Hay Wain' and pictures like it stems from four sources in particular; the sky, the light, the colour, the handling, all of them dealt with by Constable in an entirely innovatory manner.

There is a letter from Constable to Fisher in which in reply to critical remarks which Fisher had relayed to him about the sky in his 'Stratford Mill' he stresses the overriding importance of the sky in landscape painting:

'That landscape painter who does not make his skies a very material part of his composition neglects to avail himself of one of his greatest aids . . . I have often been advised to consider my sky as "*a white sheet drawn behind the objects*". Certainly if the sky is obtrusive (as mine are) it is bad but if they are *evaded* (as mine are not) it is worse, they must be and always shall with me make an effectual part of the composition. It will be difficult to name a class of landscape in which the sky is not the "*key note*", the "*standard of scale*" and the chief "*organ of sentiment*" . . . The sky is the source of light in nature and governs everything . . .'

At the time he wrote this Constable was in the middle of a campaign of study of skies of an almost scientific thoroughness and intensity. In 1822 he reported to Fisher that he had made 'about 50 careful studies of skies

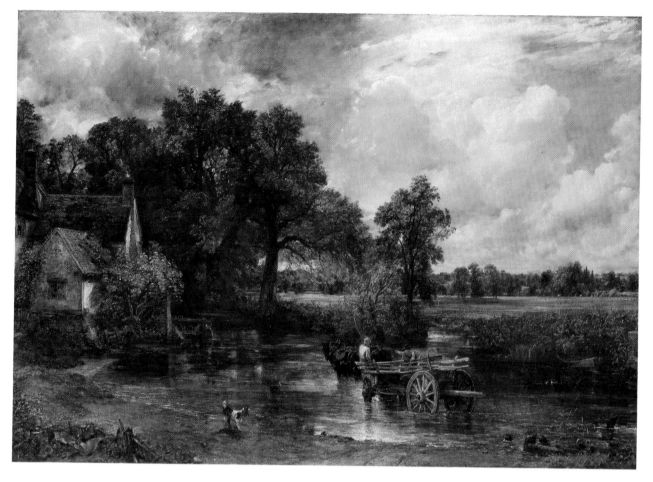

John Constable
The Hay Wain, 1821
Oil on canvas, 51¼ x 73 in/
130.2 x 185.4 cm
National Gallery, London

tolerably large'. The surviving sketches show an enormous range of types of skies and such things as the effects of light or rainbows, and not the least remarkable thing about them are the inscriptions many of them bear, for example: '10 o'clock. Morning looking South East, very brisk wind at West, very bright and fresh grey clouds running very fast over a yellow bed about half way in the sky. Very appropriate for the coast at Osmington.' This reveals the thoroughness of Constable's approach to his sources and it is not surprising to find him saying years later in the lecture he gave at the Royal Institution in 1836, 'Painting is a science, and should be pursued as an enquiry into the laws of nature. Why then may not landscape painting be considered as a branch of natural philosophy of which pictures are but the experiments?'

Light, as Constable remarked, comes from the sky, but the peculiar sparkling quality of light characteristic of his paintings comes from his practice of laying flecks and dabs of pure white paint on the surface to give the impression of light reflecting off moving water or the leaves of trees as they turn in the wind. In 'The Hay Wain' this can be seen particularly well on the water in front of the waggon or on the tree growing against the cottage.

One of the most original aspects of Constable's landscapes is the colour, odd though this statement may seem. The fact is that never before had the green of the English landscape been so vividly rendered in paint. But Constable did not just paint green, he painted the whole range and variety of greens that are present in any given scene. The importance of this was recognised by none other than the great French painter Eugene Delacroix, who deeply admired 'The Hay Wain' when it was shown in Paris at the Salon of 1824 and sought out Constable when he came to England in 1825.

He later recorded in his journal: 'Constable says that the superiority of the green in his meadows comes from it being composed of a multitude of different greens. The lack of intensity and life in the foliage of most landscape painters arises because they usually paint them in a uniform tone.' The 'intensity and life' of Constable's foliage and meadows comes not only from his use of a variety of greens but from his putting them down in separate dabs – in general he built up the whole of his large paintings using short separate 'broken' brushstrokes which convey both a tremendous sense of vitality and, more vividly than ever before, the reality of the constant movement of the elements of landscape and of our shifting fragmentary perception of the external world.

Like many great innovators Constable was understood by very few people in his own time. His contemporaries were baffled by or disliked his subject matter which seemed trivial, his colour which seemed too bright and his paint handling which seemed too rough, and Constable was bitterly aware of it: 'My art flatters nobody by imitation, it courts nobody by smoothness, it tickles nobody by petiteness, it is without either fal de lal or fiddle de dee, how then can I hope to be popular?'

He always had trouble in selling his pictures and many major works were still in his hands at his death. 'The Hay Wain' did not sell at the Academy in 1821 and the first serious offer Constable received for it was in 1823 when a Paris dealer named Arowsmith offered £70 which Constable rejected as it was 'less by over one half than I asked'. A year later Arowsmith approached

John Constable
Salisbury Cathedral, from the Meadows,
1831
Oil on canvas, 59¾ x 74¾ in/
151.8 x 189.9 cm
Private collection

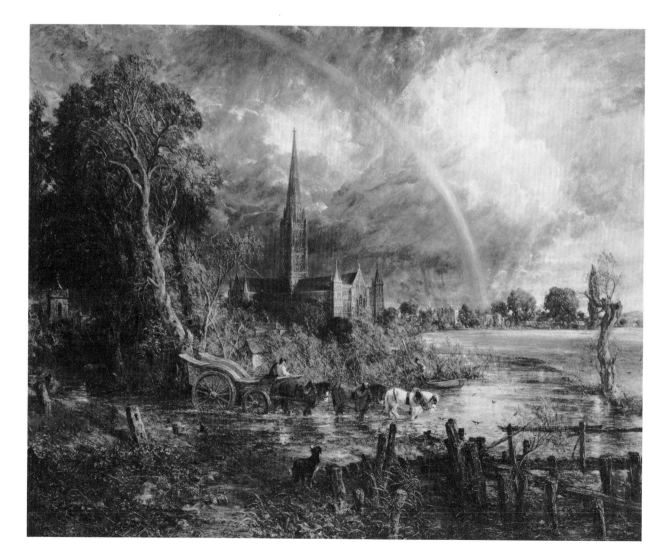

Constable again and this time Constable sold him 'The Hay Wain' together with another six-footer, 'View on the Stour', and a smaller work for £250 the three! The most Constable ever got for a painting was £300, for 'The Valley Farm' of 1815, while by comparison Turner frequently got £500 for a picture. It was subsequent to the sale to Arowsmith that the two large works were shown at the Paris Salon where they created a sensation and Constable was awarded a Gold Medal. His relationship with Arowsmith did not last but Constable did find a more intelligent appreciation in France than he ever did in England, except for a few friends, and there is no doubt that his art forms part of the background to the development of Impressionism.

In March 1828 Constable's father-in-law died and he and Maria were eventually to inherit £20,000. The following February Constable was at last elected a full member of the Royal Academy, by one vote. By a bitter irony of fate, between these two events Maria died of tuberculosis. Constable was devastated: 'Hourly do I feel the loss of my departed Angel . . . I shall never feel again as I have felt, the face of the World is totally changed to me.' This changed view of the world is noticeable in much of Constable's work in the last years of his life in the form of an increased, almost Turner-like awareness of the dynamism of the natural world. While this led in some cases to works which are almost sinister in their turbulence, like the 'Hadleigh Castle' of 1829, it also bore fruit in the form of the grandeur and glory of the storm cloud and rainbow of his last great masterpiece, 'Salisbury Cathedral, from the Meadows' of 1831.

Chapter 12
The Early Victorian Painters of Romantic Fantasy

In his early work Turner had shown how effectively classical landscape painting could be extended and adapted as the vehicle for romantic feeling and for history subjects dealt with in a landscape setting. During Turner's lifetime a number of painters took up this idea of a romantic historical landscape art, pursuing it beyond the bounds of Turner's fundamental naturalism into the realms of pure fantasy. Chief among them was John Martin (1789–1854).

At the same time the basically figurative art of the romantic history painters found a similar extension into fantasy in the work of a number of painters of the early Victorian age. This development found its most extreme form in the painting of fairy subjects, especially those inspired by Shakespeare's *A Midsummer Night's Dream* and can be seen as having its main source in the dream paintings of Henry Fuseli. The two most original

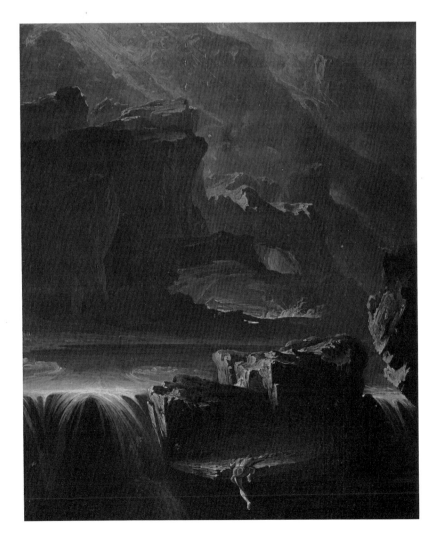

John Martin
Sadak in Search of the Waters of Oblivion,
exh. 1812
Oil on canvas, 30 x 25 in/
76.2 x 63.5 cm
Southampton Art Gallery

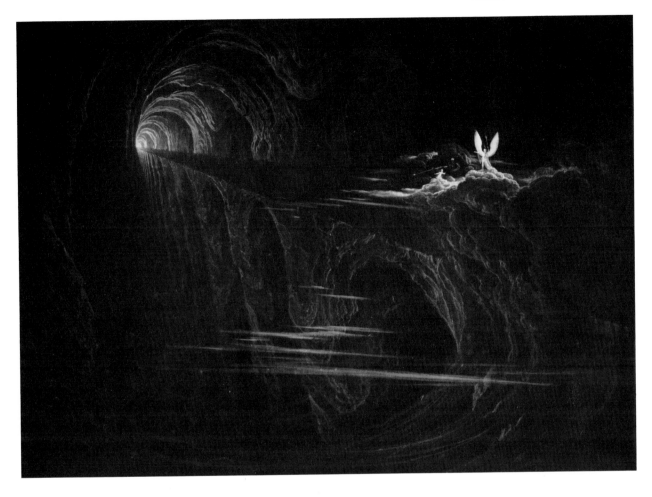

John Martin
Satan bridging Chaos, 1825–7
Mezzotint, $7\frac{1}{2}$ x $10\frac{5}{8}$ in/19 x 27 cm
Private collection

exponents of fairy painting were Richard Dadd (1817–86) and the obscure John Anster Fitzgerald (1819–1906).

John Martin was born near Newcastle-upon-Tyne, the thirteenth son of a man who among other things had been a professional soldier and a publican. However, he encouraged his son's early talent for drawing and John received some training from an Italian drawing master in Newcastle

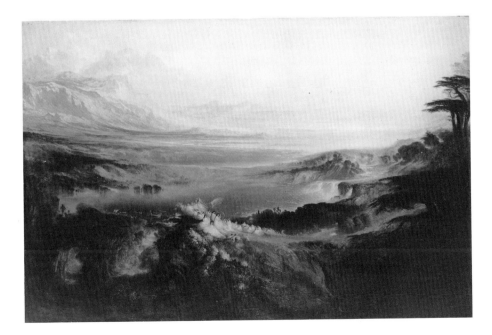

John Martin
The Plains of Heaven, 1851–3
Oil on canvas $78\frac{1}{4}$ x $120\frac{3}{4}$ in/
198.7 x 306.7 cm
Tate Gallery, London

called Musso. It was through Musso's son, Charles Musso, who became a celebrated china painter, that Martin went to London in 1806 and made an early career as a painter on china and glass. In 1811, after a dispute, he left the firm he worked for and decided to become a painter in oils. He burst into sudden and full maturity with his first substantial painting, exhibited at the Royal Academy in 1812, 'Sadak in Search of the Waters of Oblivion'. This is an illustration to one of the *Tales of the Genii*, a book of fairy tales first published in 1762 but, independent of its literary source, the picture stands as one of the great romantic images of man as a lonely, isolated being confronting the awesome grandeur and mystery of the universe, and of human existence as a process of continuous striving which leads only to oblivion. The apocalyptic note of this work, its evocation of doom, destruction and of the end of existence, was to be the chief characteristic of Martin's art from then on and for half a century it struck a strong answering chord in his audiences. Martin achieved fame with paintings of 'Belshazzar's Feast', 'The Destruction of Pompeii', 'The Deluge' and, appropriately enough, right at the end of his life, his last masterpiece, a huge tryptych of 'The Last Judgment', now in the Tate Gallery. Its three canvases, each about 6 x 10 feet (2 x 3 m) depict as a continuous panorama first 'The Plains of Heaven' then 'The Last Judgment' and finally 'The Great Day of His Wrath'.

Martin's popularity stemmed partly from the fact that almost all his major works were made widely available in the form of engravings. Moreover, Martin, a skilled engraver, usually undertook the work himself, using the technique of mezzotint which was particularly suited to his dramatic effects, so that his engraved works, in sharp contrast to the normal commercial reproductions of the day, convey all the spirit of the originals. Among Martin's mezzotints is a set of twenty-four illustrations to Milton's *Paradise Lost* which are not reproductions of finished pictures but were created directly in the print medium. These were published in 1827 both in book form with the text and as separate engravings. As a whole they are his most lasting achievement and contain some of the most extraordinary and original images of English romantic art.

Richard Dadd was trained at the Royal Academy Schools in London from 1837–42. Throughout his life he treated a variety of biblical, historical and mythological subjects, but two of his most striking early works, 'Puck' and 'Titania Sleeping', both of 1841, reveal his particular fascination with the world of fairies and with Shakespeare's *A Midsummer Night's Dream* as a source of inspiration for fairy subjects. They also reveal the stylistic influence of Fuseli. These early works already possess a remarkable imaginative power, but Dadd's art entered a completely new dimension of intensity after he became insane and murdered his father in the autumn of 1843. He was incarcerated for the rest of his life first in the criminal lunatic department of Bethlem Hospital in London and then from 1864 in the newly opened Broadmoor prison. He continued painting in both establishments and by his death in 1886 had produced a large body of work, mostly in watercolour. Among the few oils the two outstanding masterpieces of his maturity are 'Contradiction. Oberon and Titania' of 1854–8, and 'The Fairy Feller's Master-Stroke' of 1855–64, in the Tate Gallery. Both of these works are characterised by an amazing proliferation of fantastic imagery painted in minute detail and both are clearly expressions of deep obsessions that go far beyond any ostensible literary subject. Indeed, although Titania and Oberon and other fairies appear in it, 'The Fairy Feller's Master-Stroke' has little direct connection with Shakespeare's play. It is a purely personal fantasy whose precise

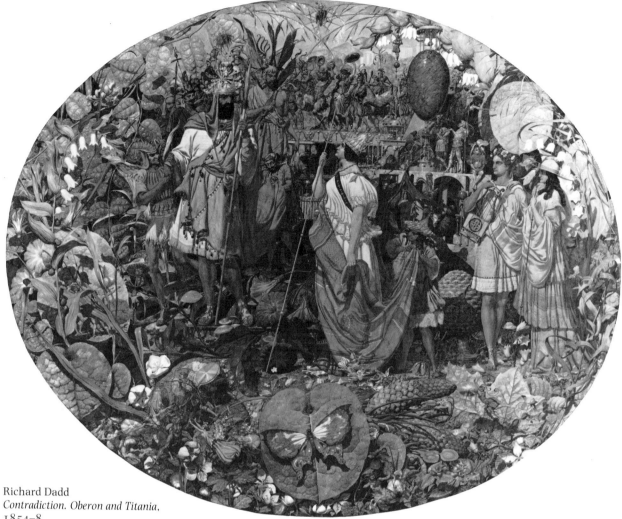

Richard Dadd
Contradiction. Oberon and Titania,
1854–8
Oil on canvas, oval, 24 x 29½ in/
61 x 74.9 cm
Private collection

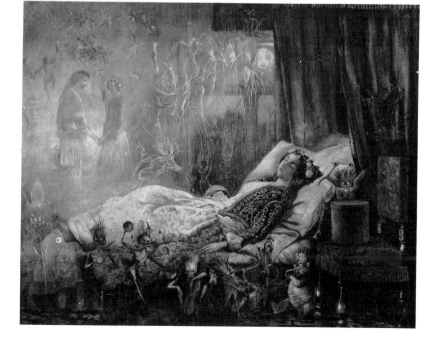

John Anster Fitzgerald
The Stuff that Dreams are Made of
Oil on canvas, 14½ x 18 in/
36.8 x 45.7 cm
Private collection

Richard Dadd
The Fairy Feller's Master-Stroke, 1855–64
Oil on canvas, 21¼ x 15½ in/
54 x 39.4 cm
Tate Gallery, London

significance remains obscure.

Virtually nothing is known of the life and career of John Anster Fitzgerald but he has left a body of paintings, most of them very small, that are perhaps the most convincing and enchanting visual evocations of fairies and the fairy world ever produced. Among them are a number of pictures of sleeping humans surrounded by their dreams. One of these is 'The Stuff that Dreams are Made of' which shows a young girl dreaming of her lover and attended by an extraordinary collection of sprites and fairies.

As with Fuseli, paintings such as this seem particularly original and fascinating now in the light of modern psychology's stress on the importance of dreams and the deep interest in them taken by a whole group of modern artists, the Surrealists.

Chapter 13
The Pre-Raphaelites

Turner and Constable had no real successors in landscape painting. Instead, the next major manifestation of genius in English art came in the field of subject painting and was the creation from 1848 onwards of three young artists, William Holman Hunt (1827–1910), Dante Gabriel Rossetti (1828–82) and John Everett Millais (1829–96) and their associates, friends and followers.

After Blake and Fuseli, subject painting in its never very popular high art form of 'history' had fallen into a condition of mediocrity. At the same time its equally mediocre minor form of 'genre' – everyday life subjects of various kinds – had become immensely popular. The leading exponents of this genre painting were David Wilkie (1785–1841) and Edwin Landseer (1802–93), and Wilkie's 'The First Ear-Ring' of 1835 is a good example both of its relentless triviality of subject matter and its general visual dullness, particularly in its dark tonality and muted colour.

It was to renew and revitalise history painting and to combat the triviality of subject matter of Victorian genre that, in 1848, Hunt, Millais and Rossetti, who had met as students of the Royal Academy Schools, banded themselves together under the name of 'The Pre-Raphaelite Brotherhood', or PRB. There were four other founder members, all relatively minor figures, James Collinson, Thomas Woolner, F. G. Stevens and Rossetti's brother Michael.

The name was chosen to indicate their rejection of the debased tradition of history painting, still upheld at the Academy and its Schools, which was rooted in an uncritical belief in the absolute unimprovability of the art of Raphael and his sixteenth- and seventeenth-century followers. In his autobiography, *Pre-Raphaelitism and the Pre-Raphaelite Brotherhood*, published in 1905, Hunt recounts how, venturing some criticism of Raphael one day in the Academy Schools he was told by a fellow student 'Then you are Pre-Raphaelite,' and continues, 'Referring to this as we worked side by side Millais and I laughingly agreed that the designation must be accepted.' The implication of the name is that they drew inspiration from art before Raphael, both Italian and Northern European, and this they clearly did since their early paintings have many of the visual characteristics of Pre-Renaissance painting – flat clear colours, sharp outlines, overall luminosity and sometimes a certain awkwardness of perspective. How much they actually knew of early art remains, however, largely a matter of speculation. Hunt mentions seeing the Van Eyck 'Arnolfini Marriage' in 1845 shortly after its acquisition by the National Gallery and, more important to the whole group, in 1848 at Millais' house they looked at a book of engravings of the famous fourteenth- and early fifteenth-century frescoes in the Campo Santo in Pisa. One of the qualities they found to admire and emulate in these was simplicity and sincerity of purpose. As Hunt wrote later, 'The innocent spirit which had directed the invention of the painter was traced point after point by each of us with the

Sir David Wilkie
The First Ear-Ring, 1835
Oil on panel, 29¼ x 23¾ in/
74.3 x 60.3 cm
Tate Gallery, London

determination that a kindred simplicity should regulate our own ambition.' Visually, the engravings (which, of course, give no indication of colour) seem to have given the Pre-Raphaelites their early rather angular and strongly linear style of drawing as well as a distinctive way of composing frieze-like arrangements of figures against architectural backgrounds.

But, however much they got from early art, there is no doubt that the single most important factor in their development of an art of sharply defined forms, meticulously painted detail and clear, bright, luminous colour was the doctrine of realism, which was introduced to the group by Hunt and which Hunt in turn found authority for in the writings of John Ruskin. According to his autobiography, Hunt had already formulated critical views on existing art and leanings towards a form of realism when in 1847 he first read part (probably Volume 2) of *Modern Painters*, Ruskin's great book on Turner. It made a considerable impact on him and confirmed him in his opinions: 'To get through the book I sat up most of the night and I had to return it ere I made acquaintance with a quota of the good there was in it. But of all its readers none could have felt more strongly than myself that it was written expressly for him.' In *Modern Painters* Hunt found a vigorous critique of contemporary art combined with the assertion, based on Ruskin's belief in the divinity of the natural world, that good art could only be made by painting nature 'without deviation from one line of the actual truth'. The following passage from Volume 2 of *Modern Painters* is a fine example of the biblical grandeur with which Ruskin expressed these ideas:

'And therefore there is not any greater sign of want of vitality and hopefulness in the schools of the present day than that unhappy prettiness and sameness under which they barter, in their lentil thirst, all the birthright and power of nature: which prettiness cannot but be revolting to any man who has his eyes, even in a measure, open to the divinity of the immortal seal on the common features that he meets in the highways and hedges hourly and momentarily . . .'

Sir John Everett Millais
Christ in the House of his Parents (The Carpenter's Shop), 1849–50
Oil on canvas, 34 x 55 in/
86.4 x 139.7 cm
Tate Gallery, London

It must be stressed that the Pre-Raphaelites considerably adapted Ruskin's ideas to the business of subject painting: in practice Pre-Raphaelite realism meant painting everything from the model or motif as meticulously as possible and trying to recreate the literary, historical or biblical subjects they chose with as much psychological and archaeological accuracy as possible. Later it also meant painting modern-life subjects dealing with contemporary social problems.

In order to capture the full freshness of real light and colour the Pre-Raphaelites adopted the practice, uncommon at the time, of painting over a pure white ground, and they later extended this technique by working on a wet white ground laid freshly over an earlier one immediately before starting work. This gave even greater brilliance and translucency to their colour.

The Brotherhood was formally created in September 1848 and their first pictures were shown the following spring, Hunt's 'Rienzi', an incident from the life of the fourteenth-century Italian revolutionary Cola di Rienzi, and Millais' 'Lorenzo and Isabella', from Keats's poem *Isabella and the Pot of Basil*, at the Royal Academy, while Rossetti, fearing rejection by the Academy, preferred for his 'Girlhood of Mary Virgin' the 'free' exhibition at Hyde Park Corner where space could simply be bought.

There is no doubt that Millais' 'Isabella', now with Hunt's 'Rienzi' in the Walker Art Gallery, Liverpool, is outstanding among the three. Even Hunt admitted this and wrote that 'It is the most wonderful painting that any youth under twenty years of age ever painted.' It is indeed a wonderful painting, luminous, gorgeous in colour and of an intense dramatic realism. The tender glances and gestures of the two lovers, Lorenzo and Isabella, on the right and the furious faces of Isabella's brothers on the left are brilliantly rendered, and the brother's leg extended across the foreground in a vicious kick at Isabella's pet dog is an effect of extraordinary power and originality.

As might be expected, the novelty and the obvious talent of the Pre-Raphaelites' first exhibited paintings attracted immediate critical attention in spite of their extreme youth. The Hyde Park Gallery Exhibition where Rossetti showed opened two weeks before the Academy so it was his 'Girlhood of Mary' that received the first notices. The critic of the influential *Athenaeum* wrote perceptively: 'It is pleasant to turn from the mass of commonplace to a manifestation of true mental power in which art is made the exponent of some high aim.' He spoke of 'a dignified and intellectual purpose', and concluded that 'the great sensibility with which it is wrought inspires the expectation that Mr Rossetti will continue to pursue the lofty career which he has here so successfully begun'. He also noted the reference to early Italian art: 'The sincerity and earnestness of the picture remind us forcibly of the feeling with which the early Florentine monastic painters wrought.'

When the *Athenaeum* came to review Hunt and Millais at the Academy the tone changed a little, possibly because a different critic was writing – praise was now mixed with some irritation at the new style: 'There is so much ability and spirit in two works by men young in age and in fame mixed up with so much that is dead and obsolete in practice that some remark is demanded on a system whose tendency may be hurtful to our growing artists...' None of the critics noticed the mysterious initials 'PRB' on the pictures.

Pre-Raphaelitism was thus launched in an atmosphere of praise mixed with some blame. Rossetti and Millais sold their pictures immediately for good prices, £80 and £150 respectively, and Hunt through his friend the painter Augustus Egg eventually found a buyer for 'Rienzi' at £100.

Sir John Everett Millais
Lorenzo and Isabella, 1849
Oil on canvas, $39\frac{1}{2}$ x 56 in/
100.3 x 142.2 cm
Walker Art Gallery, Liverpool

In 1850, Rossetti showed a sequel to his 'Girlhood of Mary', 'The Annunciation' (both are now in the Tate Gallery), again preferring one of the 'free' exhibitions, this time at the Portland Gallery. At the Academy Millais showed 'Christ in the House of his Parents', and Hunt 'A Converted British Family Sheltering a Christian Priest from the Persecution of Druids', now in the Ashmolean Museum, Oxford.

Again the star painting of the three is the Millais and it is clear that at this time he was not only gifted far in excess of the others in sheer executive ability but arguably in creative and imaginative quality as well. The background of 'Christ in the House of his Parents' was painted in a carpenter's shop in Oxford, every detail perfectly rendered, and even the sheep in the background were painted from two sheep's heads obtained from a butcher. But the most striking example of Pre-Raphaelite realism is in the painting of Joseph the carpenter. Millais used his own father as model for the head but when he came to paint the arms and torso hired a real carpenter in order to get the correct muscle structure that comes from a lifetime of doing particular physical tasks. With his obsessional attention to realism goes, however, a strong imaginative or symbolic element. The boy Christ has cut the palm of his hand on a nail and, holding it up to his mother, a drop of blood has fallen on to his foot, creating a complete set of stigmata and thus referring to his later crucifixion. Behind him a dove symbolises the Holy Spirit and it has been suggested, probably correctly, that the interior of the shop is intended to symbolise a church interior with the bench representing the altar.

The critical reaction to the Pre-Raphaelites' exhibits in their second year was very different from the first. Rossetti's 'Annunciation' was denounced as 'an example of the perversion of talent which has recently been making

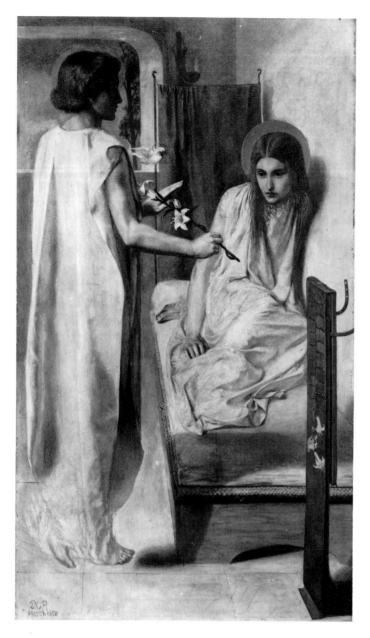

Dante Gabriel Rossetti
Ecce Ancilla Domini (The Annunciation),
1849–50
Oil on canvas, 28½ x 16½ in/
72.4 x 41.9 cm
Tate Gallery, London

so much way in our School of Art' and 'an extraordinary art whim'. Rossetti was so shocked that he vowed never to exhibit in public again. But the full brunt of the hostile critical attack was born by Millais. 'Monstrously perverse' shrieked the *Spectator*, opining too that he must have 'some fatal constitutional disease in his genius'. Thundered *The Times*, 'His picture is plainly revolting' and went on to complain about the association of the Holy Family with 'the meanest details of a carpenter's shop' – an interesting piece of Victorian double-think.

The most extraordinary attack of all came from perhaps the least expected quarter: Charles Dickens, writing in his journal *Household Words*, devoted his review of the Academy exhibition to a comprehensive denunciation of Pre-Raphaelitism in general and, using heavy irony, Millais' picture in particular:

'You come, in this Royal Academy exhibition, to the contemplation of a Holy Family. You will have the goodness to discharge from your minds all Post-Raphael ideas, all religious aspirations, all elevating thoughts, all tender, awful, sorrowful, ennobling, sacred, graceful or beautiful associations, and to prepare yourselves, as befits such a subject – Pre-

Raphaelly considered – for the lowest depths of what is mean, odious, repulsive and revolting.

'You behold the interior of a carpenter's shop. In the foreground of that carpenter's shop is a hideous, wry-necked, blubbering, red-headed boy in a bed-gown who appears to have received a poke in the hand from the stick of another boy with whom he has been playing in an adjacent gutter and to be holding it up for the contemplation of a kneeling woman, so horrible in her ugliness that (supposing it were possible for any human creature to exist for a moment with that dislocated throat) she would stand out from the rest of the company as a monster in the vilest cabaret in France or the lowest gin-shop in England.'

The question arises of why the Pre-Raphaelites aroused such critical fury in 1850. The general answer is that the Brotherhood had originally been founded as a self-consciously revolutionary body, in that year of revolutions, 1848. 'Our talk is deepest treason against our betters,' remarked Hunt at the time, and he also wrote, 'The name of our Body was meant to keep in our minds our determination ever to do battle against the volatile [that is, insubstantial, transient] art of the day.' By 1850 the existence of the Brotherhood, hitherto kept a secret, had been publicised in the press and the Victorian art establishment was outraged to find a revolt on its hands, by young men hardly out of their teens which was bad enough and who, perhaps even worse, adopted a tone of high moral reproof towards the art of their elders. However, the most specific cause for complaint, exemplified in Dickens's attack and the remarks of *The Times*, was undoubtedly the Pre-Raphaelites' realism which, like the contemporary realism of Courbet in France, offered an uncomfortable challenge to the existing prevailing notion that art should present an idealised, not a real, view of the world.

In spite of the initial onslaught the Pre-Raphaelites persisted in their endeavour and, in the early months of 1851 they gained several followers, including the major figure of Ford Madox Brown, who had earlier briefly been Rossetti's teacher, and two influential defenders. Pre-Raphaelitism, according to the press 'one of the strangest manias of the day', became a *cause célèbre*.

The first of these defenders was none other than Prince Albert. In 1851 the art critics were for the first time invited to the Royal Academy dinner, traditionally held on the Saturday before the opening of the Academy Exhibition on the first of May. It can be imagined how complacent they must have felt at the new honour and what a salutary shock they received as they listened to the principal speech of the evening by the Prince Consort: 'The production of all works in art or poetry requires in their conception or execution, not only an exercise of the intellect, skill and patience, but particularly a concurrent warmth of feeling and a free flow of imagination. This renders them most tender plants . . . An unkind word of criticism passes like a cold blast over their tender shoots and shrinks them up . . .' He also spoke pointedly of the vanity of professional writers on art 'who often strive to impress the public with a great idea of their own artistic knowledge, by the merciless manner in which they treat works which cost those who produced them the highest efforts of mind and feeling'.

These splendid words seem to have had little immediate effect, for as soon as the Exhibition opened the PRB was subjected to a positive barrage of abuse, and at this point the second Pre-Raphaelite defender, John Ruskin, stepped into the lists. Ruskin was then thirty-two and already a writer on art of immense influence. The plight of the young artists whose inspiration came partly from his own work was drawn to Ruskin's attention by the poet

Coventry Patmore, a friend of Hunt. Ruskin wrote two letters to *The Times*, one of the most hysterical denunciators of the PRB, in the second of which (30 May 1851) he concluded, 'And so I wish them all, heartily, good-speed, believing, in sincerity, that if they temper the courage and energy which they have shown in the adoption of their system with patience and discretion in framing it, and if they do not suffer themselves to be driven by harsh or careless criticism into rejection of the ordinary means of obtaining influence over the minds of others, they may, as they gain experience, lay in our England the foundations of a School of Art nobler than the world has seen for three hundred years.'

Although, inevitably, criticism was to continue, there is no doubt that Ruskin's letters mark a watershed in the fortunes of the Pre-Raphaelites and the initiative seized was thrust home when, at the next Academy Exhibition, in 1852, Millais and Hunt showed two outstanding masterpieces, Hunt's 'The Hireling Shepherd' and Millais' 'Ophelia', paintings which mark the full dazzling maturity of Pre-Raphaelite art.

In 'Ophelia' the starkness, coolness and clarity and the devotional subject matter of 'Christ in the House of his Parents' has been succeeded by jewel-like richness and depth of colour and high romantic subject matter – the suicide of a beautiful virgin – shot through with delicate undertones of eroticism. Every detail of 'Ophelia' was painted from the motif (the model was Elizabeth Siddal, later Rossetti's wife) yet the final effect is haunting, mysterious, dream-like, hallucinatory.

Hunt's 'Hireling Shepherd' is an example of one of the most important categories of Pre-Raphaelite subject: the real-life subject dealing with some moral, social or ethical problem or illustrating and commenting on contemporary society. All the Pre-Raphaelites and many of their friends and followers produced pictures of this kind at one time or another.

Sir John Everett Millais
Ophelia, 1852
Oil on canvas, 30 x 44 in/
76.2 x 111.8 cm
Tate Gallery, London

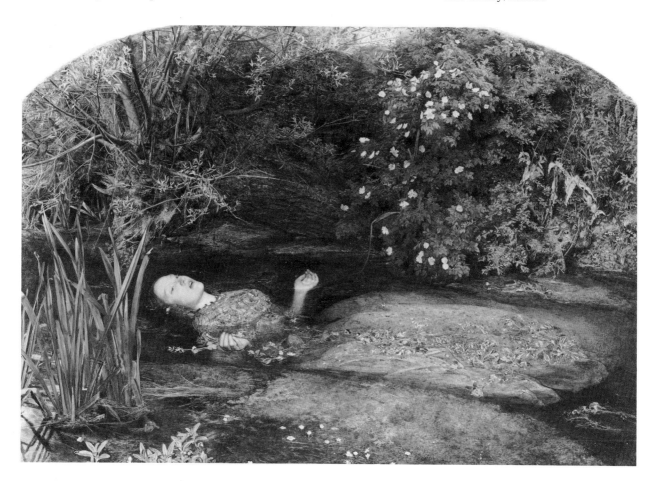

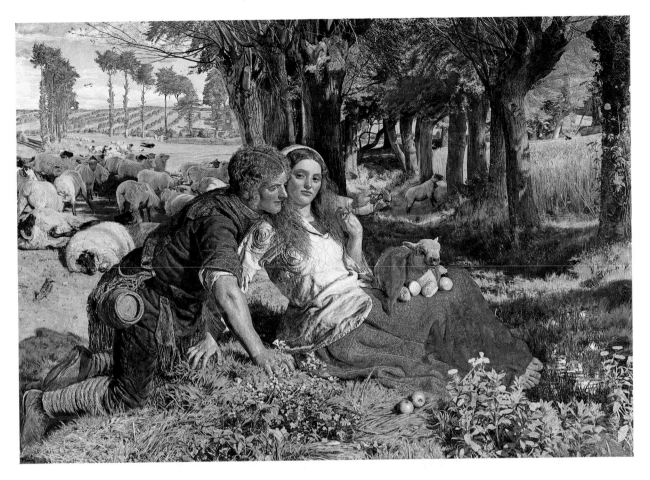

William Holman Hunt
The Hireling Shepherd, 1851
Oil on canvas, 30⅛ x 43⅛ in/
76.5 x 109.5 cm
City Art Gallery, Manchester

Again, everything is painted from life and Hunt recorded that he used the 'wet white' technique for the flower blossom, draperies and flesh. Certainly it is a work of astonishing luminosity and brilliance of colour, something which, together with its extreme realism, was much commented on by the critics. The background was painted at Ewell in Surrey at the same time and place as Millais did the background for 'Ophelia'. The model for the shepherdess was one Emma Watkins, a field hand on a nearby estate and probably Hunt's mistress for a time. The basic message of the picture is that the amorous dalliance of the shepherd has led to the escape of his flock into the corn, and Hunt pointed this up by a quotation from Shakespeare's *King Lear* in the Academy catalogue, 'Sleepest or wakest thou, jolly shepherd? Thy sheep be in the corn.' However, the meaning is more complex than just that. Close examination reveals that the moth being used by the shepherd as an excuse to get close to the girl is a death's head moth, a brutal reminder, at this moment of intense life, of mortality, of the inevitable human life cycle of love, birth and death. The picture, perhaps, is also a statement of the power of erotic feeling temporarily to block out all other considerations, and more generally it is one of the most vivid images in art of the preliminary stages of human sexuality. Hunt himself stated that he had intended the shepherd to represent a type of priest who neglects his congregation to discuss obscure theological points – a reference to contemporary religious controversy whose relevance is now largely lost. Hunt gave that explanation when the painting was acquired by Manchester City Art Gallery in 1897 but, he added, 'My first object as an artist was to paint, not Dresden china *bergers*, but a real shepherd and a real shepherdess and a landscape in full sunlight with all the colour of luscious summer,' and in this object he undoubtedly succeeded supremely well.

It was Ford Madox Brown (1821–93) who became the most consistent practitioner of the Pre-Raphaelite contemporary life subject and who produced the two undoubted masterpieces of this genre, 'Work' of 1852–65 now in Manchester City Art Gallery and 'The Last of England' of 1855. Of the two 'Work' is certainly the most ambitious in its programme to symbolise work in all its forms and thus encapsulate in one picture the whole social structure. However, as almost all commentators on Brown have remarked, it is an unsatisfactory painting in its cluttered composition and rather dry intellectuality. 'The Last of England' on the other hand, with its simple group in a circular format and poignant evocation of the feelings of a young emigrant couple as they take their last look at England, is much more successful both aesthetically and in its direct emotional appeal.

From about 1853 the Pre-Raphaelite Brotherhood lost cohesion as a group, the most decisive move being that of Hunt in January 1854 to the Holy Land, the only place, he reasoned, with relentless Pre-Raphaelite logic,

Ford Madox Brown
The Last of England, 1855
Panel, $32\frac{1}{2}$ x $29\frac{1}{2}$ in/82.6 x 74.9 cm
City Museum and Art Gallery,
Birmingham

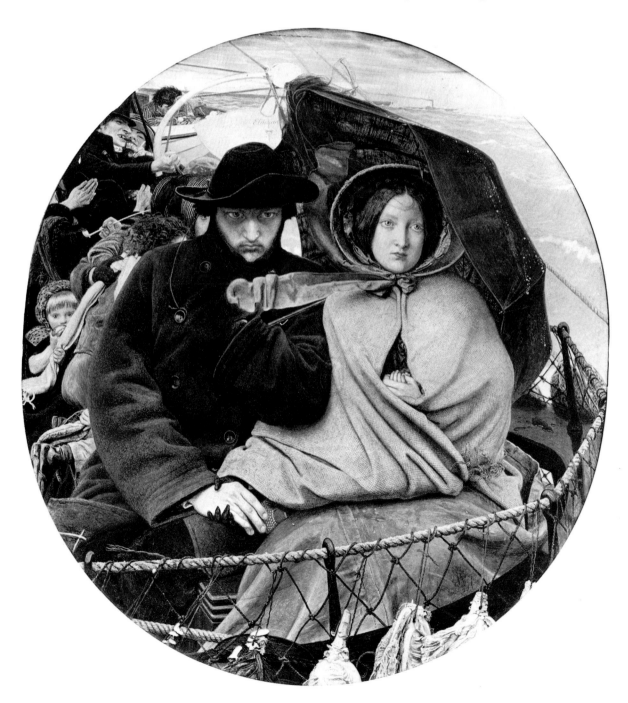

where he could paint truly authentic biblical pictures.

But although the original Brotherhood broke up, its influence rapidly spread and grew, to provide the most vital current in British art in the second half of the nineteenth century until the arrival of Impressionism. Setting out to revolutionise British art, the Pre-Raphaelites succeeded beyond their wildest dreams. Ruskin's prophecy that they would found 'a School of Art nobler than the world has seen for three hundred years' needs only the substitution of 'Britian' for 'the world' to be in essence true.

Chapter 14
Rossetti, Burne-Jones, Symbolist and Aesthetic Painting

After the break-up of the Pre-Raphaelite Brotherhood in 1854 its members went their separate ways. Of the founders, Hunt and Millais continued to pursue the original ideals of Pre-Raphaelite painting, Hunt more or less for the rest of his life, Millais only until about 1860 when he lost or abandoned his inspiration and began to turn out the sort of insipid and visually dull sentimentalities that the Brotherhood had been founded to combat. He became enormously successful and in the last year of his life was elected President of the Royal Academy. Rossetti, however, through the later 1850s and in the 1860s moved rapidly away from the Pre-Raphaelitism of his two colleagues to create a personal and individual art. Essentially, he dropped all pretence of concern for realism together with the sharp focus, high-precision technique and clarity of light and colour of early Pre-Raphaelite painting. Instead he became increasingly concerned with the expression of his own private obsessions in a style both softer and of a sombre richness.

Initially in the 1850s these obsessions revolved around the medieval fantasy world of the Arthurian legends, which Rossetti adored and read in the fifteenth-century English version by Sir Thomas Malory, *Morte d'Arthur*, and around that other medieval visionary world of the thirteenth-century Italian poet Dante, after whom Rossetti's father had named his son. Later, in the 1860s and 70s, Rossetti turned even further back in time to the ancient world and particularly to the realms of pagan mythology. This mythology he used not primarily for its own sake, but as a framework for the expression of his true obsession at this period which was an erotic one: his work from about 1865 consists of a succession of idealised portraits of beautiful

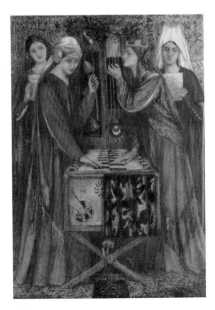

Dante Gabriel Rossetti
The Blue Closet, 1857
Watercolour, 13½ x 9¾ in/
34.3 x 24.8 cm
Tate Gallery, London

women, most of whom were his mistresses, in various mythological guises.

Rossetti had, as he promised, given up exhibiting in public after the attacks on 'The Annunciation' in 1850. He also gave up painting in oils for about the next ten years and his 'medieval' work of the 1850s is exclusively in watercolour, a medium in which he developed a highly personal and original technique, building up the pigment on the paper to achieve rich, softly glowing effects of colour. The crowded compositions, flattened spaces and deliberate colour harmonies of these works create a dense decorative effect which Rossetti further enhanced by the flat, simple, Japanese-inspired frames he designed for them so that frame and picture became a unified pictorial whole. One of the best is 'The Blue Closet' of 1857, depicting two Arthurian queens and their attendants playing a clavichord and singing in a room lined with blue tiles. As with much of Rossetti's later work, there is

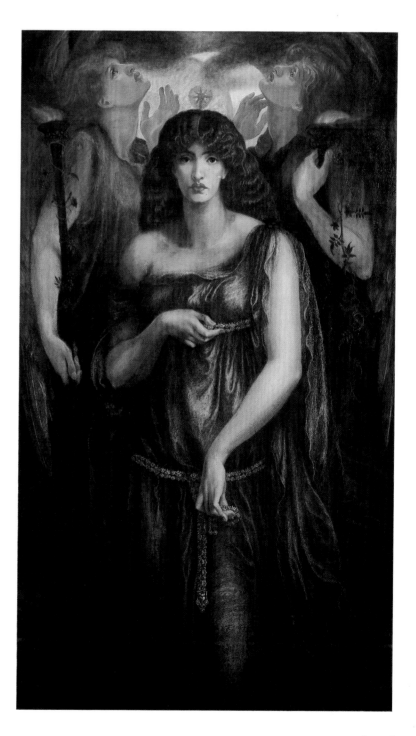

Dante Gabriel Rossetti
Astarte Syriaca, 1877
Oil on canvas, 72⅞ x 43 in/
185.1 x 109.2 cm
City Art Gallery, Manchester

no real narrative content in this picture, it simply evokes a mood, dreamy, poetic and other-worldly, and is decorative. In these respects it represents a concept of art now generally known as Symbolism that was to become widespread in the second half of the nineteenth century as an alternative to Realism and the Impressionist movement which developed out of it. Impressionism did not begin to make a real impact in Britain until the late 1880s and until then, and indeed up to the mid 1890s, Symbolism in one form or another predominated, having its last great manifestation in the art of Aubrey Beardsley who died in 1898. Rossetti, it is now apparent, was one of the founders of the Symbolist tradition both in his watercolours of the 1850s and perhaps more particularly in the later oil paintings of mythological women.

The atmosphere of the watercolours is generally delicate and spiritual but the oils often possess an intensive brooding sensuality. The masterpiece among them and one of the great eccentric masterpieces of British painting is the extraordinary 'Astarte Syriaca' of 1877. Astarte was the ancient Syrian goddess of love, precursor, according to Rossetti, of Aphrodite and Venus, and this picture with its single main figure staring enigmatically out, and its symmetry and flatness, does have an overtly iconic character; it is a pagan religious image. The oppressive atmosphere is reinforced by the colours, strange sea-greens, dark blood-reds and almost iridescent greeny-blues, and the slow, heavy, sinuous rhythms of the drapery. But the single most important source of the picture's disturbing power is the face and body of the goddess herself. Undoubtedly this is because she is in fact an idealised and transmuted image of a real woman loved by Rossetti, Jane Morris, wife of his friend and follower William Morris. They were never able to declare their love, but he painted her repeatedly, and in many of these paintings, but perhaps most of all in 'Astarte Syriaca', he has charged her image with all his frustrated longings.

In 1856 Rossetti acquired two followers. One of these was William Morris and the other was Edward Burne-Jones. Both had been students together at Oxford and both, starting by studying for the priesthood, had become increasingly drawn to imaginative literature, to architecture and to art. A crucial turning point for both of them came when they discovered the Pre-Raphaelites, and particularly Rossetti. In 1855 they visited the Oxford collector Thomas Coombe among whose Pre-Raphaelite pictures they found Rossetti's watercolour 'Dante Drawing an Angel'. This, Burne-Jones later wrote, filled him and Morris with 'the greatest wonder and delight...at once he seemed to us the chief figure in the Pre-Raphaelite Brotherhood'. That summer they toured the cathedrals of northern France and visited the Louvre where by coincidence there was an exhibition of Pre-Raphaelite painting. On the way back Burne-Jones decided to become a painter: 'the most memorable night of my life'. That autumn his interest in Rossetti crystallised when he came across his illustration 'The Maids of Elfinmere' in a book of poems by William Allingham: 'It is the most beautiful drawing I have ever seen...such as only a great artist could conceive.' After meeting Rossetti in January 1856 he left Oxford in May and settled in London under Rossetti's supervision.

Morris meanwhile had decided to become an architect and apprenticed himself to the Oxford-based G. E. Street. He soon realised he had no talent for architecture and moved to London to join Burne-Jones in Rossetti's old studio in Red Lion Square with the intention of becoming a painter. This too he had no real gift for (his only easel painting is in the Tate Gallery) and he turned finally to the arts of design in which he proved to be possessed of genius. The story of Morris's remarkable career and achievements lies

outside the scope of this book, but he represents a whole dimension of Pre-Raphaelite influence beyond the narrow field of pictorial art. It should be emphasised that with the foundation of his firm, Morris, Marshall, Faulkner and Company, of which Rossetti, Ford Madox Brown and Burne-Jones were also members, he initiated a revolution in design which spread rapidly in Britain under the name of the Arts and Crafts Movement and by the end of the century had developed into an international phenomenon now generally known as Art Nouveau from which in turn emerged the Modern style in architecture and design.

Not surprisingly, the early work of Burne-Jones strongly reflects the influence of Rossetti's watercolours in both style and subject matter. But in the 1860s, when Rossetti began his paintings of women, Burne-Jones began to evolve a more personal style, lighter, more deliberately decorative than Rossetti and retaining a delicately ethereal atmosphere in contrast to the increasing sensuality of Rossetti.

His art came to its full maturity in the 1870s after two visits to Italy made in 1871 and 1873, and he created a sensation with the eight paintings he showed at the opening in 1877 of the famous Grosvenor Gallery, which subsequently became the major showplace for artists whose work was too unconventional for the Royal Academy or who did not wish to be associated with it. These paintings and all Burne-Jones's later work fall roughly into two categories, enormously rich, sumptuous and romantic pictures of which 'Laus Veneris' ('In Praise of Venus') of 1878 is perhaps the greatest, and cool classicising pictures among which 'The Golden Stairs' of 1880 is outstanding. Both these kinds of painting are, however, the outcome of a single overriding idea of what a painting should be, encapsulated in Burne-Jones's much quoted statement, 'I mean by a picture a beautiful romantic dream of something that never was, never will be – in a light better than any that ever shone – in a land no one can define or remember, only desire – and the forms divinely beautiful.' This idea stems in turn from an attitude fundamental to the Symbolist stream in late nineteenth-century art, a positive rejection of the modern urban, industrial and commercial world, becoming increasingly obtrusive to artists at that time because of its ugliness and ruthless materialism. In the case of Burne-Jones this attitude was already clearly formed in his Oxford days when he and Morris proposed to form, as Hunt, Rossetti and Millais had before them, a Brotherhood. Inspired by the *Morte d'Arthur*, which Burne-Jones discovered in 1855 and which was to remain the most important single source of his imagery, the Brotherhood was to be called the Order of Sir Galahad. Its aim, Burne-Jones wrote, was to make a 'Crusade and Holy Warfare against the age ... the heartless coldness of the times'. This led on one hand to the evocation of strange and remote worlds as in 'Laus Veneris', where the ancient goddess Venus is placed in an Arthurian setting, and on the other to the creation of an art increasingly purely decorative or aesthetic like 'The Golden Stairs', whose title has no meaning beyond the simply descriptive. It is, in the phrase which became popular at the time, 'Art for art's sake.' In both cases the central motif remains the image of woman. In the decorative works she is spiritualised to represent a pure and ideal beauty, but in the romantic work there is a definite undercurrent of eroticism and beyond the medievalism and mythology these pictures, like Rossetti's, represent the turning away from material reality to the much more potent internal reality of the artist's erotic fantasies.

As well as belonging to the broad European current of Symbolism the art of Rossetti and Burne-Jones in the 1870s and 80s is now seen as part of an identifiable phase in art, design and fashion in Britain at that time that

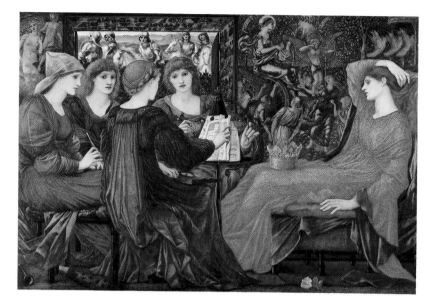

Sir Edward Burne-Jones
Laus Veneris, 1873–5, completed 1878
Oil and tempera on canvas,
48¼ x 72¼ in/
122.6 x 183.5 cm
Laing Art Gallery, Newcastle-upon-Tyne

became known as 'The Aesthetic Movement'. A number of established painters who were essentially later followers of the Royal Academy tradition of history painting were affected by this current, most notably George Frederick Watts (1817–1904) and Frederick Lord Leighton (1830–96), whose Greek mythological picture 'The Garden of the Hesperides', with its compelling mood of hothouse languor evoked by the sensual rhythms of the figures and the extraordinary colour harmony of vivid peach tones, is an outstanding example of high Victorian Academy painting.

Lord Leighton
The Garden of the Hesperides, exh.1892
Oil on canvas, diameter 66 in/167.6 cm
Lady Lever Art Gallery, Port Sunlight

Two other artists, independent of the Academy, were central to the Aesthetic Movement, Albert Moore (1841–93) and James McNeill Whistler. Moore's use of classical settings links him with artists like Leighton but his pictures have no literary or mythological content. His languid young women simply evoke an atmosphere of delicate, dreamlike eroticism and form the basis of beautifully organised compositions which are above all notable for their colours, exquisite both individually and in their overall harmonies. Whistler was to take the idea of a purely aesthetic painting further even than Moore and will be dealt with in the next chapter.

Albert Moore
A Summer Night, exh.1890
Oil on canvas, 51 x 88½ in/
129.5 x 224.8 cm
Walker Art Gallery, Liverpool

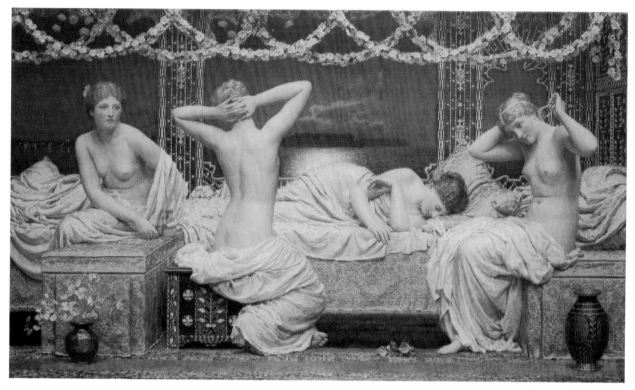

Chapter 15
J.A.M.Whistler

In 1862 the circle around Rossetti was joined by a man who was to become an important and influential artistic figure in Britain in the latter part of the nineteenth century, James Abbott McNeill Whistler (1834–1903).

Whistler was an American by origin who, after a military training at West Point Academy, decided in 1885 to become an artist and went to Europe, first to London and then on to Paris where he remained until 1859. Although he followed a conventional routine in Paris, studying at the Académie Gleyre and copying in the Louvre, he was drawn to the newer influences gaining ground in French art at the time, specifically the Realism of Gustave Courbet whose influence is all-pervasive in Whistler's early work. In 1859 he moved to England and naturally gravitated to the most lively area of British art at the time – Pre-Raphaelitism. He seems to have met Millais first, but it was with Rossetti that he formed a close friendship: as one of his old friends rather resentfully wrote in 1863, 'Jimmy [Whistler] and the Rossetti lot . . . are thick as thieves.'

After his move to England Whistler's painting began to take on an increasingly decorative quality. This can already be seen in the extraordinary almost all-white colour scheme of his famous 'The White Girl' of 1862, which created a sensation and was subjected to a barrage of hostile criticism when it was shown in Paris in 1863 at the Salon des Refusés, the great exhibition of work rejected by the official Salon des Beaux Arts which is generally seen as the first public manifestation of modern art. One critic, however, got the point when, praising the picture, he wrote that it was nothing but 'la symphonie du blanc' – the symphony of white.

Nine years later, in 1872, when Whistler exhibited 'The White Girl' at the *International Exhibition* in London, he changed its title to 'Symphony in White, No. 1'. From this time on he gave all his paintings musical titles. In so doing Whistler became the first painter clearly and consciously to assert in his art one of the most important aesthetic ideas of the second half of the nineteenth century, that painting can be like music in the sense that a painting should be a purely visual object, functioning solely through the relationships of its various elements, without literary or narrative content. Or, as Whistler himself put it, replying to his critics in an article titled 'The Red Rag' in 1878, 'Art should be independent of all clap-trap – should stand alone and appeal to the artistic sense of eye or ear without confounding this with emotions entirely foreign to it . . . that is why I insist on calling my works "arrangements" and "harmonies".' Eventually, in the early twentieth century, this idea was extended to encompass the exclusion of all external references and abstract art, one of the major forms of modern art, was born.

'The White Girl' does have some remnants of anecdotal content (it was thought for example to be an illustration to the novel by Wilkie Collins, *The Woman in White*) but over the next decade Whistler rapidly stripped away any such associations, painting portraits, like the famous portrait of his

J. A. M. Whistler
*The White Girl (Symphony in White,
No.1)*, 1862
Oil on canvas, $84\frac{1}{2}$ x $42\frac{1}{2}$ in/
214.6 x 108 cm
Harris Whittemore collection, National
Art Gallery, Washington

mother exhibited at the Royal Academy in London in 1872 as
'Arrangement in Grey and Black', and figure compositions which were
more and more purely concerned with creating delicate relationships
('harmonies', 'arrangements') of tone and colour. Finally in the early 1870s
he dropped the human figure with its inevitable connotations and began to
paint the works he is most remembered for, the radically simplified dusk and
night views of the Thames in London to which he gave the generic title of
'Nocturnes'. In 'Nocturne in Blue and Gold: Old Battersea Bridge' the blues
are set off by a scattering of carefully placed notes of gold, the excuses for
which are bursting rockets from the old pleasure gardens at Cremorne,
lights on the shore and the single lantern on the barge in the foreground.
The composition is of great daring and originality for its time. Only a single
pillar of the bridge is represented, distorted, flattened and cut off in such a
way as to reduce it to an almost abstract pattern.

For the 'Nocturnes' Whistler began to design his own frames as Rossetti
had done before him and with the same aim – to unify picture and frame
into a single decorative whole. In achieving this Whistler went further than
Rossetti in two ways. First, he positively linked image and frame by
decorating the frame with a simple painted pattern in the dominant tone of
the picture. Then he transformed his signature from word into image – the
famous stylised butterfly – so that it could be fully integrated into the
pictorial structure instead of appearing as an alien element creating what
Whistler would probably have thought of as a 'discord'. In some
'Nocturnes' he even removed the signature altogether from the picture and
placed it on the frame, as in 'Battersea Bridge' where the butterfly appears as
part of the pattern just over half way down the right-hand side.

During the fifteen years or so between Whistler's arrival in England in
1859 and the full flowering of his art in the 'Nocturnes' in the 1870s, the
revolution of Impressionism had taken place in France. This revolution had
of course its origins in precisely those Realist circles around Courbet that

Whistler had frequented in Paris in the 1850s, and before he left France he had already formed a close friendship with Edgar Degas, who was to become one of the major figures in the Impressionist group. Later, in 1865, he met and became a friend of the arch-Impressionist himself, Claude Monet.

Whistler always actively maintained these and other contacts with French art and in the final analysis, although his methods were not those of the Impressionists and although he was formed partly by English influences, Whistler's mature art, with its stress on expression through purely visual and aesthetic means, had more in common with Impressionism, particularly the Impressionism of Monet, than with anything being done in England at the time.

Not only did Whistler create an art which can be seen as the only real counterpart in England in the 1870s of French Impressionism, he was, too, a tireless and vociferous propagandist on behalf of this art and the theories and ideas which lay behind it. In this role he achieved considerable notoriety, especially after the great John Ruskin publicly attacked his work in his review of the first Grosvenor Gallery exhibition where Whistler showed alongside Burne-Jones. Whistler sued for libel and the result was a celebrated court case. A full account of this, together with his 'Ten O'Clock Lecture' and other writings, was published by Whistler in *The Gentle Art of Making Enemies* in 1891.

Both by example and by precept Whistler introduced modern art into Britain and he was the means by which Continental influences were initially transmitted to a younger generation of British artists.

J. A. M. Whistler
*Nocturne in Blue and Gold:
Old Battersea Bridge,* c.1872–5
Oil on canvas, 26¾ x 20 in/
67.9 x 50.8 cm
Tate Gallery, London

Chapter 16
London Impressionists

Philip Wilson Steer
A Summer's Evening, 1887–8
Oil on canvas, $57\frac{1}{2}$ x 90 in/
69.9 x 228.6 cm
Private collection

The influence of modern French art first appeared in Britain in the work of two artists, exact contemporaries, Walter Richard Sickert and Philip Wilson Steer (both 1860–1942). Both were initially strongly influenced by Whistler, Sickert directly as a pupil and studio assistant roughly from 1881–5, Steer indirectly through knowledge of Whistler's exhibited work. Subsequently both came into contact with the French *avant-garde* and learned directly from it. Sickert met Degas in 1883 in Paris and then again much more fruitfully in 1885 in Dieppe, while Steer probably had his formative experience of Impressionist painting in Paris in the summer of 1887 where he would have seen an exhibition of work by Monet, Renoir, Pissarro and Sisley as well as Whistler at the Georges Petit Gallery. There had also been a major exhibition of Impressionists in London in 1883 and four Monets were included in the Academy Winter Exhibition of 1887–8. However, by that time Steer was already painting his first and what was to remain his most important Impressionist work.

Both Sickert and Steer were members, Steer a founder member, Sickert from 1888, of the New English Art Club, an exhibiting society founded in

1886 by a group of artists broadly sympathetic to French art and hostile to the Academy. In fact the NEAC turned out to be on the whole fairly conservative and Sickert and Steer quickly became the leaders of an *avant-garde* faction referred to by Sickert in a letter of 1889 as 'the Impressionist nucleus of the NEAC'. The same year the 'Impressionist nucleus', ten artists altogether, staged their own independent exhibition at the Goupil Gallery under the title *London Impressionists*. Sickert was the chief organiser and wrote an introduction to the catalogue. However, in spite of this early secession by Sickert and Steer – who anyway remained members – the New English Art Club played a central role as an exhibiting society for advanced art in England until as late as 1910.

At this point it should be stressed that the term 'Impressionism' in an English context was, as the contemporary critic D. S. MacColl noted, applied to 'any new painting that surprised or annoyed the critics or public'. The key word is 'new': both Sickert and Steer were innovators in England but of the two only Steer could be called a true Impressionist and then only for a brief period, roughly from 1887–94. During these years he produced a series of pictures, mostly of scenes at the east coast resort of Walberswick, that sparkle with light and colour. Of these the first and greatest is 'A Summer's Evening', shown at the New English Art Club in April 1888. The overall colour composition of this painting is built on the strong contrast of the deep blue sea and the hot orange of the beach and bodies of the girls. Closer to, as Bruce Laughton has noted in his monograph on Steer, it can be seen that Steer has worked 'to gain the luminous effects of Impressionism by the juxtaposition of near-primary colours, particularly on the sandy beach, the bathers' skins and in the long purple shadows. Strokes of blue, pink and subdued orange are thickly overlaid on the sand and the orange becomes more dominant on the girls' bodies. The colour is also broken in the shadows with strokes of crimson and blue.' The total effect is of hot shimmering light and colour which combines with the calm and monumental arrangement of the figures against the empty expanse of beach and sea and the astonishingly ambitious scale to make 'A Summer's Evening' the most powerful and extreme production of the first phase of modern British art.

Sickert's painting developed very differently from that of Steer. In 1889, the year after Steer first exhibited 'A Summer's Evening', Sickert painted 'Minnie Cunningham at the Old Bedford', a picture whose smooth surfaces and delicate, muted tones still reveal the dominating influence of Whistler. However, its subject matter was essentially un-Whistlerian. The 'Old Bedford' was a London music hall, a haunt of low life, which Whistler would have considered far too squalid to be the basis for a painting. Sickert rejected the refinement of Whistler – 'Taste is the death of a painter,' he wrote in 1908 – and embraced the doctrine of French Realism as it had been created by Courbet and developed by Degas. The basis of this doctrine is that the only serious and vital subject for art is not just reality but aspects of reality that have a particularly raw, basic and earthy character, precisely those aspects of reality which in fact in the mid-nineteenth century were not generally considered suitable subjects for art. Sickert himself summed up his attitude when he wrote in 1910, 'The more our art is serious, the more will it tend to avoid the drawing-room and stick to the kitchen. The plastic arts [i.e. painting and sculpture] are gross arts, dealing joyously with gross material facts . . . and while they will flourish in the scullery, or on the dunghill, they fade at a breath from the drawing-room.'

However, it must be emphasised that, paradoxically, although Realist painters attached great importance to a particular kind of subject matter

they attached even more importance to *treatment* – to the rendering of the subject simply as a pattern of form, line, texture, tonal relationships. Again, Sickert himself made this quite clear in the preface to the catalogue of the 1889 *London Impressionists* exhibition where he wrote that his kind of painting 'has no wish to record anything merely because it exists. It is not occupied in a struggle to make intensely real and solid the sordid and superficial details of the subjects it selects. It accepts as the aim of the picture . . . beauty.' Thus in Realist painting 'sordid and superficial' subject matter is treated in such a way as to transform it into a purely pictorial and abstract form of beauty in which, however, enough of the subject remains present to charge the work with vitality and to engage strongly the spectator's attention. In Sickert's case this treatment involved the use of certain compositional devices which tend to give the image an abstract quality: the use of odd viewpoints, the eccentric placing of the subject towards or at the edge of the picture and the abrupt and apparently arbitrary cutting off of the image at the edges so that a human figure for example sliced in half becomes difficult to recognise and functions purely as a shape. But, perhaps even more important than these compositional devices, is the way in which Sickert sees his subjects in terms of patterns of light and shade with very little colour and renders these patterns in rich paint textures which do not imitate the objects but have their own independent character. These qualities are first fully developed in his

Walter Richard Sickert
The Old Bedford, 1895
Oil on canvas, 30 x 23⅞ in/
76.2 x 60.6 cm
Walker Art Gallery, Liverpool

Walter Richard Sickert
Minnie Cunningham at the Old Bedford,
*c.*1889
Oil on canvas, 30¼ x 25½ in/
76.8 x 64.8 cm
Tate Gallery, London

mature music-hall paintings like 'The Gallery at the Old Bedford' of 1894, in which the influence of Whistler is finally shaken off.

Apart from the group around Sickert and Steer one other British artist who responded fruitfully to French influence in the 1880s was the American born John Singer Sargent (1856–1925). Sargent met and became friendly with Claude Monet in France about 1882 and after settling in London in 1885 produced a group of paintings reflecting Impressionist light and colour before adopting a much darker manner for the fashionable portraits for which he became celebrated in the period 1890–1910. The masterpiece of his Impressionist phase is undoubtedly the ravishing 'Carnation, Lily, Lily, Rose' painted entirely out-of-doors in 1885 and 1886.

John Singer Sargent
*Carnation, Lily, Lily, Rose,*1885–6
Oil on canvas, 68½ x 60½ in/
174 x 153.7 cm
Tate Gallery, London

Chapter 17
Aubrey Beardsley

While the influence of French Realism and Impressionism was gaining ground in Britain in the later 1880s and early 1890s one last follower of the imaginative tradition of Rossetti and Burne-Jones appeared. This was Aubrey Vincent Beardsley who, born in 1872 in Brighton and educated at Brighton Grammar School, went to London at the age of sixteen. There, in just under ten years before his death from tuberculosis in 1898, he carved out a short but glittering career and achieved lasting fame.

Beardsley, like Blake, is something of an oddity in the history of British pictorial art in that he was a draughtsman rather than a painter. However, also like Blake, the power of his ideas and the strength and originality of his means transcend the limitations of his 'minor' medium to place him among the very greatest artists. It should be added that unlike Blake he was not neglected. This was partly because of the extremely startling nature of both the style and content of his art—he became notorious rather than famous—and it was partly because new photographic methods of re-production, especially the line block, enabled him both to reach a wide audience and for that audience to receive his work in a form so close to the original as to make no difference. Also, very importantly, Beardsley's short career coincided exactly with a period where there was an enormous upsurge of interest in the arts of design, decoration and illustration. People were inclined to attach equal importance to the expression of genius in both the decorative and the fine arts.

The first major influence on the formation of Beardsley's style was the art of Burne-Jones and when Beardsley first met Burne-Jones in July 1891 the great man also gave him vital encouragement: 'Nature has given you every gift which is necessary to become a great artist. I *seldom* or *never* advise anyone to take up art as a profession but in *your* case *I can do nothing else.*' But, crucially, with the influence of Burne-Jones Beardsley also blended that of Whistler and of Japanese woodcuts by which Whistler himself had been strongly influenced. From this mixture of influences Beardsley soon evolved a unique and totally original style of black-and-white drawing which was both highly illustrative and possessed very strong formal and abstract qualities.

The subject matter of Beardsley's art tends to fall into two distinct categories, one of which represents a continuation of the imaginative literary, mythological and medievalising world of Burne-Jones and Rossetti. But he also looked keenly, with a satirical and almost a caricaturist's eye, at the world around him. In both cases, however, the choice of subject and the actual content of the work reflect certain overriding obsessions of Beardsley's with the fantastic, the bizarre, the grotesque, the macabre, the perverse and the erotic. These concerns are not, of course, uncommon in late nineteenth-century art—in a subdued form they are present in the art of Burne-Jones and, more overtly, in that of Rossetti as well as in the work of the European Symbolist painters. They reflect the Symbolists' disgust with

Aubrey Beardsley
The Woman in the Moon, 1894
Pen and black ink on white paper,
$8\frac{3}{4}$ x $6\frac{1}{2}$ in/22.2 x 16.5 cm
Fogg Art Museum, Harvard University,
Cambridge, Mass.

the gross materialism of Western capitalist society and their desire to attack and undermine the accepted standards of taste, decency and morality of that society in order to expose the reality beneath.

Beardsley was launched on his career by the publisher J. M. Dent who in 1892 commissioned him to illustrate an edition of Malory's *Morte d'Arthur*, the book so beloved of Rossetti and Burne-Jones. This enormous task (20 full-page drawings, 100 small drawings, 350 initial letters and a cover design) took over a year to complete and acted as a forcing house for Beardsley's talent. A rapid stylistic evolution can be traced through the pages of the book. The complete *Morte d'Arthur* is an astonishing work, the greatest illustrated book ever produced by ordinary commercial means, but Beardsley's full maturity as a picturemaker came with his next major commission, to illustrate the English edition of Oscar Wilde's play *Salome*. *Salome* was published in March 1894 and created a sensation, almost wholly on account of Beardsley's drawings which were described by *The Times* as 'fantastic, grotesque, unintelligible for the most part and, so far as they are intelligible, repulsive'. This comment reflects both the content of the drawings and, more significantly in the charge of unintelligibility, the total originality of their style. It is difficult to single out one of the *Salome* drawings but perhaps 'The Woman in the Moon' now in the Fogg Art Museum, Harvard, which illustrates the opening lines of the play,

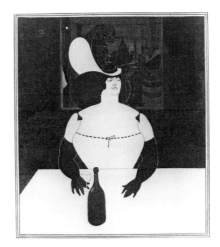

Aubrey Beardsley
The Fat Woman, 1894
Watercolour, 7 x 6⅜ in/17.8 x 16.2 cm
Tate Gallery, London

Aubrey Beardsley
Binding designed by Beardsley for
Morte d'Arthur by Sir Thomas Malory
Published by J. M. Dent 1894
Gold stamped on cloth, 9¾ x 8¼ in/
24.8 x 21 cm
Tate Gallery Library, London

represents most perfectly Beardsley's mature art in which intensely striking figurative images are wholly integrated into, and simultaneously form part of, an equally striking decorative and abstract structure. Beardsley achieved this by eliminating naturalistic backgrounds and by working exclusively in line and in masses of pure black against the white paper so that conventional perspective and modelling of form ceases to exist and the picture reads as a flat pattern. The three-pronged device in the bottom right corner of 'The Woman in the Moon' is the signature which, like Whistler, Beardsley turned into a pictorial device. It is thought to be based on three candles and their flames.

By the time *Salome* was published Beardsley had become the art editor of a new periodical of art and literature called *The Yellow Book*, the first issue of which appeared in April 1894 with a cover design, title page and four drawings by Beardsley. One of the four drawings, 'A Night Piece', now in the Fitzwilliam Museum, Cambridge, showed a prostitute in Leicester Square, and Beardsley's involvement with *The Yellow Book* also marks the beginning of his depiction of modern life subjects. His particular interests led him to take these subjects more or less exclusively from the world of London's night life – the *demi-monde* of theatres, cafés and prostitution. Appropriately enough, his drawings of this type tend to be dominated by black and often, with amazing virtuosity, he creates a form simply by allowing a few white lines to remain in a field of black. One of the finest of them is 'The Fat Woman' in the Tate Gallery, which would have appeared in the first *Yellow Book* if the editor had not noticed that this sinister woman of the night seated alone at her café table (probably in the old Café Royal) bore a strong resemblance to Whistler's wife!

There can be no doubt that Beardsley was the most original and influential artist working in Britain in the last decade of the nineteenth century. While Sickert and the London Impressionists were assimilating influences from abroad, Beardsley's art was being admired and its lessons absorbed by, among others, Charles Rennie Mackintosh and his circle in Glasgow, the artists of the Vienna Secession Group in Austria, the young Picasso in Barcelona and the young Paul Klee in Germany.

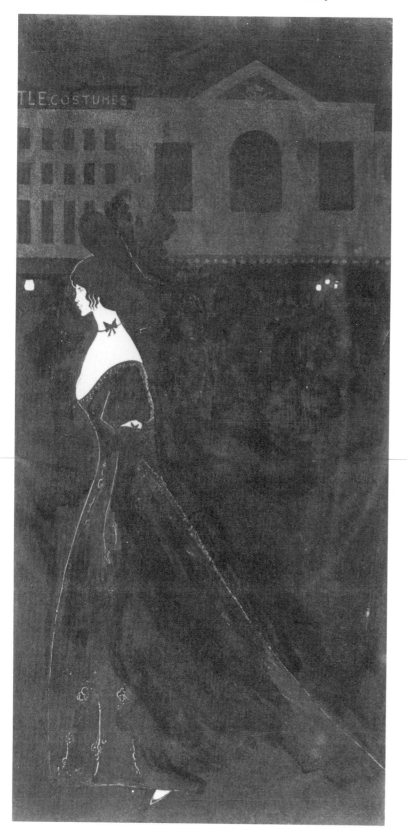

Aubrey Beardsley
A Night Piece, 1894
Pen and brush, black Indian ink,
$12\frac{5}{8} \times 6\frac{1}{8}$ in/32 x 15.5 cm
Fitzwilliam Museum, Cambridge

Chapter 18
The Growth of Modernism

Walter Richard Sickert
*Le Lit de Cuivre, c.*1906
Oil on canvas, 16 x 20 in/
40.6 x 50.8 cm
Private collection

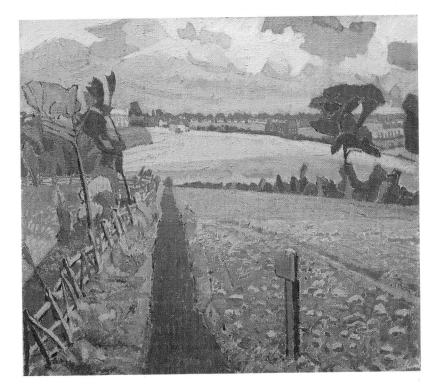

Spencer Gore
The Cinder Path, 1912
Oil on canvas, 27 x 31 in/
65.6 x 78.7 cm
Tate Gallery, London

Beardsley's career seems to have marked a hiatus in the active spread of Impressionist influence in England. There was no further group exhibition of the London Impressionists after 1889 and Wilson Steer, who with Sickert had been the most advanced member of the New English Art Club, reverted, in about 1894, to a much more conventional style of painting.

Sickert apparently felt increasingly isolated. He resigned from the NEAC in 1897 and the following year, according to Wendy Baron, author of the major critical monograph on Sickert, 'He decided that he would no longer tolerate the apathetic insularity which characterised his professional colleagues in Britain' and removed himself to France, to Dieppe where he remained until 1905. On his return to London he once again became active in the propagation of modern art, founding in 1907 the Fitzroy Street Group, an exhibiting society with premises at 19 Fitzroy Street where he also had a studio at number 8. As well as this studio Sickert rented living accommodation at 6 Mornington Crescent in Camden Town, a seedy area to the north of Fitzroy Street where he had had a studio and had painted the interior of the Old Bedford Music Hall in Camden High Street before his departure for France. The area once more became a source of inspiration to him and his work of this period, and by extension that of the Fitzroy Street Group, has become known as Camden Town painting.

Sickert resumed painting music-hall interiors but his most characteristic and most memorable Camden Town paintings are the nudes. These nudes, mostly done around 1906–9, mark the climax of Sickert's development as a painter and among them are to be found some of the outstanding masterpieces of early twentieth-century British painting. They are perfect realisations of the aim of creating a painting which functions as a purely pictorial and aesthetic entity but which is charged with vitality and power by being based on what Sickert called 'a gross material fact'. The material facts of his nudes could hardly be grosser – completely unidealised naked women sprawling in positions of great intimacy and often, thighs spread, of great abandon, on beds in Camden Town lodging-house interiors. The effect of intimacy is often heightened by the placing of the figure close to the picture plane so that it appears very near the spectator. At the same time for Sickert, from the pictorial point of view as he wrote in 1910, '...the chief source of pleasure in the aspect of a nude is that it is in the nature of a gleam – a gleam of light and warmth and life. And that it should appear thus it should be set in surroundings of drapery or other contrasting surfaces.' The paintings precisely reflect this attitude. In them the nudes are treated in terms of the patterns of light and shade created by the highlights of their flesh gleaming amidst the rumpled bedclothes in the dimly lit rooms. And these patterns are rendered in muted but often very beautiful colours wrought into richly encrusted textures that sometimes take on an almost jewel-like quality.

The Fitzroy Street Group was a success and over the years from its foundation it grew and expanded until in 1911 Sickert reconstituted it under the name of the Camden Town Group.

At this point much of the art of the Group naturally reflected the influence of Sickert, especially in choice of subject matter, nudes, interiors, street scenes and so on. But while Sickert retained the darker palette of a Realist many of the Fitzroy Street Group developed much lighter 'Impressionist' palettes along with an interest in colour analysis and an Impressionist handling of paint, the so-called 'broken' touch. This development was primarily the result of the presence in the group of Lucien Pissarro (1863–1944), son of the great French Impressionist, who had settled in London in 1890 but only became active as a painter in about 1904.

Between 1907 and 1911, then, the art of the Fitzroy Street Group can be seen as a brief late flowering of Impressionism in Britain. For most of the Group, however, this Impressionism was a transitional phase: by the time the Camden Town Group was formed they had been overtaken by events not only in France but in London.

In France Impressionism had been followed by Post-Impressionism (from about 1885, Cézanne, Seurat, Van Gogh, Gauguin); Fauvism (from 1905, Matisse and his circle); Cubism (from 1909, Picasso and Braque); and Futurism (from 1909, based on the machine art theories of the Italian poet Marinetti). These were all vital and dynamic movements which continued and expanded the transformation of art that Impressionism had set in train. Although some British artists, Sickert notably but there were others, were well aware at least of Post-Impressionism there is little evidence of this in their art until 1910–11. Then suddenly there was a tremendous process of catching up. There is no doubt that the crucial stimuli in bringing this about were the now celebrated exhibitions of modern French art organised by the critic, art historian and painter Roger Fry (1866–1934). The first of these was *Manet and the Post-Impressionists*, held at the Grafton Galleries in London from November 1910 to January 1911. Besides works by Manet the show included twenty-one Cézannes, thirty-seven Gauguins, twenty Van Goghs and works by Matisse and Picasso, although the Picassos were all pre-Cubist. Then in October 1912 came the *Second Post-Impressionist Exhibition*. This included Cubist works and no less than thirty-four paintings and drawings by Matisse. It also included work by those British artists whose work already revealed the impact of the first exhibition. Earlier in 1912, in March, there had been an *Exhibition of Works by the Italian Futurist Painters* at the Sackville Gallery, so London had now been exposed to the full gamut of Continental modernism.

From this time a vigorous *avant-garde* developed in Britain, reaching a climax in the short period immediately preceding and following the outbreak of the First World War in 1914. By then all the major tendencies were represented and three distinct groupings or factions had emerged. The first of these was of course the Camden Town Group, consisting of artists who had evolved from Impressionism to Post-Impressionism. The second

Left:
Gwen John
Nude Girl
Oil on canvas, 17½ x 11 in/
44.5 x 27.9 cm
Tate Gallery, London

Right:
Vanessa Bell
Abstract, c.1914
Gouache on canvas, 17⅜ x 15¼ in/
44.1 x 38.7 cm
Tate Gallery, London

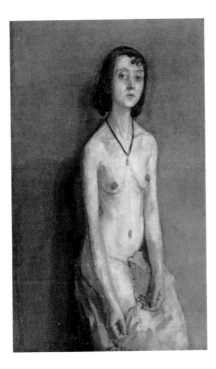

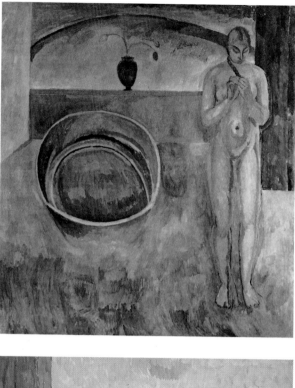

Vanessa Bell
The Tub, 1917
Oil(?) and gouache on canvas.
71 x 65½ in/180.3 x 166.4 cm
Tate Gallery, London

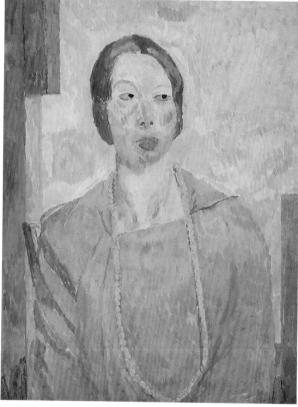

Vanessa Bell
Mrs St. John Hutchinson, 1915
Oil on board. 29 x 22¾ in/73.7 x 57.8 cm
Tate Gallery, London

consisted of Roger Fry and the Bloomsbury painters Duncan Grant
(1885–1978) and Vanessa Bell (1879–1961). Fry naturally embraced
Post-Impressionism but Grant and Bell responded most fruitfully to the in-
fluence of Matisse. They all also assimilated some influence of Cubism and
very briefly practised pure abstraction. An independent figure who also
responded to the Fauvism of Matisse was Matthew Smith (1879–1959).
The third group formed around Wyndham Lewis (1882–1957) and
practised a form of combined Cubism and Futurism which Lewis called
Vorticism. Associated with Vorticism, although not a formal member of the
group, was David Bomberg (1890–1957).

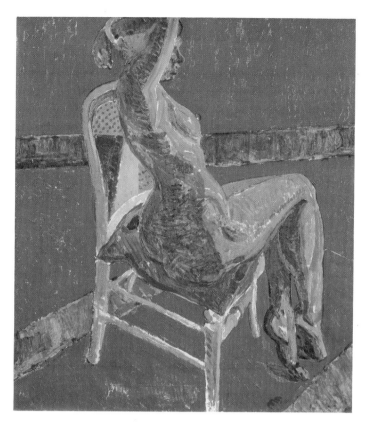

Sir Matthew Smith
Nude, Fitzroy Street, No.1, 1916
Oil on canvas, 34 x 30 in/86.4 x 76.2 cm
Tate Gallery, London

The principal members of the Camden Town Group were Robert Bevan (1865–1925), Spencer Gore (1878–1914), Harold Gilman (1876–1919), Charles Ginner (1878–1952), James Innes (1887–1914) and Augustus John (1878–1961). Around 1912 they all developed personal variations of a kind of painting influenced mainly by Van Gogh and Gauguin but also to some extent by Cézanne. Spencer Gore's 'The Cinder Path' of 1912 is characteristic in its simplified, strongly outlined, flattened forms, each filled with a single strong, luminous colour – sometimes non-naturalistic as in the bright red field in the foreground – so that the picture takes on a highly decorative and abstract quality.

An independent artist who can be associated with the Camden Town painters was Augustus John's gifted sister Gwen (1870–1939) who after training at the Slade School in London settled in Paris in 1898. There she developed a highly personal form of Realism, painting in particular figure studies of women. These are all remarkable for their extreme sensitivity both of observation and execution and some, like the marvellous 'Nude Girl' painted some time before 1911, now in the Tate Gallery, combine this with a powerful emotional force.

Also in this context can be mentioned Sir William Nicholson (1872–1949) who began his long career in the 1890s as a designer and illustrator but developed into a consistent painter of very beautiful, extremely sensitive and luminous still lives and landscapes.

The art of the Bloomsbury Group was extremely rich and varied, the more so since all its members were actively involved in the design firm founded by Fry in 1913, the Omega Workshops, and produced a great deal of striking decorative art, particularly textile designs, screens and murals. However, the story of the Omega (which at one time or another involved practically every leading member of the *avant-garde*), like that of Morris's firm, lies outside the scope of this book.

Primarily influenced by Cézanne, Roger Fry developed a highly

structured art of simplified forms which led him briefly to the brink of total abstraction in works like the painting with collage of 1914, now in the Tate Gallery, which he called 'Essay in Abstract Design'.

Vanessa Bell and Duncan Grant both pursued a number of directions more or less simultaneously. In 1911 Vanessa Bell began to simplify drastically some of her paintings, 'Studland Beach', for example, in the Tate Gallery, and by 1913 was producing abstract paintings and collage characterised by a pure but not clinical geometry and lyrical colour. 'Abstract' of 1914 is one of the few to have survived. At the same time she developed her own form of the Fauvism of Matisse in which, although the motif remains fully recognisable, colour is used with great freedom. Most of these Fauve works are portraits, like the 'Mrs St. John Hutchinson' of 1915 in which the sitter still remains remarkably recognisable through the intense and completely non-naturalistic colour scheme of acid pink, green and yellow. Finally she moved on, as Matisse had done after Fauvism, to a less intensely coloured, calmer, more contemplative, lyrical and decorative painting like the very large and beautiful 'Tub' of 1917.

Duncan Grant was the most individually varied of the Bloomsbury painters. In 1911 he emerged into sudden maturity with the two enormous canvases he painted as mural decorations for the students' dining-room at the Borough Polytechnic in London. One of these in particular, 'Bathing' with its dynamic rhythms, is a work of great power. Over the next few years he worked closely alongside Vanessa Bell, developing the Fauve style, although he also employed a dotted manner (called by Vanessa Bell his leopard manner) derived from Seurat. Then around 1914 he evolved a personal blend of influences from Matisse and Cubism which resulted in a group of lyrical and sensuous abstractions in which still life arrangements or domestic interiors are still just discernible, and at least one substantial completely non-representational painting. He later added figurative elements to this and it is now known as 'The White Jug'. He also produced the extraordinary 'Abstract Kinetic Collage Painting with Sound' in the Tate Gallery, a geometrically abstract work in the form of a scroll about 15 feet (4.5m) long, designed to be viewed moving slowly across a gap in a screen to the accompaniment of music that complements the unfolding rhythms of its forms, colours and textures. This work relates to and in some

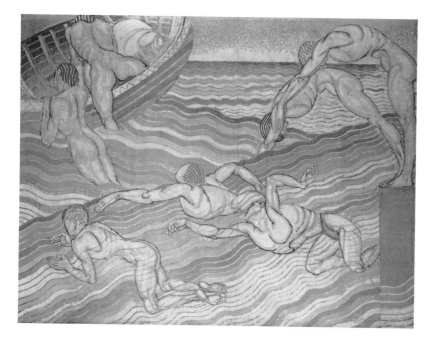

Duncan Grant
Bathing, 1911
Tempera on canvas, 90 x 120½ in/
228.6 x 306 cm
Tate Gallery, London

cases anticipates a number of important preoccupations of modern artists at that period: with abstraction, with movement, with the relationship between painting and music and with exploring new physical means for both the making and the presentation of art.

Matthew Smith (1879–1959) studied painting at the Slade School in London but then went to Paris where for part of 1911 he attended the school run by Matisse from 1908–11. This experience made him above all sensitive to the importance of colour and brushstroke in painting as can be seen in his 'Nude, Fitzroy Street, No. 1' of 1916, with its astonishing contrast of complementary red and green and bold brushwork. By about 1920 Smith had modified this directness of approach and evolved a style of sensuous richness in which he painted still lives of fruit and flowers and lush nudes.

Vorticism marked the most extreme point of development of the British *avant-garde* before the First World War both in the degree to which those artists associated with it were committed to the idea and practice of a geometric abstract or near abstract art and in the vigour and aggressiveness of the polemic they carried out on behalf of that art.

The Vorticist Group was not officially formed until June 1914 and only one group exhibition was ever held, exactly a year later. However, since at least 1912 Wyndham Lewis and a number of associated artists, most notably Edward Wadsworth (1889–1949), William Roberts (born 1895), David Bomberg and the sculptors Henry Gaudier-Brzeska (1891–1915) and Jacob Epstein (1880–1959), had been making an important contribution to *avant-garde* art.

The basic inspiration of Vorticism was essentially the same as that of Italian Futurism. In 1909, in the first *Manifesto of Futurism*, its founder, the Italian poet Fillipo Tomaso Marinetti, wrote: 'We declare that the world has been enriched by a new beauty – the beauty of speed. A racing motor car, its frame adorned with great pipes, is more beautiful than the Victory of Samothrace.' It seemed to Marinetti that the essence of the modern world lay in the machine, and in the urban and industrial civilisation that Western man had built around it. Futurism was a call to artists to reflect in their work both the forms and the restless, aggressive and dynamic nature of that civilisation. In some respects Lewis and his colleagues were more successful than the Futurists in achieving this end and Lewis's term 'Vorticism' for the British movement perfectly encapsulates, with its implication of a concentrated continuous whirlpool of energy, the idea of the dynamism of modern life.

Vorticism was launched by the publication of the first number of *Blast*, a periodical edited by Lewis and containing among other material two aggressive manifestos vigorously attacking – blasting – what Lewis considered the effeteness of British art and culture and proclaiming the Vorticist aesthetic: 'The New Vortex plunges to the heart of the Present . . . we produce a New Living Abstraction.'

Only two major oil paintings by Lewis have survived from the Vorticist period although there is a substantial number of highly finished watercolours by which the extent of his achievement can be judged. Of the two oils 'Workshop' of c. 1914–15 is a fine example of fully mature Vorticist painting. It is a dynamic arrangement of interlocking or interpenetrating diagonals which, although completely geometrically abstract, echo the forms of the modern urban and industrial environment: they are both architectural and mechanistic in character and this quality is reinforced by the harsh, clear colour and smooth, impersonal paint surface. No oil paintings of the Vorticist period have survived by the other two leading members of the group, William Roberts and Edward Wadsworth, but there

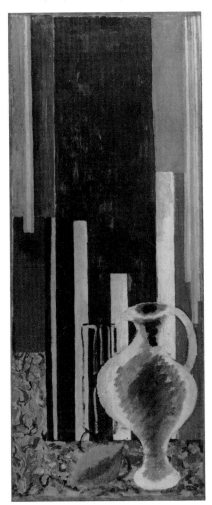

Duncan Grant
The White Jug, 1915–22
Oil on panel, 42 x 17½ in/
106.7 x 44.5 cm
Private collection

are striking works in watercolours by both as well as an important series of woodcuts by Wadsworth.

David Bomberg, although he is always associated with the Vorticists, was in reality a sturdily independent figure who forged his own personal and remarkable brand of Cubo-Futurism and achieved sudden prominence in the *avant-garde* in 1914 first with his exhibits at the first exhibition of the London Group (which had developed out of the Camden Town Group) in March and then with his own one-man exhibition of no less than fifty-five works at the Chenil Galleries in July. The hit of the London Group show was Bomberg's large canvas 'In the Hold', while the star of the Chenil Galleries show, which also included 'In the Hold', was another large picture, 'The Mud-Bath', listed first in the catalogue and hung by Bomberg *outside* the gallery in order, he noted, 'to have every advantage of lighting and space'. Both these paintings, now in the Tate Gallery, have a figurative basis but in both cases Bomberg has transformed his motif into an abstract composition whose degree of confidence, boldness, power, and sheer accomplishment makes these pictures perhaps the outstanding surviving examples of British Cubo-Futurism.

In the catalogue of the Chenil Galleries exhibition Bomberg also published a statement:

'I APPEAL to a *sense of form*... In some of the work I show in the first room, I completely abandon *Naturalism* and Tradition. I am searching for an *Intenser* expression. In other work in this room where I use Naturalistic form I have *stripped it of all* irrelevant matter... My object is the *construction of Pure Form.* I reject everything in painting that is not Pure Form.'

Both 'The Mud Bath' and 'In the Hold' exemplify this search for 'Pure Form' and an 'intenser expression' than that available through the use of naturalistic images, but of the two 'In the Hold' is perhaps the most successful in achieving these aims. In it Bomberg has taken the image of men working in the hold of a steel ship ('I live in a *steel city*' he also wrote) and shattered it into a glittering, shifting mosaic of sharp-edged, harshly coloured fragments which express in a purely pictorial and abstract way his vision of modern urban life.

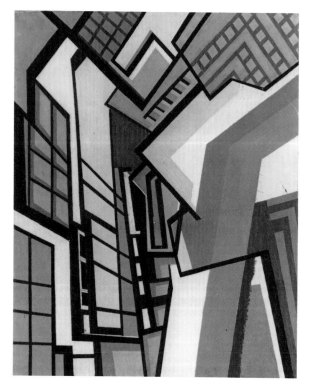

Wyndham Lewis
Workshop, c.1914–15
Oil on canvas, 30⅛ x 24 in/76.5 x 61 cm
Tate Gallery, London

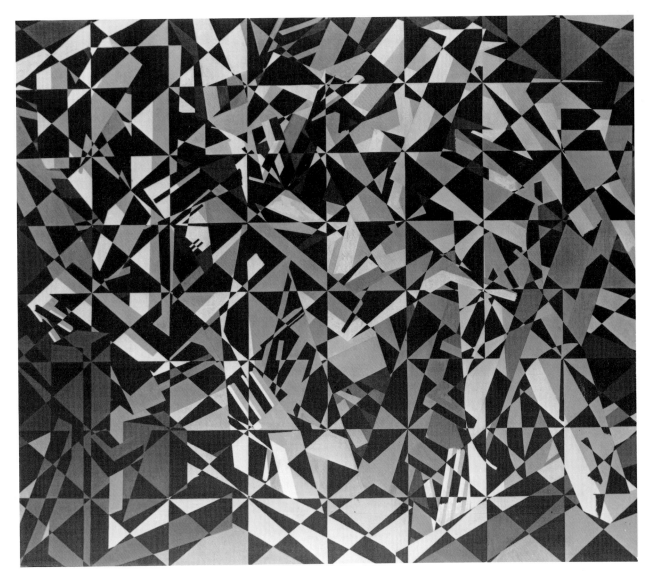

David Bomberg
In the Hold, *c.*1913–14
Oil on canvas, 30⅛ x 24 in/76.5 x 61 cm
Tate Gallery, London

Chapter 19
The Beginning of Modern Sculpture in Britain

In Europe sculpture had taken very much a second place to painting as a medium for 'high' art ever since the death of the great Italian sculptor Bernini in 1680. In Britain throughout the period so far covered by this book sculpture played if anything an even more minor role than on the Continent and has not, therefore, been discussed. However, in the late nineteenth century a revival of sculpture took place in France – part of the whole creative explosion of French art in the second half of the nineteenth century – with the emergence and rise to enormous fame of Auguste Rodin (1840–1917). By the early twentieth century sculpture was firmly re-established as a major medium for art and it then underwent very rapidly the sort of transformations that in painting had been taking place at a more leisurely pace since about 1850.

Rodin had been essentially the last great exponent of the Renaissance tradition – 'this son of Michelangelo' he was called in his funeral oration – and the generation of sculptors who came after him felt the same need as painters had done earlier to renew and revitalise their art. One major move was, of course, as in painting, away from straightforward naturalism towards an emphasis on the work of art as an autonomous object functioning, in the case of sculpture, through the expressive power of pure form and of relationships of form, and through the innate qualities of the material of which the form is made – its colour, texture and so on. All early modern sculpture tended towards abstraction in this sense but within that overall tendency sculptors began to explore new kinds of imagery and new methods and materials. Two broad categories of new imagery appeared, the geometrically abstract and mechanistic, strongly influenced by Cubism and Futurist ideas about the relationship of art to the modern industrial world, and the 'primitive' where the artist sought inspiration in the forms and themes of ancient or primitive ritual art or in the elemental world of the animal kingdom.

Some of the abstract and mechanistic sculptors continued to use traditional methods, particularly bronze, but some of them increasingly began to use a radically new technique particularly suited to their purpose, that of assemblage, that is constructing a sculpture from disparate elements rather than carving or casting it in bronze, using whatever materials the artist thought fit. This technique is now generally referred to as Constructivism.

The 'primitive' sculptors continued to use traditional methods and materials but they developed new approaches to both. They extended the range of types of stone and marble and wood employed but, most important of all, they adopted the use of carving, specifically *direct* carving, as their primary method. Direct carving has two fundamental principles: the artist must execute the work himself and he must not have a detailed preliminary model to guide him. This makes it a significantly different practice, both from the normal way in which stone or marble sculpture was generally

Left:
Sir Jacob Epstein
The Rock Drill, original state 1913–15
Plaster mounted on rock drill,
75 in/190 cm (approx)

Right:
Sir Jacob Epstein
Torso in metal from 'The Rock Drill',
1913–14
Bronze, $27\frac{3}{4}$ x 23 x $17\frac{1}{2}$ in/
70.5 x 58.4 x 44.5 cm
Tate Gallery, London

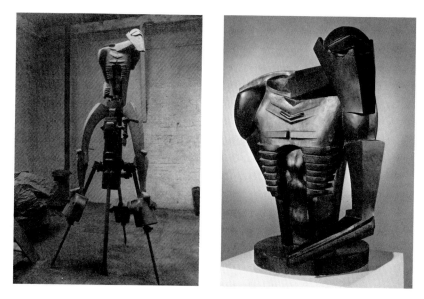

made in the late nineteenth century, typified by Rodin, who made a plaster model and handed it over to a professional marble-carver, and even more from the procedures of modelling, where a clay object passes through several stages to become finally a bronze. In both cases the object ends up in a different medium, and often on a different scale, from the original. In direct carving the artist forges the final form directly into the chosen material, thinking and feeling it out as he goes along. This approach resulted in a new immediacy of impact and freshness of inspiration, together with a new and, aesthetically, extremely satisfying relationship between form and material in which the form tends to grow out of the material and reflect its nature. This effect was deliberately sought by direct carvers and came to have the status of a doctrine which can be summed up in the phrase 'Truth to material'.

In Britain in the years before the First World War two very gifted sculptors, Jacob Epstein (1880–1959) and Henry Gaudier-Brzeska (1891–1915), strongly reflected these developments in their art and founded what has proved to be a sculptural tradition of great vigour.

Epstein was born in New York in the USA where he trained briefly before going to Paris in 1902. He settled in London in 1905, becoming naturalised in 1907. Gaudier-Brzeska was born in France in 1891 and settled in London in 1911.

Both sculptors were initially influenced by Rodin but then, in the Louvre in Paris and the British Museum in London, began to look at 'primitive' sources, ancient Egyptian and Greek sculpture as well as art, particularly African art, that lay entirely outside the European tradition. Both then came crucially under the influence of Constantin Brancusi, the great founder of the Primitive stream of modern sculpture. Epstein met him and visited his studio in 1912 in Paris. Gaudier met him in 1913 in London when Brancusi exhibited his 'Sleeping Muse 11' at the Allied Artists Salon, an important *avant-garde* exhibition society responsible for bringing the most advanced Continental art to London before the First World War. These meetings were catalytic: Epstein in particular had already been moving in the same direction as Brancusi, if somewhat more fitfully, since 1908 when he made his first direct carving, and Gaudier, eleven years younger, had come under Epstein's influence in 1911. In particular it seems to have been Epstein who introduced Gaudier to the idea of direct carving.

Epstein and Gaudier both possessed dynamic and aggressive personalities, a fact reflected in their art, which tends to have a rawness and energy

which sets it apart from the more refined work of Brancusi. In view of this it is not surprising that both gravitated within the British *avant-garde* into the circle of Wyndham Lewis and the Vorticists, Gaudier becoming a member of the group, Epstein remaining a close associate without formalising the attachment, and both reflect the forceful and mechanistic forms of Vorticism in some of their mature work. This is more generally the case with Gaudier, and Epstein produced only one really mechanistic work, 'The Rock Drill' of 1913–15 which, however, turned out to be the purest masterpiece of Vorticist sculpture.

After his trip to Paris and meeting with Brancusi in 1912 Epstein retreated from London to a bungalow in a remote part of Sussex called Pett Level. Here he entered a period of intense activity lasting till 1916, when he moved back to London, during which he produced an astonishing series of direct carvings as well as 'The Rock Drill'. These carvings all deal with the theme of fertility. There are three groups of giant copulating doves, one of which is now in the Tate Gallery, a series of pregnant female figures and two mother-and-child groups. Undoubtedly the most imposing of all the carvings are the two great marble Venuses, both now in the USA, in both of which the pregnant goddess stands on a base formed by copulating doves.

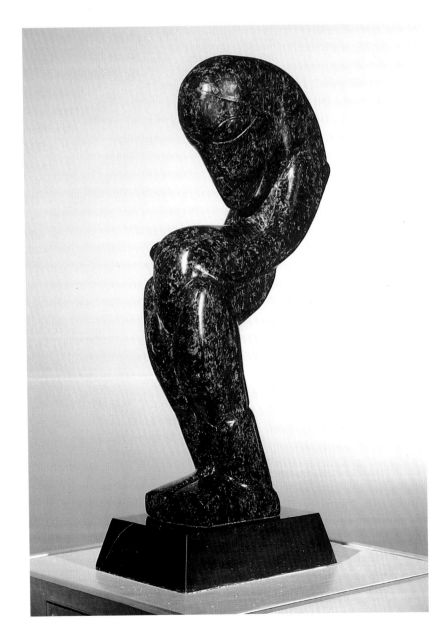

Sir Jacob Epstein
Figure in Flenite, 1913
Serpentine, 18 x 3¾ x 4¾ in/
45.7 x 9.5 x 12.1 cm
Tate Gallery, London

Perhaps more sculpturally satisfying and successful, however, is the small pregnant 'Figure in Flenite'. Like the Venuses, this figure strongly reflects the influence of African art in its simplified forms and magical fetish-like character. This iconic quality, central also to the work of Brancusi at the time but without the African associations, became an important characteristic of much modern sculpture. The figure is in fact a goddess of fertility and Epstein has carefully orchestrated the rhythms of her form so that the two main curves of legs and torso intersect at the swollen belly which becomes the out-thrust focus of the composition to which the eye is automatically drawn. Typical of a direct carving, 'Figure in Flenite' retains strongly the compressed and solid feel of the original block in spite of its quite complex structure. Flenite is more commonly known as serpentine, and the flat uncluttered surfaces of the sculpture reveal the beautiful colour and grain of the hard stone which Epstein has enhanced by polishing.

'The Rock Drill' is not a carving. In its original state it was a combination of a plaster figure with a real industrial object, a rock drill, a remarkably bold and original idea at the time. It is the only example in Britain at that period of constructed, or assembled, sculpture using non-traditional elements. Thematically 'The Rock Drill' represents a synthesis of Epstein's own deepest interests with the current *avant-garde* fascination with the machine. The phallic significance of the drill is made very clear in the numerous pencil sketches Epstein made for 'The Rock Drill', and the final work is one of the most powerful images in art of the brute male procreative force, a more than adequate counterpart to Epstein's swollen Venuses.

Gaudier-Brzeska's most substantial piece of direct carving is also a phallic image, a colossal bust of his friend, the *avant-garde* poet and critic Ezra Pound as a kind of fertility idol, and a surviving photograph of Gaudier at work on this is a vivid evocation of the process of direct carving – the sculptor attacks the huge, raw block with nothing to guide him but a few lines chalked on its surface. However, as with Epstein it is perhaps his less ambitious works which are most sculpturally satisfying. In 'Birds Erect' the themes of life and growth are conveyed in almost abstract terms by the dynamically thrusting cluster of upright forms.

Gaudier was killed in the trenches in 1915. Epstein when he resumed full activity after the war became mainly interested in making portrait busts in bronze. However, he continued all his life to produce occasional imaginative and monumental sculptures that reflect his early aims and inspiration.

Henry Gaudier-Brzeska
Birds Erect, 1914
Limestone, 26⅝ x 10¼ x 12⅜ in/
66.7 x 26 x 31.4 cm
Museum of Modern Art, New York

Chapter 20
Between the Wars

The First World War brought an end to the intense ferment of innovative artistic activity that had developed in Britain in the pre-war years. Many leading artists joined the army. Others, Duncan Grant for example, did agricultural work as conscientious objectors. Group activity largely ceased and individuals retreated from the extreme positions, up to and including pure abstraction, they had taken up in 1914–15. By 1917 it was possible for Epstein to write to his patron, the American collector James Quinn, 'I think you are inclined to over-rate what you call advanced work, not all advanced work is good, some of it is damn damn bad...great work can be done on a natural basis.' This process continued after the war. By about 1920 all the members of the pre-war *avant-garde* had reverted to more conventional modes of painting and sculpture although it should be stressed that they continued to produce valid and interesting work. Among a younger generation of artists a positive hostility to experiment and innovation seems to have developed: the catalogue of the first exhibition of the newly formed Seven and Five Society in 1920 contains the following disclaimer: 'The Seven and Five desire to explain that they are not a group formed to advertise a new "ism"...The Seven and Five are grateful to the pioneers, but feel that there has of late been too much pioneering along too many lines in altogether too much of a hurry...'

In this situation one artist in particular who had already done important work in the pre-war years came into his own. This was Stanley Spencer (1891–1959), whose work possessed a new, fresh and intense vision but was largely untouched by the formal developments of modern art. Enormously naturally gifted as a draughtsman, Spencer trained at the Slade School of Art from 1908–12 where he perfected an essentially traditional figurative technique within which he forged an individual style suited to his own expressive needs.

The primary basis of Spencer's visionary art was his early life in the village of Cookham, on the Thames in Berkshire, which was, we are told by his biographer, an experience of such unalloyed happiness that it seemed to him that the village must be a kind of paradise and everything in it possessed of a mystical significance. This, combined with more conventional religious feelings and an extensive reading of the Bible, led him from about 1912 to paint a remarkable series of pictures in which Cookham becomes the setting for various heavenly events, most of them highly personal transpositions of episodes from the scriptures. One of the earliest of these and the painting that marks Spencer's maturity is 'Apple Gatherers' of 1912. This picture, basically of a commonplace of village life – picking apples – is treated in such a way that the scene takes on an intensely mysterious and other-worldly quality so that it strongly suggests the idea of Adam and Eve in the Garden of Eden, a view of the picture reinforced by the unnatural prominence of the apples and especially the fact that the central couple, much larger than the other figures, are clasping one between them. Many years later, in 1940,

Sir Stanley Spencer
Apple Gatherers, 1912–13
Oil on canvas, 28 x 36¼ in/
71.1 x 92.1 cm
Tate Gallery, London

Sir Stanley Spencer
The Resurrection, Cookham, 1923–7
Oil on canvas, 108 x 216 in/
274.3 x 548.6 cm
Tate Gallery, London

Spencer wrote of this picture, 'Places in Cookham seem to be possessed by a sacred presence, of which the inhabitants are not aware. The people in 'Apple Gatherers' are, as it were, brought forth by the place and, therefore, are aware of its divinity. They are expressions of the divinity there presiding.' Other notable early works of the kind are 'The Centurion's Servant' of 1914 where the setting is the maid's bedroom in the Spencer family home and the sick servant is the artist himself, and 'Christ Carrying the Cross' in which Spencer has imagined Cookham High Street as the route to Calvary. Both these are now in the Tate Gallery. But the most extraordinary of all and the picture that marks the climax of Spencer's early career is the huge canvas depicting the resurrection of the dead into

Paradise taking place in Cookham churchyard that he painted between
1923 and 1927. This picture is the ultimate expression of Spencer's view of
Cookham as a paradise on earth. It was painted during what was probably
the most intensely happy period in his adult life, just before and just after his
first marriage in 1925 at the age of thirty-four to Hilda Carline. This new
relationship is perhaps the inspiration of the scene of joyful resurrection, for
Spencer has painted himself life-size and nude at the centre of the picture
and there are no less than five images of his wife among the surrounding
figures.

Spencer's personal and domestic life remained an important ingredient
of his art, often forming the sole inspiration of his pictures as in the
extraordinarily intense double nude portrait of himself and his second wife
Patricia painted in 1936. But Cookham was never far away and when he
died he left unfinished a series of paintings of 'Christ Preaching at Cookham
Regatta'. The largest of these, showing Christ standing in a boat, can be
seen in its incomplete state in the Spencer Museum in Cookham.

Mark Gertler (1891–1939) had also begun to paint in a straightfor-
wardly figurative way before the war. In the 1920s he came to full maturity
and, somewhat influenced by Picasso, developed an idiosyncratic style of
clearly defined forms and hot mellow colour of which a fine example is 'The
Queen of Sheba'.

Meanwhile on the Continent energetic activity had been continuing with
the wartime Dada movement, with the founding of Surrealism in Paris in
1924, dedicated to the revival of imaginative art, with the entering of
Picasso, in 1925, on a new and vital phase of his development and with the
continuing development of various forms of pure abstract art around Piet
Mondrian in Paris and Paul Klee and Wassily Kandinsky at the Bauhaus,
the great art school founded in Germany in 1919 by the pioneer modern
architect Walter Gropius.

Sir Stanley Spencer
*Double Nude Portrait: the Artist and his
Second Wife*, 1936
Oil on canvas, 33 x 36⅞ in/
83.8 x 93.7 cm
Tate Gallery, London

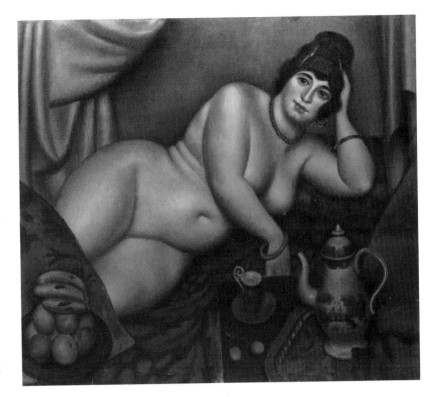

Mark Gertler
The Queen of Sheba, 1922
Oil on canvas, 37 x 42¼ in/94 x 107.3 cm
Tate Gallery, London

Britain remained cut off from all this until, in the early 1930s, a resurgence of the *avant-garde* began. This was essentially the doing of four major artists who had been maturing through the Twenties, the sculptors Henry Moore and Barbara Hepworth and the painters Ben Nicholson and Paul Nash, together with the theorist, philosopher and art critic Herbert Read.

Ironically, one of the focal points of the new *avant-garde* was the Seven and Five Society which Ben Nicholson had joined in 1924. The society's policy and membership gradually changed through the Twenties: Barbara Hepworth and Henry Moore both joined in 1932 and in 1935 all non-abstract members were eliminated, the society was renamed 'Seven and Five Abstract Group' and the first all-abstract exhibition in the history of British art was held at the Zwemmer Gallery.

Meanwhile, in 1933 Paul Nash had founded 'Unit One', a group which included Nicholson, Hepworth and Moore. Its purpose, according to Nash in a letter to *The Times* announcing the formation of the group, was 'to stand for the expression of a truly contemporary spirit, for that thing which is recognised as peculiarly of *today* in painting, sculpture and architecture'. The first exhibition of Unit One was held in 1934 and a book was published at the same time edited by Herbert Read and called *Unit One*, subtitled *The Modern Movement in English Architecture, Painting and Sculpture*. It consisted of statements made by all the artists in the group, photographs of their work and an introduction by Read.

A third exhibiting society which played an important role in the development of modern art in Britain in the 1930s was the Artists' International Association founded in 1933. It was politically orientated and embraced all stylistic tendencies, its aim being the 'Unity of Artists for Peace, Democracy and Cultural Development' under which motto it held two huge exhibitions in 1937 and 1939.

In 1935, inspired by the Paris group Abstraction Creation and their magazine, Myfanwy Evans and John Piper, a member of the Seven and Five

Abstract Group, founded *Axis* – a quarterly review of abstract art – and in the same year work began on the preparation of *Circle, International Survey of Constructive Art* edited by J. L. Martin, Ben Nicholson and the Russian Constructivist sculptor Naum Gabo, who lived in England from 1935–46 and during that period was an important and influential member of the circle of Nicholson, Moore and Hepworth. *Circle* was eventually published as a book in 1937.

Besides Gabo a number of other major Continental artists spent time in England during the 1930s and contributed vitally to the development of modern art there during that period. Most important was Piet Mondrian, who was in London from 1938–40 where he was in close contact with Nicholson and Hepworth, but other distinguished visitors included Walter Gropius, Erich Mendelsohn, Lazlo Moholy-Nagy and Marcel Breuer from the Bauhaus, the American sculptor Alexander Calder and the Belgian Surrealist E. L. T. Mesens. In 1936 two major international exhibitions took place in London, *Abstract and Concrete* organised by Nicolette Gray in collaboration with *Axis* and the hugely sensational *International Surrealist Exhibition*. This last was organised by Roland Penrose, the painter, poet, collector and friend of Picasso, with the help of a committee which included Moore, Nash and Herbert Read. The previous year Penrose had also been responsible for founding an English Surrealist group which in 1938 began publishing a monthly and then fortnightly magazine called the *London Bulletin*.

In sum London once again became, as it had been before the First World War, an international art centre. Barbara Hepworth later wrote, '. . . suddenly England seemed alive and rich – the centre of an international movement in architecture and art. We all seemed to be carried on the crest of this robust and inspiring wave of imaginative and creative energy.' Sadly, this vital development was to be once again cut short by war.

It was Henry Moore who first inherited the new tradition of modern sculpture founded in England by Epstein and Gaudier-Brzeska and developed it with such power of imagination and fertility of invention that he emerged in his full maturity in the late 1930s as the greatest of all modern sculptors after Brancusi.

Moore was born in Yorkshire in 1898. After first training as a teacher and then having his career interrupted by army service during the 1914–18 war he went to Leeds College of Art in 1919 and two years later won a scholarship to the Royal College of Art in London. By this time Moore was already aware, he later recalled, 'of Brancusi, Gaudier-Brzeska, Modigliani and the early Epstein and of all that that direction in sculpture stood for' and once in London he also discovered primitive art, pre-Columbian Mexican sculpture in particular, in the British Museum. At the same time he adopted the practice of direct carving with its associated doctrine of truth to materials.

His first major carvings were the mother-and-child groups of 1924 and 1925. These carvings already announce the most important theme of Moore's art, that of the constant renewal of life, of fertility and growth, and, squat and massive as they are with chunky forms thrusting dynamically against each other, they express this theme with great power. This feeling of power is a quality of his sculpture to which Moore attaches overriding importance. In his first published statement on sculpture in 1930 he wrote: 'The sculpture which moves me most is full-blooded and self-supporting . . . its component forms . . . work as masses in opposition . . . it is static and it is strong and vital, giving out something of the energy and power of great mountains . . .' And in his statement published in *Unit One* in

Henry Moore
Reclining Figure, 1929
Brown Hornton stone, 33 in/83.9 cm long
City Art Gallery, Leeds

1934 he stressed that 'a work can have in it a pent-up energy, an intense life of its own'.

It is very important to an appreciation of Moore's work to know that he consciously values this quality of power and energy above that of beauty. He also explained this in *Unit One*:

'Beauty, in the later Greek or Renaissance sense, is not the aim in my sculpture. Between beauty of expression and power of expression there is a difference of function. The first aims at pleasing the senses, the second has a spiritual vitality which for me is more moving and goes deeper than the senses.'

Although the mother-and-child image remained common in Moore's art through the 1920s and 30s it was overshadowed by his development from 1927 onwards of the motif of the recumbent female figure which was to be the basis of many of his greatest works. When a woman reclines naturally on her elbow with one knee bent her body instantly suggests a landscape with mountains, valleys and hills. In his recumbent figures Moore exploited this correspondence to create images of woman which are still images of fertility but which also and much more effectively than before 'give out something of the energy and power of great mountains'. The massive, slightly parted lower limbs of the marvellous 1929 'Reclining Figure' in brown Hornton stone (known as the 'Leeds figure') are literally mountainous but also powerfully evoke her biological function.

In the early 1930s Moore entered his most abstract phase, in which overt figurative references all but disappeared from some of his work, but during

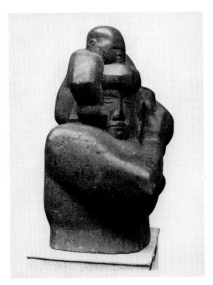

Henry Moore
Mother and Child, 1924
Hornton stone, 22⅛ x 15¾ x 11⅞ in/
56.2 x 40 x 30.2 cm
City Art Gallery, Manchester

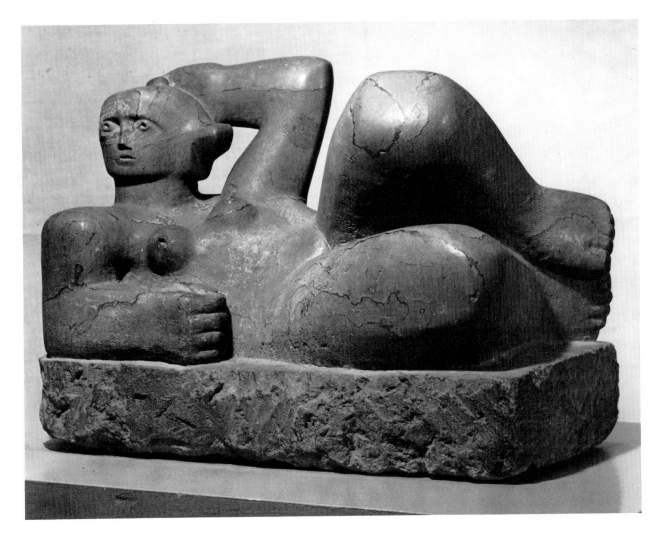

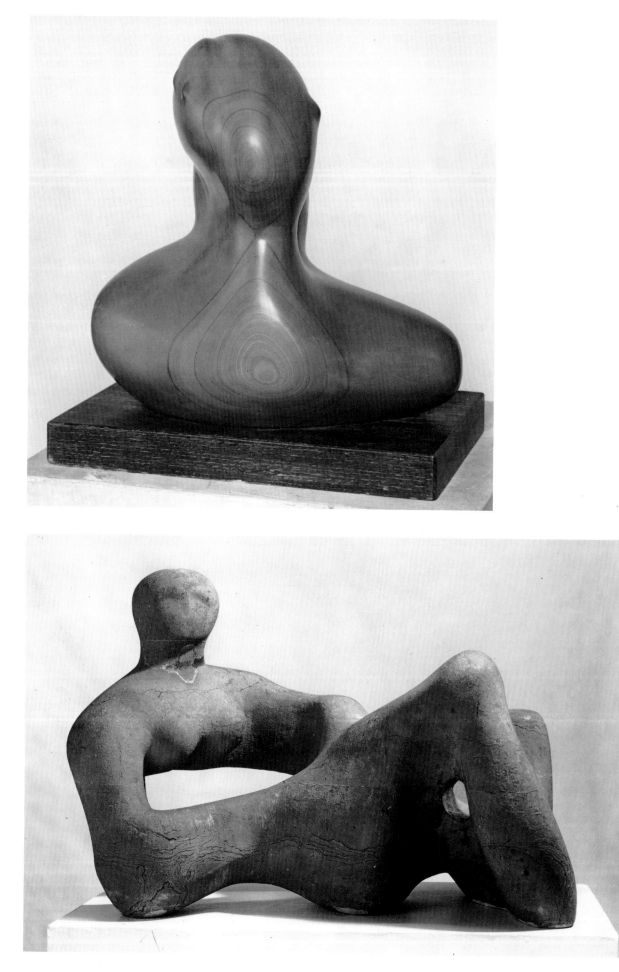

which he was also at his most imaginatively inventive of sculptural form. The decade of the Thirties saw an immensely fertile outpouring of extraordinary and original works, among which are some of his most powerful and concentrated expressions of the themes that preoccupied him. He achieved this by exploiting the directly associative and evocative force that shapes and forms can have when they are freed from a literal representational function. As Moore himself put it, 'My sculpture is becoming less representational, less an outward visual copy, and so what some people would call more abstract, but only because I believe that in this way I can present the human psychological content of my work with the greatest directness and intensity.' One of the best of these works is 'Composition, 1932'. Its softly swelling form is also rearing and tumescent, suggesting both the male and female principle. It has strange, nipple-like protrusions on its side, and a shallow groove on top. Its surfaces are smooth and highly tactile. It is an intensely mysterious work which, not directly representational, nevertheless speaks very directly to our deepest human instincts.

In 1938 Moore returned to the idea, foreshadowed in the Leeds figure of 1929, of the association of the human figure and landscape and brought it to a full development in the 'Recumbent Figure' which Lord Clark has rightly characterised as one of Moore's most satisfying works. The Leeds figure was still square-cut and block-like, but here the forms are fully rounded and express the idea of the fertility of the earth as well as its weight and power. Here too the massive thighs of the figure are now spread wide apart and a deep cavernous hollow is scooped out between them to create an archetypal image of the earth mother, the source of all life.

This figure was the first in stone to be substantially opened out, both by freeing the forms much more from the limitations of the block than in earlier works like the Leeds figure and by the decisive step of carving holes right through it. This new open structure functions both formally and thematically. Formally, it maximises what Moore called the 'three-dimensional realisation', that is, it makes the sculpture as three-dimensional as possible, a point of crucial importance to Moore since it produces 'an infinite number of different views giving . . . a never-ending interest and surprise'. Also, Moore has written, 'A hole can have as much shape meaning as a solid mass.' Thematically, the holes have a connection with landscape and perhaps too with the female body: in *The Sculpture Speaks* in 1937 Moore spoke of 'The mystery of the hole–the mysterious fascination of caves in hillsides and cliffs.'

Barbara Hepworth (1903–75) was the other great sculptor who emerged in England between the wars. Like Henry Moore she was born in Yorkshire, and they were together at both Leeds and the Royal College of Art. Like Moore, Hepworth adopted direct carving and like Moore she looked initially for inspiration to primitive sources. Not surprisingly her early work is in many ways close to that of Moore and she reached her first maturity in the period 1932–4 with a series of carvings which, like Moore's works of that period, are abstractions which still refer to the forms and processes of life. The white alabaster 'Large and Small Form' of 1934 is recognisably a mother and child but transformed and simplified into an image suggestive of the flowing, pulsing, budding, amoeba-like creatures from which all animal life on earth originated. It is an image which, like many of Moore's works, makes the human image a metaphor for the idea of life itself.

The correspondences between Moore's and Hepworth's work at this time should not obscure the fundamental difference in their sculptural temperament. Moore, as we have seen, sought the expression of power

Henry Moore
Composition, 1932
African wonderstone, $17\frac{1}{2}$ x 18 x $11\frac{3}{4}$ in/
44.5 x 45.7 x 29.8 cm
Tate Gallery, London

Henry Moore
Recumbent Figure, 1938
Green Hornton stone, 35 x $52\frac{1}{4}$ x 29 in/
88.9 x 133.4 x 73.7 cm
Tate Gallery, London

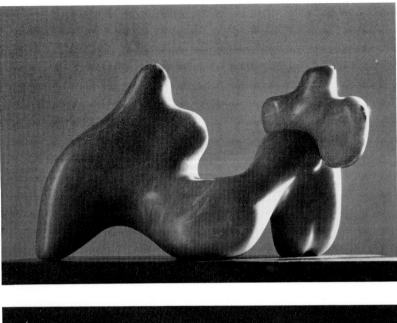

Barbara Hepworth
Large and Small Form, 1934
White alabaster, $14\frac{1}{2}$ x 9 in/
36.8 x 22.9 cm
Pier Arts Centre Trust, Orkney

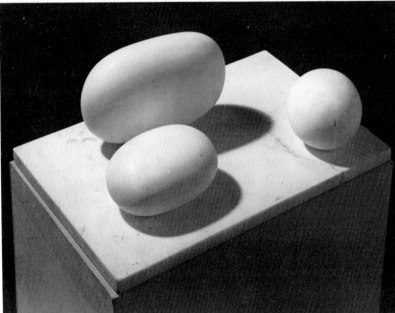

Barbara Hepworth
Three Forms, 1935
White marble, $7\frac{7}{8}$ x 21 x 13$\frac{1}{2}$ in/
20 x 53.3 x 34.3 cm
Tate Gallery, London

rather than beauty which, he felt, pleasing only the senses, did not go deep enough. Barbara Hepworth, however, always laid great stress on the purely sensuous aspects of her sculpture. Right from the beginning her work is characterised by extreme sensitivity and delicacy of form and surface and by the use of a wide variety of rare and exotic woods, stones and marbles carefully chosen for their intrinsic beauty and treated in such a way as to enhance this beauty and make it central to the finished sculpture. This emphasis led to the final divergence from Moore when in 1934–5 she began to make completely abstract sculptures using a range of simple primary forms such as the sphere, the cylinder and the ovoid. In the same year she wrote in *Unit One* that she sought 'to project into a plastic medium some universal or abstract vision of beauty'. The first of these abstract sculptures was 'Three Forms' of 1935. Here the reduction and abstraction of form places even more emphasis on the purely sensuous qualities of the sculpture, and in this and the long succession of carvings which followed Barbara Hepworth created some of the most pristinely beautiful of all modern sculptures.

The most important early influence on Ben Nicholson (born 1894) was Cubism and he has recorded the impact on him of the first Cubist painting he saw in Paris in 1921: 'I remember suddenly coming on a Cubist Picasso at the end of a small upstairs room at Paul Rosenberg's gallery. It must have been a 1915 painting – it was what seemed to me then completely abstract.' Over the next ten years Nicholson developed a more highly sophisticated appreciation of the new pictorial freedoms and possibilities offered by Cubism than any other English artist had so far done and with this went a technique and painterly sensibility of outstanding delicacy and refinement. He also developed an interest in surface texture which was to remain central to his art. The texture in Nicholson's paintings always comes from the freely brushed ground, sometimes thickened with marble dust. Over this ground he paints extremely thinly, sometimes drawing on it in pencil as well and frequently scraping away the painted surface or incising into it to expose the ground.

His early works reached a climax about 1932–3 when he painted a group of stunningly beautiful Cubist near-abstractions in which, although figurative imagery is still present, the painting functions through an extraordinary subtle interplay of line, texture and delicate muted tones of grey or brown.

Nicholson's interest in working physically on the surface of his pictures led him to the use of panel rather than canvas as a base, and as his involvement with the surface grew his work became more abstract until in 1933 he began to produce completely abstract carved relief panels which in 1934 he began to paint pure white. He continued to produce these white reliefs until the outbreak of war at the end of the decade and as a group they constitute a major contribution to the whole idea of an abstract art of pure, timeless, universal beauty which, as we have seen, was also being pursued at this time by Barbara Hepworth, to whom Nicholson was now married.

Nicholson's formal concerns in the white reliefs were with creating

Ben Nicholson
White Relief, 1935
Oil on wood relief, 40 x 65½ in/
101.6 x 166.4 cm
Tate Gallery, London

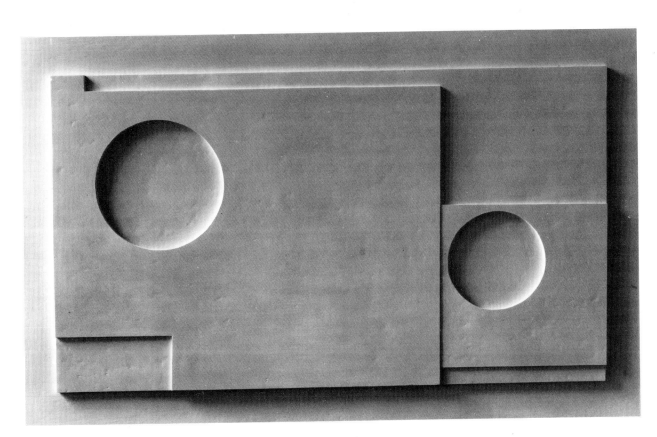

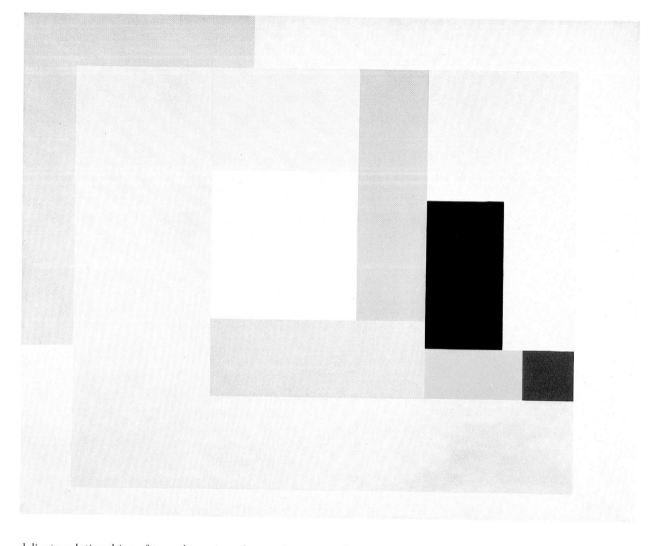

delicate relationships of two elementary forms of opposite character – the square or rectangle and the circle – and then in extending this relationship into a series of levels (planes) in the shallow relief spaces. He says:

'You can take a rectangular surface and cut a section of it one plane lower and then in the higher plane cut a circle deeper than but without touching, the lower plane. One is immediately conscious that the circle has pierced the lower plane without having touched it... and this creates space. The awareness of this is felt subconsciously and it is useless to approach it intellectually as this, so far from helping, only acts as a barrier.'

Nicholson, like almost all pure abstract artists, emphasises the poetic and aesthetic character of his art:

'The geometrical forms often used by abstract artists do not indicate, as has been thought, a conscious, intellectual, mathematical approach – a square and a circle in art are nothing in themselves and are alive only in the instinctive and inspirational use an artist can make of them in expressing a poetic idea.'

In the 'White Relief' of 1935, now in the Tate Gallery, the two circles relate to each other, call to each other, across the surface, while both penetrate to different levels of the rectangular planes establishing a relationship in three-dimensional space as well. Nicholson says, 'The problems dealt with in abstract art are related to the interplay of forces... you can create a most exciting tension between these forces.' In the Tate relief the 'tension' between the two circles is enhanced by the fact, usually perceived unconsciously rather than consciously so sure is

Ben Nicholson
Painting 1937
Oil on canvas, $62\frac{3}{4} \times 79\frac{1}{4}$ in/
159.4 × 201.3 cm
Tate Gallery, London

Alfred Wallis
Schooner under the Moon, ?c.1935–6
Oil on board, $11\frac{1}{2}$ x $11\frac{1}{2}$ in/
29.2 x 29.2 cm
Tate Gallery, London

Paul Nash
Nocturnal Landscape, 1938
Oil on canvas, $30\frac{1}{8}$ x $40\frac{5}{8}$ in/
76.5 x 103.2 cm
Tate Gallery, London

Nicholson's hand, that one was drawn with a compass and one without.

Although the white reliefs now appear as perhaps Nicholson's most powerful and original works of the Thirties, he was from 1935–8 making paintings on canvas of an equal degree of abstraction and dealing with the same formal concerns in which colour, instead of relief, was used to establish the planes. Among these perhaps his masterpiece is the large 'Painting 1937' which, as Charles Harrison has written, 'has the ambitious uncompromising quality of the best international art of this century'.

Two Seven and Five members, John Piper (born 1903) and Ivon Hitchens (born 1893) are landscape painters who were strongly affected by the idea of abstraction in the mid-Thirties. Piper made coolly coloured paintings and reliefs in which he explored relationships of flat geometric forms. Hitchens used positive colour in loose forms and the expressive brushwork which has since become the principle feature of his painting.

A rather different approach to abstraction was that developed from about 1933–7 by Geoffrey Tibble (1909–52), Rodrigo Moynihan (born 1910) and others and known as Objective Abstraction from the title of an exhibition held in 1934 at the Zwemmer Gallery in London. It was a non-geometric form of abstraction in which the painting evolved in an improvisatory way from freely applied brush strokes. Although short-lived, Objective Abstraction clearly anticipated a basic approach to painting that became widespread in the following decades.

Standing completely apart from all groups and developments in British art in the period between the wars was the Cornish primitive painter Alfred Wallis (1855–1952) who was 'discovered' in 1928 by Nicholson and his

Cecil Collins
The Cells of Night, 1934
Oil on canvas, 30 x 25 in/
76.2 x 63.5 cm
Tate Gallery, London

friend Christopher Wood (1901–30), a young painter of promise who died prematurely. Wallis took up painting at the age of about seventy with no training and his pictures of the Cornish scene have a simple freshness and vitality that stems from a completely natural self-expression. Nicholson and Wood were both influenced by his art, and Nicholson seems to have been especially stimulated in his development of relief by Wallis's practice of working on irregular-shaped pieces of old card or wood and using the shape and sometimes the surface texture and colour as part of the design.

Paul Nash (1889–1946) extended into the twentieth century the imaginative and visionary tradition of William Blake. Unlike Blake, however, he was not concerned with the image of man but with landscape and the world of objects both natural and man-made.

Nash's sense of affinity with Blake is revealed in his *Unit One* statement where he wrote, 'William Blake...perceived among other things the hidden significance of the land he always called Albion [England]. For him Albion possessed great spiritual personality and he constantly inveighed against Nature [that is, appearances] which he mistrusted as a false-reality.' To Nash, too, the surface appearance of objects and landscapes seemed a false reality and in his art they appear as still recognisable but transformed to correspond to his visionary perception of them. Nash achieved his transformations of the world through three basic means: abstraction, distortion and, perhaps most important, the power of association, the way in which objects perhaps familiar in themselves can take on new and strange significances when brought unexpectedly together or removed from their normal setting and placed in some new and unprecedented one.

Although fundamentally a visionary, as his earliest work reveals, Nash was strongly influenced by ideas of abstract art in the 1920s and his works of that period tend to deal with naturally geometric objects or land-scapes – such as the coast of Kent at Dymchurch with its vast length of

sea wall—and in 1930–5 he even painted a few completely abstract works like the Tate Gallery's 'Kinetic Feature'. But he was to write later that 'a few attempts to escape into the refuge of abstract design proved to me unsuited'.

The full liberation of Nash's imagination which finally came in the decade of the Thirties was stimulated by two things. One was the climate engendered by the increasing influence of French Surrealism with its overwhelming emphasis on the imagination, the other was his discovery in 1933 of the great prehistoric stone circles, the megaliths, at Avebury in Wiltshire.

The influence of Surrealism in England reached a climax in 1936 with the *International Surrealist Exhibition* in London of which Nash was one of the organisers and to which he was a major contributor. The rise of Surrealism merely confirmed Nash in his true direction. 'I did not find Surrealism, Surrealism found me,' he wrote, but he did take one very valuable new idea from the Surrealists, the use of the dream as a source of imaginative and visionary material.

Of his first view of the megaliths at Avebury Nash wrote:

'The great stones were then in their wild state, so to speak. Some were half covered by the grass, others stood up in the cornfields, were entangled and overgrown in the copses, some were buried under the turf. But they were always wonderful and disquieting and as I saw them then I shall always remember them...their colouring and pattern, their patina of golden lichen, all enhanced their strange forms and mystical significance.'

This encounter made Nash aware of the mystical and symbolic character of stones in general and of other natural objects such as driftwood, bones and shells. He began to collect examples of these which possessed a particular quality which he defined in an article called 'The Life of the Inanimate Object' published in 1937: 'An object must show in its lineaments a veritable personality of its own . . . it must be a *thing* which is an embodiment and most surely possesses power.' He called them 'object personages'.

Out of all this emerged a group of intensely dreamlike paintings of strange objects in landscape, one of the most haunting of which is 'Nocturnal Landscape' of 1938.

An imaginative painter even more directly in the visionary tradition of Blake came to maturity in about 1935. This was Cecil Collins (born 1908) who has continuously asserted the importance of art as a revelation of the life that lies beyond the surface of things. 'The Cells of Night' (1934) is one of the earliest works in which the essentials of Collins's vision are fully expressed. This richly coloured and textured painting represents the human psyche (the head) at night, when consciousness of the spiritual world is

John Armstrong
Dreaming Head, 1938
Tempera on wood, 18¼ x 30¾ in/
45.6 x 76.9 cm
Tate Gallery, London

Ceri Richards
Two Females, 1937–8
Wood and metal, 63 x 46 x 3½ in/
160 x 116.8 x 8.9 cm
Tate Gallery, London

Sir William Coldstream
Mrs Winifred Burger, 1936–7
Oil on canvas, 30¾ x 21½ in/
78.1 x 54.6 cm
Tate Gallery, London

Edward Burra
Dancing Skeletons, 1934
Gouache, 31 x 22 in/78.7 x 55.9 cm
Tate Gallery, London

heightened, being drawn towards the eternal or infinite.

A less emphatic visionary and, like Nash, basically concerned with landscape, was the Welsh painter and poet David Jones (1895–1974) who used the medium of watercolour to create lyrical works of ethereal delicacy.

Another Welsh artist, Ceri Richards (1903–71), was closely associated with Surrealism in Britain in the Thirties. Like Nash, he was interested in the association of objects as a means of reflecting imaginative fantasy. 'Two Females' is one of a series of striking relief assemblages in which arrangements of found objects suggest or hint at human forms.

A number of artists pursued a much more literal or illustrative imaginative art, among them John Armstrong and Edward Burra. Armstrong's paintings have a strongly dreamlike quality while Burra's large watercolours are often characterised by a macabre fantasy.

In 1938 a group appeared who were in conscious reaction against what they took to be the extremes of the *avant-garde*. Specifically, they asserted the importance of painting traditional subjects, landscape, both urban and rural, and the figure, in a style of cool objective realism. Some of the group were members of the Communist Party, and their support for realism was partly for social and political reasons; to create a comprehensible and

socially relevant art. After an exhibition at the Storran Gallery in London in 1938 they became known as the Euston Road School from the School of Painting and Drawing at 316 Euston Road at which most of them were either studying or teaching. The leading members of the group were Graham Bell, William Coldstream, Claude Rogers and Victor Pasmore. In practice the Euston Road style was one of disciplined intensity characterised by great sensitivity of touch and delicate harmonies of low key colour.

Chapter 21
The Second World War and its Aftermath

The Second World War was far less disruptive of artistic activity in Britain than had been the conflict of 1914–18. In fact what now appears in retrospect to be a rich artistic life persisted throughout the war and laid the foundations of the tremendous resurgence and expansion of modern art in Britain that has taken place in the post-war era. What did happen, very significantly, was that purely formal research in art came to seem irrelevant in the circumstances of war and it is symptomatic of their new situation that of the leaders of the pre-war *avant-garde*, the basically figurative Moore and Nash played a central role, while the abstract Hepworth and Nicholson spent the war and immediate post-war period in Cornwall in an isolation that was both geographical and artistic. Pure abstraction was not to be an issue again in British art until the celebrated conversion of Victor Pasmore to abstraction in 1948.

A major factor in this persistence of artistic activity during the 1939–45 war was the War Artists' scheme which was set up early in 1940 to commission works of art recording aspects of the war. Both Moore and Nash

Henry Moore
Tube Shelter Perspective, 1941
Pencil, pen and ink, wax crayon and
watercolour, $18\frac{7}{8}$ x $17\frac{1}{4}$ in/48 x 43.8 cm
Tate Gallery, London

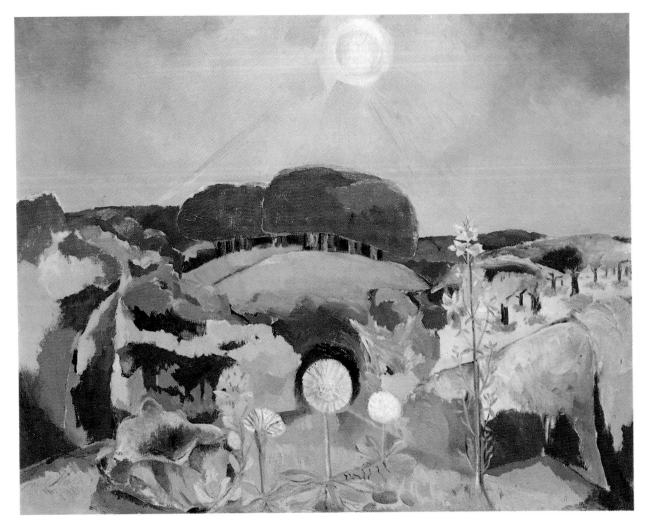

Paul Nash
Landscape of the Summer Solstice, 1943
Oil on canvas, 28 x 36 in/
71.1 x 91.4 cm
National Gallery of Victoria, Melbourne

were commissioned as war artists and so too was Graham Sutherland who, although only five years younger than Moore, had not really begun to develop as a painter until the mid-Thirties and came to full maturity during the war.

Moore has described how at the beginning of the war he applied to train as a precision toolmaker and while waiting for the result of his application gave up sculpture and took up drawing: 'Months went by, waiting, I went on drawing. Then the air raids began – and the war from being an awful worry became a real experience. Quite against what I expected I found myself strangely excited by the bombed buildings but more still by the unbelievable scenes and life of the underground shelters.' At this time the official shelters were inadequate so Londoners took to sleeping in the underground railway system and the stations soon became, in Moore's words, 'like a huge city in the bowels of the earth. When I first saw it quite by accident – I had gone into one of them during an air raid – I saw hundreds of Henry Moore Reclining Figures stretched along the platforms. I was fascinated visually, I went back again and again.' It was the sketchbook he filled with drawings of the shelters that led to his first commission from the War Artists' Committee for fully finished drawings of these scenes. He eventually spent a year on the project and produced about a hundred often richly coloured drawings whose combination of human and imaginative qualities with superb draughtsmanship (like many great sculptors before him Moore is a draughtsman of genius) have placed them among the best known and best loved of all his works.

It is arguable that Paul Nash reached the height of his imaginative powers in the war years, which were also the last years of his life. His work of this period falls into three distinct groups, the war pictures, a group of extraordinary visionary landscapes dealing with the changing seasons, and a series of equally visionary sunflower paintings on which he was still working at the time of his death in 1946.

Nash's subject as a war artist was aircraft, and most of his war pictures are of crashed enemy aircraft. One of the best known of them is 'Totes Meer' (Dead Sea). It is based on photographs of the dump for wrecked German aircraft at Cowley near Oxford, but Nash saw this place through visionary eyes: 'The thing looked to me suddenly like a great inundating sea...It is hundreds and hundreds of flying creatures which invaded these shores...by moonlight, this waning moon, one could swear they began to move and twist and turn as they did in the air. A sort of rigor mortis? No, they are quite dead and still.'

Paul Nash
Totes Meer, 1940–1
Oil on canvas, 40 x 60 in/
101.6 x 152.4 cm
Tate Gallery, London

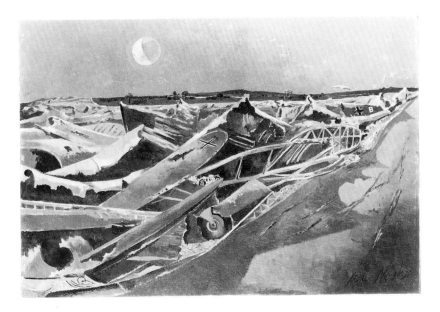

Paul Nash
Solstice of the Sunflower, 1945
Oil on canvas, 28 x 36 in/
71.1 x 91.4 cm
National Gallery of Canada, Ottawa

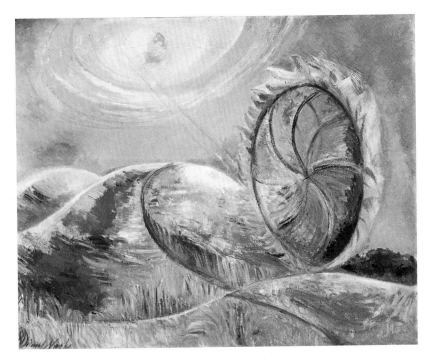

The visionary landscapes are quite different from Nash's work of the Thirties. They are pure landscapes, without objects, and have a new richness and warmth of colour and texture which makes them among the most sensuously satisfying of all his works. In them, through the theme of the changing of the seasons, through the images of the sun and moon and through the use of soft swelling forms of landscape, rather reminiscent of Samuel Palmer's Shoreham pictures, Nash expresses a vision of the fertility of nature and of the constant natural cycle of change, decay, death and the renewal of life. This development in his art reached its climax in 1943 with pictures like 'Landscape of the Summer Solstice'.

In 1942 he had painted a small canvas, 'Sunflower and Sun', which was the precursor of his last great works, the sunflower paintings. In these Nash focused on the sun itself as the source of life and on the sunflowers as representative of the sun on earth. Of the two sunflower paintings Nash completed before his death the most dramatic is 'Solstice of the Sunflower', which was apparently inspired by the ancient fertility rite of rolling a firewheel at the time of the summer solstice. Nash wrote of it, 'The spent sun shines from its zenith encouraging the sunflower in the dual role of sun and firewheel to perform its mythological purpose. The sun appears to be whipping the sunflower like a top. The sunflower tears over the hill cutting a path through the standing corn and bounding into the air as it gathers momentum. This is the blessing of the Midsummer fire.' In the context of the war these pictures can be seen as an optimistic reaffirmation of the forces of life in the face of those of death.

The art of Graham Sutherland (b.1903) is also rooted in an imaginative vision of nature. In the early part of his career, when he worked as an engraver, this was expressed in a series of etchings which strongly reflected the influence of Samuel Palmer, but from 1935 he developed a much more personal style in the medium of oil painting which came to its full maturity at the outbreak of war in 1939–40 in works like the richly poetic 'Green Tree Form: Interior of Woods'. Here Sutherland has adopted essentially the same procedure as Nash and Moore, the transformation or metamorphosis of natural forms to correspond to his own imaginative perception of them, and the tree trunk in this painting is invested with a mysterious and supernatural presence. As with Moore and Nash this imaginative approach proved extraordinarily fruitful when applied to war subjects. Sutherland in 1940 turned to an aspect of the war not touched on by the other two, the landscape of devastation left by the bombing, and produced a series of haunting and tragic visions of the ruined streets and buildings of London.

Brooding on war an artist's thoughts might naturally turn to the theme and image of the Crucifixion, that central symbol in our civilisation of torture, suffering and death, of man's inhumanity to man. So, when in 1944 Sutherland was asked by the present Dean of Chichester to paint an 'Agony in the Garden' for St. Matthew's Church, Northampton, he offered the counter suggestion of a Crucifixion which was accepted. This commission seems to have given a focus and stimulus to Sutherland's imagination and before painting the Crucifixion which now hangs in St. Matthew's he produced a series of paintings based on thorn trees which are very personal expressions of the same theme.

Douglas Cooper in his monograph on Sutherland tells us that the idea of thorns and of wounds made by thorns kept recurring to the artist because he had come to regard the Crown of Thorns as the central symbol of the cruelty involved in the act of crucifixion. All of a sudden he found himself beginning 'to notice thorn bushes and the structure of thorns which pierced the air in all directions'. Sutherland began to draw thorn bushes and has

Graham Sutherland
Somerset Maugham, 1949
Oil on canvas, 54 x 25 in/
137 x 63.5 cm
Tate Gallery

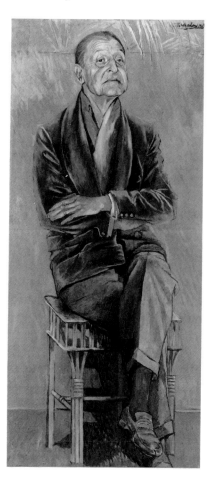

Graham Sutherland
Thorn Trees, 1946
Oil on canvas, 50 x 40 in/
127 x 101.5 cm
British Council

described their visionary transformation as he drew: 'A curious change took place. While preserving their normal life in space, the thorns re-arranged themselves and became something else – a sort of paraphrase of a Crucifixion or a crucified head.' One of the finest of the paintings which resulted from these drawings is the 'Thorn Trees' of 1946 in the collection of the British Council. The thorn tree paintings mark the beginning of the association of human forms and feelings with natural forms, animal and insect as well as vegetable, which has remained the basis of much of Sutherland's art.

However, in the late 1940s he also, unexpectedly, began to paint portraits and quickly proved to have an extraordinary ability to capture the essence of very powerful and successful personalities in compositions often notable for their highpitched but beautiful colours and delicate paint texture. His portrait of Winston Churchill of 1953 seems to have possessed such disturbing power that the Churchill family, as was publicly revealed in early 1978, were driven to destroy it.

With the wartime tendency to increased emphasis on figuration, Euston Road painting came into its own and flourished through the 1940s. Victor Pasmore in particular, following his marriage in 1940, painted a number of marvellously tender and sensitive nudes of his wife Wendy and then in 1942 after his discharge from the army embarked on the series of delicately atmospheric views of the Thames which have become his best known works.

Graham Sutherland
Green Tree Form: Interior of Woods,
1940
Oil on canvas, 31 x 42½ in/
78.7 x 108 cm
Tate Gallery, London

Victor Pasmore
Reclining Nude, 1942
Oil on canvas, 12 x 16 in/
30.5 x 40.6 cm
Tate Gallery, London

The last year of the Second World War and the first years of peace saw the emergence into a late maturity of one of the major figures of post-war British art, Francis Bacon.

Bacon was born in 1909 but only began to paint consistently and

effectively in 1944. He had made some early reputation as an interior designer and painter in the period 1929–34 but then dropped out of sight, painting only sporadically through the Thirties and finally giving up altogether in 1942. The work he produced when he resumed painting in 1944, a tryptych called 'Three Studies for Figures at the Base of a Crucifixion', was the first of his mature masterpieces, the work with which, he has said, 'I began'. 'Three Studies' was exhibited in April 1945 at the Lefevre Gallery in London in a mixed show which also included work by Moore and Sutherland among others. In his book on Bacon published in 1964 the critic John Russell recalled the sensation it caused: 'British art has never been quite the same since the day in April, nineteen years ago, when three of the strangest pictures ever put on show in London were slipped without warning into an exhibition at the Lefevre Gallery. Visitors tempted into that gallery by the already familiar name of Graham Sutherland were brought up short by images so unrelievedly awful that the mind shut with a snap at the sight of them . . . these figures had an anatomy half human, half animal . . . they were equipped to probe, bite and suck . . . two at least of

Francis Bacon
Painting, 1946
Oil and tempera on canvas,
77⅞ x 52 in/197.8 x 132.1 cm
Museum of Modern Art, New York

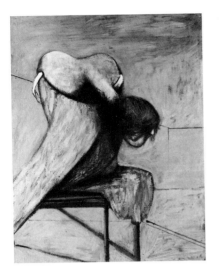
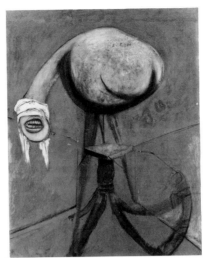
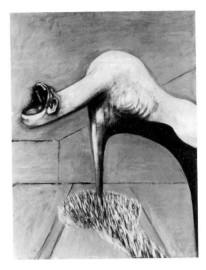

Francis Bacon
*Three Studies for Figures at the Base of a
Crucifixion*, c.1944
Oil on board, each 37 x 29 in/
94 x 73.7 cm
Tate Gallery, London

them were sightless. One was unpleasantly bandaged. They caused a total consternation.'

As we have seen in the case of Sutherland, it is not unnatural for an artist's imagination to turn to the theme of the Crucifixion in time of war, but Bacon had already painted no less than three Crucifixion pictures in 1933, during the first abortive phase of his career, and his example probably helped to turn the thoughts of Sutherland, whom Bacon knew, in that direction in 1944. Two of these Crucifixions look directly forward to his mature work in both style and content and they are evidence of the early appearance in his art of an anguished vision of man which simply took on a new intensity and relevance in the context of war.

The shattering effect of 'Three Studies' and of much of Bacon's subsequent work has its origins, obviously, in the strength of the artist's feelings about the world and his fellow men. But Bacon's genius lies in his ability to create very precise and powerful pictorial equivalents for those feelings. In doing this his basic approach is not unlike that of, for example, Henry Moore; an imaginative transformation of the human figure into an expressive form. However, a crucial difference between Moore and Bacon in this respect is that whereas Moore's figures are generalised, archetypal and timeless images of man, Bacon's, in spite of their distortions, are intensely naturalistic and this is one of the things that gives them their immediacy of impact. Bacon achieves this quality by using photographs as the basis of his paintings. He especially uses high-speed photographs or snap-shots which catch people in unusual or even bizarre attitudes which can be highly suggestive to him. One of Bacon's best known photographic sources is the shot of the screaming nursemaid from Eisenstein's film *Battleship Potemkin* and the two screaming heads in 'Three Studies' are probably based on this. Naturalism becomes much more marked in Bacon's work after 'Three Studies' and, very significantly, the image becomes specifically one of modern urban man, as in the astonishing 'Painting' (it has no other title) of 1946, which remains perhaps Bacon's greatest work. Here Bacon's vision of man as an anguished, isolated being whose only certainty is of death is fully developed and remains essentially unchanged to this day. The sides of meat in particular are powerful emblems of mortality, and in an interview with the critic David Sylvester in 1966 Bacon said, 'Well, of course, we are all meat, we are potential carcasses.'

The effectiveness of Bacon's painting does not just stem from the imagery. By the time he made 'Painting' in 1946 he had evolved an extraordinary and unique method of spontaneous and improvisatory painting in which

the image is not rendered in an illustrational way but embodied in the very texture of the paint and the form of the brushstroke. This produces an exceptionally direct impact on the perception of the spectator. In a tribute to the painter Matthew Smith written in 1953 Bacon himself has summed up his attitude to the act of painting better than anyone who has ever written about him. Here he wrote that for him painting meant making 'idea and technique inseparable. Painting in this sense tends towards a complete interlocking of image and paint so that the image is the paint and vice versa. Here the brushstroke creates the form and does not merely fill it in. Consequently every movement of the brush on the canvas alters the shape and implications of the image. That is why real painting is a mysterious and continuous struggle with chance – mysterious because the very substance of the paint, when used in this way, can make such a direct assault on the nervous system; continuous because the medium is so fluid and subtle that every change that is made loses what is already there in the hope of making a fresh gain. I think that painting today is pure intuition and luck and taking advantage of what happens when you splash the bits down . . .'

In the 1940s Moore, Nash, Sutherland and Bacon appear as the dominant figures in a phase of British art which has come to be known as Neo-Romanticism. This included artists of an older generation like Ceri Richards, John Piper and Ivon Hitchens who turned to imaginative landscape painting as well as a whole group of younger artists. Of these John Craxton (b.1922), John Minton (1917–57) and Michael Ayrton (1921–1975) all produced richly romantic landscapes in the tradition of Samuel Palmer and Nash before turning in other directions. The Scottish

Lucian Freud
Girl with a White Dog, 1950–1
Oil on canvas, 30 x 40 in/
76.2 x 101.6 cm
Tate Gallery, London

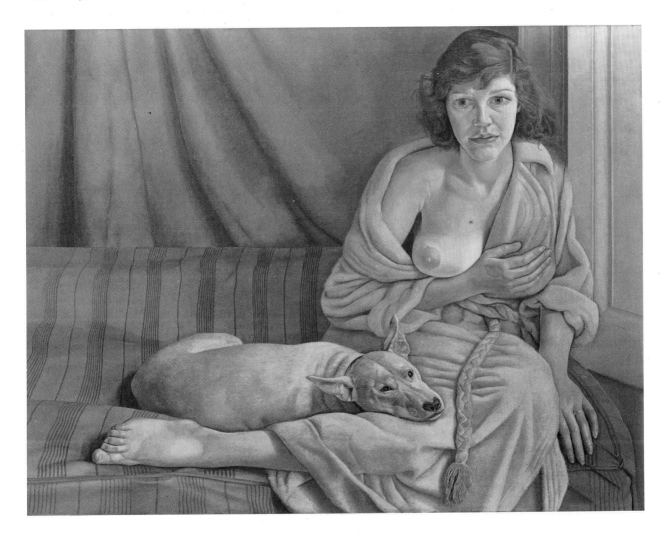

artists Robert Colquhoun (1914–62) and Robert MacBryde (1913–66) painted figure subjects expressive of pathos and loneliness.

Lucian Freud (b.1922) was perhaps the outstanding figure among the young Neo-Romantics, painting figure subjects in a sharply focused, obsessive manner to produce an effect of almost neurotic emotional intensity. About 1960 his style became looser, more 'painterly', but without any loss of intensity of vision, and he remains one of the most distinguished living British painters of the human figure.

Chapter 22
Abstract Art Post-War

Victor Pasmore
Spiral Motif in Green, Violet, Blue and Gold: the Coast of the Inland Sea, 1950
Oil on canvas, 32 x 39½ in/
81.3 x 100.3 cm
Tate Gallery, London

About the year 1950 a renewal of interest in abstract art took place in Britain. A central figure in this was the Euston Road painter Victor Pasmore. At the time he was painting his Thames pictures he had begun a searching investigation of the nature of modern art, reading the published writings of the great Post Impressionists, Van Gogh, Gauguin and Cézanne, and of the Russian pioneer of abstraction, Kandinsky, and he came to feel that modernism could not be ignored. He was confirmed in this view by the great Picasso and Matisse exhibition at the Victoria and Albert Museum in 1945, English artists' first view of Continental modernism since the beginning of the war. His Thames views became more and more abstract and, apparently, difficult to finish and finally in 1948, after moving to Blackheath, he decided to start from scratch with abstract art and systematically explore its possibilities.

Victor Pasmore
Synthetic Construction (White and Black), 1965–6
Relief in various media,
48¼ x 48¼ x 10¾ in/
122.6 x 122.6 x 27.3 cm
Tate Gallery, London

Victor Pasmore
Yellow Abstract, 1960–1
Oil on board, 48 x 48 in/
121.9 x 121.9 cm
Tate Gallery, London

By about 1950 he was using a range of simple geometric forms, the square, the spiral and the triangle, and using them to create richly coloured and lyrical pictures like 'Spiral Motif in Green, Violet, Blue and Gold: the Coast of the Inland Sea' (1950) which still, as this title implies, retains some residual landscape reference. However, Pasmore was at pains to point out that this was only a *reference*. The painting was essentially an abstract construction. In 1945 he wrote, 'The picture was one of a limited series of landscape themes developed by means of a free construction of pure form elements, either the spiral line as in this case or the square as in the "Eclipse" (also in the Tate Gallery). By developing and arranging those forms in certain ways and by emphasising their emotive qualities an image finally formed suggestive of certain landscape forms.' And he emphasises that 'In each case the title was suggested by the completed picture, in no instance was the picture a representation of an existing or preconceived image.' In spite of this he felt he needed to eliminate the landscape reference but found this extremely difficult to do, perhaps because of his long practice as a figurative painter. He was also dissatisfied with the illusionistic nature of space in painting. In the end he was only able to achieve a pure non-referential abstraction and to create a concrete and real, as opposed to illusionistic, space by making a radical change of format and starting to work in relief.

His first 'Relief Paintings' were made in 1951 and still had a 'painterly' hand-made quality. But this quickly disappeared, together with colour, since Pasmore had come to believe that modern art should come to terms with machine technology, and the reliefs became extremely pure and impersonal with a mechanically crafted feel. He also began to explore the possibilities of transparent material, perspex, and perhaps his most striking reliefs are those in which he creates subtle and complex spatial effects by introducing a transparent plane and building both forwards, backwards and sideways from it. A good example is the 'Synthetic Construction (White and Black)' of 1965-6.

In 1957 Pasmore felt able to return to two-dimensional painting without compromising the degree of pure abstraction he had achieved, although the paintings he then began to make, like 'Yellow Abstract' of 1960-1, have a freer and more lyrical quality than the reliefs and mark a return to his work of some of the qualities of his earlier painting. Since 1957 he has moved freely between relief construction and painting.

Besides Pasmore a number of British artists moved sharply towards abstraction in the period around 1950. They fall naturally into two quite distinct groups. Closest to Pasmore were Kenneth Martin (b.1905), his wife Mary (b.1907) and Anthony Hill (b.1930), all of whom adopted the extreme approach of abandoning painting in favour of pure geometric construction, and together with Pasmore they are generally referred to as the British Constructivists.

The other much larger group continued to use painting as a medium and adopted a free 'painterly' approach which emphasised richness of colour and texture and bold spontaneity of brushwork rather than an impersonal geometry. In fact almost all these artists retained more or less strong references to landscape or, less often, the human figure. Most of them found their way sooner or later to Cornwall, specifically to St. Ives and its environs, drawn by the place's long history as an art colony dating back to the 1880s, and of course by the continuing presence of Ben Nicholson and Barbara Hepworth, who had quietly continued working throughout the war and who in the post-war period were beginning to acquire international reputations. With this influx of new talent St. Ives became a

Peter Lanyon
Porthleven, 1951
Oil on board, 96¼ x 48 in/
244.5 x 121.9 cm
Tate Gallery, London

centre of some importance in British art in the 1950s and 60s and the artists associated with it have become known as the St. Ives School.

Among the leading figures Peter Lanyon (1918–64) was the only native-born Cornishman. He had been taught by Ben Nicholson privately during the war and was also strongly influenced by Naum Gabo who had settled in St. Ives in 1939. He produced some remarkable pure abstract constructed reliefs during the war but afterwards turned, in both painting and relief construction, to the landscape-based abstraction which is the typical form of St. Ives art. His enormous 'Porthleven' of 1951 is one of his major paintings and a good example of the way in which in his work the elements of a view, including colours, light and atmosphere as well as buildings – the village church can be seen at the top of the picture – can be brought together in an essentially abstract arrangement.

Very similar is the approach of Terry Frost (b.1915), a close friend of Lanyon before Lanyon's premature death in 1964, who first went to St. Ives in 1946. Frost went to Camberwell School of Art in London in 1947 where he was taught by Victor Pasmore – 'He was my god,' Frost later said – and on his return to Cornwall worked for Barbara Hepworth for a time which also had an important effect on his development. Between 1951 and 1953 Frost painted a number of pictures, among his most important early works,

inspired by the rocking movement of boats in St. Ives harbour and in 1954, in a book called *Nine Abstract Artists* edited by the critic Lawrence Alloway, he published a highly illuminating account of the genesis of one of them, 'Blue Movement' of 1953:

'I had spent a number of evenings looking out over the harbour at St. Ives in Cornwall. Although I had been observing a multiplicity of movement during those evenings, they all evoked a common emotion or mood – a state of delight in front of nature. On one particular blue twilit evening, I was watching what I can only describe as a synthesis of movement and counter-movement. That is to say the rise and fall of the boats, the space drawing of the mastheads, the opposing movements of the incoming sea and out-blowing off-shore wind – all this plus the predominant feel of blue in the evening and the static brown of the foreshore generated an emotional state which was to find expression in the painting...I was trying to give expression to my total experience of that particular evening. I was not portraying the boats, the sand, the horizon or any other subject matter but

Patrick Heron
Horizontal Stripe Painting:
November 1957–January 1958
Oil on canvas, 110 x 60 in/
279.4 x 152.4 cm
Tate Gallery, London

Terry Frost
Blue Movement, 1953
Oil on masonite, $43\frac{5}{8} \times 48\frac{1}{8}$ in/
110.8 x 122.2 cm
Vancouver Art Gallery

Roger Hilton
February 1954
Oil on canvas, 50 x 40 in/
127 x 101.6 cm
Tate Gallery, London

concentrating on the emotion engendered by what I saw. The subject matter is in fact the sensation evoked by the movement and the colour in the harbour. What I have painted is an arrangement of form and colour which evokes for me a particular feeling.'

The approach of Lanyon and Frost is very close to that also adopted by Roger Hilton (b.1911), although he did not work in Cornwall until 1957, finally settling there in 1965. Hilton uses forms relating to the human figure as well as landscape, and his work is particularly notable for its rich and sensuous handling of paint and bold flat patterning of interlocking shapes, as in the Tate Gallery's 'February 1954', where the image is based on a girl lying on her back.

Patrick Heron (b.1920) settled in Cornwall in 1956, at which time he was already established as a notable writer on art as well as a painter, and in his role as critic he played a crucial role both in hammering out the theoretical basis of abstract painting in Britain and in conducting a vigorous polemic on its behalf at a time when it was far less readily accepted than is now the case. Very importantly, he was one of the first British artists to respond to the radically new kind of painting, very large-scale and completely abstract without any of the landscape associations of, for example, St. Ives, which was being developed by the post-war generation in America, mainly in New York. The first proper showing in London of the New York School, as it has come to be called, was in 1956 at the Tate Gallery. Heron was at this time London correspondent of the New York magazine *Arts* and he wrote of the exhibition, 'I was instantly elated by the size, energy, originality, economy and inventive daring of many of the paintings...your new school comes as the most vigorous movement we have seen since the war.'

The American influence plus an existing belief in the overriding importance of colour as an element in painting led Heron in 1957, virtually from the moment he settled in St. Ives, to take a decisive step beyond his contemporaries there and develop a large-scale art of pure colour and space from which all vestiges of reference to external reality were eliminated. In March 1957 he began a remarkable series of paintings which were composed simply of broad, loosely brushed stripes of colour running from edge to edge of the canvas, either horizontally on a tall vertical canvas or vertically on a long horizontal canvas. The largest and most spectacular of these is the 'Horizontal Stripe Painting: November 1957–January 1958'. In an article published in 1958 Heron wrote, 'My main interest, in my painting, has always been in colour, space and light,' and, specifically on the subject of 'Horizontal Stripe Painting', he wrote, 'Early in 1957 when painting my first horizontal and vertical colour stripe paintings, the reason why the stripes sufficed as the formal vehicle of the colour, was precisely that they were so very uncomplicated *as shapes*. I realised that the emptier the general format was the more exclusive the concentration upon the experiences of colour itself.' After exploring the stripe format for almost a year Heron then developed a more complex compositional structure in which simple coloured forms, basically circles and rectangles, are floated against a ground of another colour and he has continued to extend this format up to the present day.

One other artist was crucially influenced by American post-war art in the late Fifties, the painter and sculptor William Turnbull, (b. 1922), who visited New York for the first time in 1957. On his return Turnbull began to produce large paintings which are remarkable for their extreme degree of abstraction. Like Heron, Turnbull is obsessed with colour, but he went much further than Heron ever had in making colour the main vehicle of

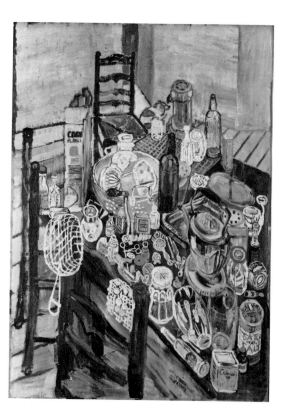

expression in painting, and a number of his canvases of the late Fifties are actually monochrome, inflected only by the texture of the paint like 'No.7 1959'.

Two independent figures, both of whom had early contact with post-war American painting were Alan Davie (b.1920) and William Scott (b.1913). Davie was strongly affected by the work of Jackson Pollock which he first saw in 1948 in the Peggy Guggenheim collection in Venice. He began to produce freely painted works which although in effect abstract retained a strong suggestiveness and mystery in their forms.

The effect of American painting on William Scott seems to have been largely a negative one, confirming his belief in the traditions of modern European painting. His mature art is richly sensuous and semi-abstract based on still life and occasional figure motifs in the tradition of Matisse and Bonnard.

Above left:
William Turnbull
No.7 1959
Oil on canvas, 78 x 58½ in/
198.1 x 148.6 cm
Tate Gallery, London

Above right:
John Bratby
Still Life with Chip Frier, 1954
Oil on board, 51¾ x 36¼ in/
131.4 x 92.1 cm
Tate Gallery, London

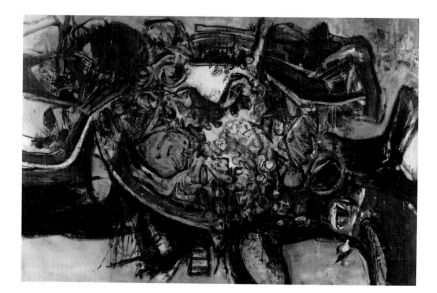

Alan Davie
Birth of Venus, 1955
Oil on board, 63 x 96 in/
160 x 243.8 cm
Tate Gallery, London

[170]

Frank Auerbach
E.O.W. Nude, 1953–4
Oil on canvas, 20 x 30¼ in/
50.8 x 76.8 cm
Tate Gallery, London

Two other individualists who came to maturity in the early 1950s were Frank Auerbach (b.1931) and Leon Kossof (b.1926) both of whom had been pupils of David Bomberg and inherited the freely painted manner Bomberg had developed between the wars in sharp contrast to his early work. Both evolved a semi-abstract art in which the image, figure or landscape is buried in, and appears to emerge from, extremely thick freely applied paint.

About 1953–6, and to some extent paralleling the Euston Road School's reaction to abstraction in the late Thirties, a group of young painters made a shortlived return to realism. The leading figures were Jack Smith (b.1928), Edward Middleditch (b.1923) and John Bratby (b.1928). Their characteristic paintings of ordinary domestic surroundings led to their being named the Kitchen Sink School.

An isolated figure whose work came to seem of particular relevance in the post-war period was L. S. Lowry (1887–1976). Throughout a long career he consistently expressed a bleak but not inhumane vision of the people and surroundings of the old industrial cities of Manchester and Salford in a simple, almost childlike style which has proved to have great popular appeal.

Chapter 23
Sculpture Post-War

The post-war period saw an explosion of sculptural activity in Britain. Henry Moore and to a lesser extent Barbara Hepworth remained the dominant figures, but in the late Forties and early Fifties a whole generation of younger sculptors came to maturity: Eduardo Paolozzi, William Turnbull, Reg Butler, Kenneth Armitage and Lynn Chadwick.

The work of this group of sculptors, like the painting of Bacon and Sutherland, undoubtedly reflects feelings and ideas aroused by the war and its aftermath and these feelings were expressed through various distortions,

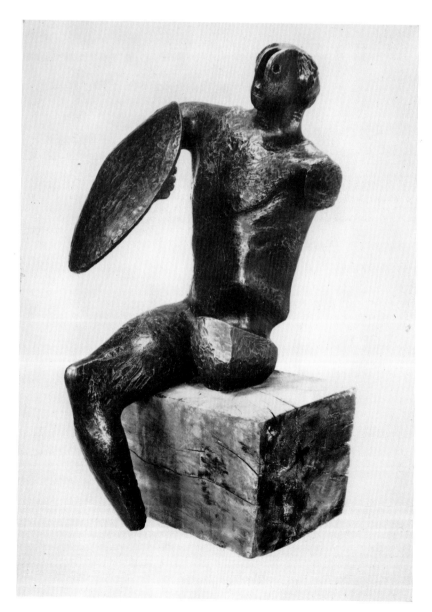

Henry Moore
Warrior with Shield, 1954
Bronze, 60¼ in/153 cm high
City Art Gallery, Birmingham

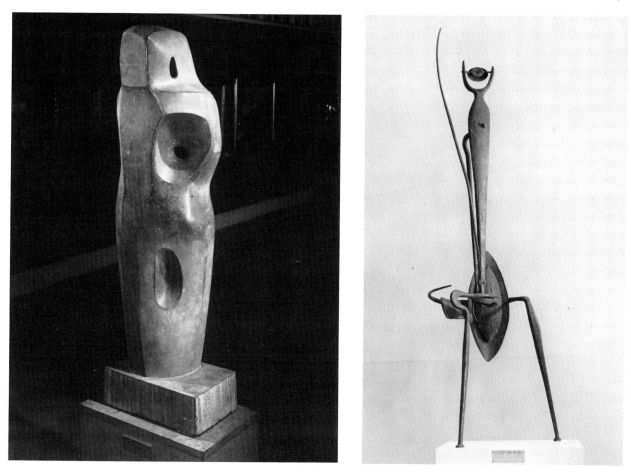

Above left:
Barbara Hepworth
Bicentric Form, 1949
Blue limestone, $62\frac{1}{2}$ x 19 x $12\frac{1}{4}$ in/
158.8 x 48.3 x 31.1 cm
Tate Gallery, London

Above right:
Reg Butler
Woman, 1949
Iron, 87 x 28 x 19 in/
221 x 71.1 x 48.3 cm
Tate Gallery, London

mutilations and imaginative transformations of human and sometimes animal and insect forms and through the use of open, spidery, spiky structures and jagged textures. The medium of bronze proved particularly suitable and appropriate for the creation of such imagery and at least two artists, Reg Butler (b.1913) and Lynn Chadwick (b.1914), made extremely effective use of forged iron. Carving as a sculptural medium took very much of a back seat from this time on.

Perhaps the central example of this development was created by Henry Moore in 1953–4 when he made the 'Warrior with Shield' of which five casts exist, one of them in the City Art Gallery in Birmingham. In 1955, Moore gave an extremely explicit and revealing account of this work:

'The idea for the "Warrior" came to me at the end of 1952 or very early in 1953. It was evolved from a pebble I found on the seashore in the summer of 1952 and which reminded me of the stump of a leg, amputated at the hip . . . this gave me the start of the Warrior idea. First I added the body, leg and one arm and it became a wounded warrior, but at first the figure was reclining. A day or two later I added a shield and altered its position and arrangements into a seated figure, and so it changed from an inactive pose into a figure which, though wounded, is still defiant. The head has a blunted and bull-like power but also a sort of dumb animal acceptance and forbearance of pain.

'The figure may be emotionally connected (as one critic has suggested) with one's feelings and thoughts about England during the crucial and early part of the last war. The position of the shield and its angle gives protection from above . . . This sculpture is the first single and separate male figure that I have done in sculpture and carrying it out in its final large scale was almost like the discovery of a new subject matter: the bony, edgy, tense

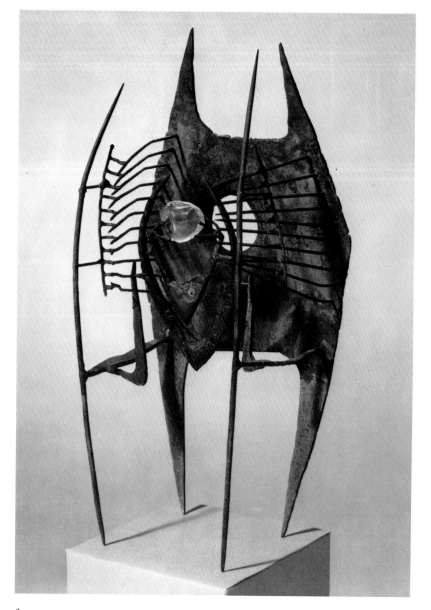

Lynn Chadwick
The Inner Eye (Maquette III), 1952
Metal and glass, 11¼ x 6 x 4 in/
28.6 x 15.2 x 10.2 cm
Tate Gallery, London

forms were a great excitement to make.'

Sculpture of welded and forged iron can be made much lighter and more open than is possible even in bronze and both Reg Butler and Lynn Chadwick exploited this fact to create strange skeletal creatures, like Butler's 'Woman' of 1949 and Chadwick's 'The Inner Eye' of 1952, which combine in a disturbing fashion human and insect characteristics. Like Moore's warrior, defiant behind his shield, these figures express both aggression and protectiveness. The vulnerable 'inner eye' of Chadwick's creature is enclosed within its body behind a threatening barrier of spikes, and the abdomen of Butler's 'Woman' is protected on one side with a massive plate in the form of her sexual parts and on the other by a tapering, outward-curving spike.

Armitage (b.1916), Turnbull and Paolozzi (b.1924) all worked in bronze. Armitage's 'Diarchy' of 1957 is one of a series of works in which he combined two or even three human figures into, as he has said, 'Simple masses in which an indefinite number of limbs, sex appendages etc. could then fully be used...' As in 'Diarchy', the result of this combination is always a flat slab or wall from which protrude heads, breasts, arms and legs. Armitage has suggested that these slab forms may be connected with memories of the shape and silhouette of tanks which were deeply impressed

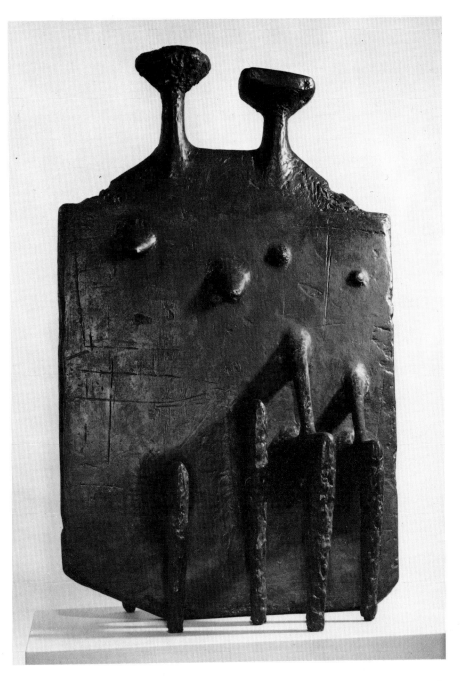

Kenneth Armitage
Diarchy, 1957
Bronze, 67¼ x 42¾ in/
170.8 x 108.6 cm
Tate Gallery, London

on him during the war, when he ran a War Office training centre in tank and aircraft identification.

The work of Turnbull and Paolozzi is distinguished by the degree to which in about 1948–9 they abandoned direct figurative references while still expressing recognisably the same themes as their contemporaries through the forms and textures of their work. One of William Turnbull's most effective works of that period, 'Heavy Insect' of 1949, still has residual figurative references although he made other works in the same year which consist simply of spiky or blobby stick-like elements. In the same year Paolozzi made 'Forms on a Bow' in which mutually threatening forms are threaded on a rod.

Barbara Hepworth continued to carve but also began increasingly to use bronze. In both media, references to landscape and the human figure became more overt than in her immediately pre-war work although her sculpture lost none of its basic formal purity. She became particularly pre-occupied with the idea of an upright form referring both to man and to

prehistoric religious monuments like the Avebury stones and with the relationship of this form to landscape. One of her most powerful and beautiful expressions of this theme is the large carving 'Bicentric Form' of 1949.

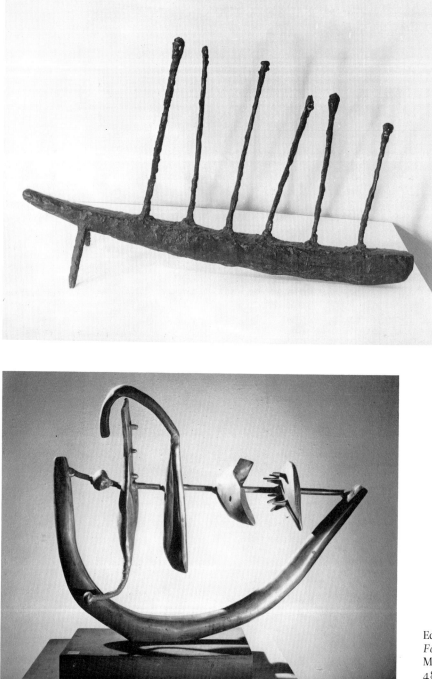

William Turnbull
Heavy Insect, 1949
Bronze, $18\frac{3}{4} \times 9\frac{1}{2} \times 33\frac{1}{4}$ in/
47.6 x 24.1 x 84.5 cm
Kim Lim

Eduardo Paolozzi
Forms on a Bow, 1949
Metal, $19 \times 25 \times 8\frac{1}{2}$ in/
48.3 x 63.5 x 21.6 cm
Tate Gallery, London

Chapter 24
Sculpture in the Sixties

In the early 1960s a revolution took place in British sculpture. This revolution was pioneered by two artists, Anthony Caro (b.1924) and the younger Phillip King (b.1934), both of whom had been assistants to Henry Moore–Caro from 1951–3, King from 1958–9–and whose work up to about 1959–60 was close to his. However, at that time both became dissatisfied with the prevailing sculptural style, probably largely because in both form and content it seemed a hangover from the war and no longer relevant in the social climate of the new decade. This was certainly the case with King, who visited the international *Documenta* exhibition in Germany in 1960 and later wrote, 'The sculpture there was terribly dominated by a post-war feeling which seemed very distorted and contorted. Moore stood out with the English school ... And it was somehow terribly like scratching your own wounds–an international style with everyone showing the same neuroses.' King was made particularly aware of this neurotic quality of English and European sculpture by the presence in the same exhibition of the large-scale, luminous, colourful, decorative abstract painting of the American post-war school whose counterpart was beginning to emerge in Britain in the work of painters like Patrick Heron: 'The contrast with the American painting there was important too ... a message of hope and optimism, large-scale, less inbred.'

By the time King made that crucial visit to *Documenta*, Anthony Caro had already been to America and experienced that 'message of hope and optimism' at first hand, not only in painting but in the sculpture of the American David Smith who by the late 1950s was doing completely

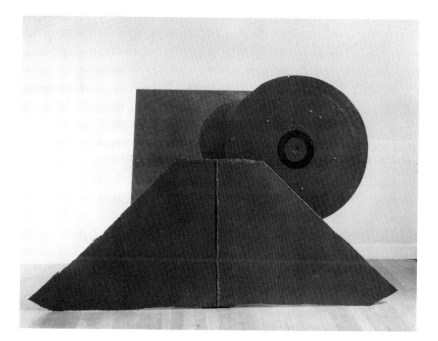

Anthony Caro
Twenty-Four Hours, 1960
Painted steel, 54½ x 88 x 33 in/
138.4 x 223.5 x 83.8 cm
Tate Gallery, London

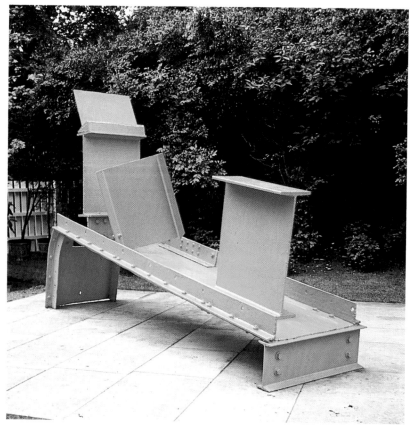

Anthony Caro
Midday, 1960
Painted steel, 94 x 38 x 144 in/
238.8 x 96.5 x 365.8 cm
Artist's collection

abstract sculptures made up of separate sections of iron or steel plates, beams and girders welded together into very open and often very large structures and sometimes painted in bright colours with car-body enamel. Especially in their use of colour, but also in the way they functioned through the relationship of separate shapes in space, these sculptures were like a three-dimensional abstract painting. This was a completely new concept of sculpture and it was a revelation to Caro.

When he returned to Britain he began working in welded iron and steel and after making what can be seen as a transitional work, 'Twenty-Four Hours', which still has rather 'Fiftyish' jagged edges and a sombre brown colour, he broke through to full maturity in 1960, almost like the sun breaking through clouds, with the radiant, bright yellow-orange sculpture he called 'Midday', his first masterpiece and still one of his greatest works.

From the beginning Caro's sculpture was crucially different from that of Smith in that it had no base but rested directly on the ground. The significance of this for Caro's own work and for that of all later sculptors was enormous; freeing sculpture from the base was like letting a man out of prison: a completely new scale became possible, as for example in Caro's 20-foot (6 m) long 'Early One Morning' in the Tate Gallery, as well as an equally new relationship both to its environment, indoor or out, and to the spectator.

The exceptionally open, sprawling character which baselessness gave to Caro's sculpture led him to use colour in a different way from Smith too, painting his sculptures in a single colour rather than several, in order to unify them. This practice, however, gives the colour much greater prominence and impact than in the work of the American and one of the most important and original aspects of Caro's sculpture is that in it, as in no other sculpture ever before, colour plays an equal role with form and structure.

Colour also plays a very important part in Phillip King's work, but right from the beginning he was also fundamentally concerned with the systematic exploration of the basic vocabulary of sculptural form. This is clearly apparent in his first mature work, 'Declaration' made early in 1961. This is an extraordinarily original and personal piece made of green-coloured concrete and marble chippings, although King was strongly stimulated in making his breakthrough by Caro's example in his work of 1960. King later wrote of 'Declaration', 'I called it "Declaration" because in a sense it was a manifesto piece for me. I suddenly established new ideas about fundamental forms and sculpture being off the pedestal and extending on the ground and stretching out. I was also interested in repetition and symmetry.' 'Declaration' is essentially an exploration of the sculptural possibilities of three elementary forms, the circle, the square and the cross. What is remarkable about it, however, is the way in which King has forged these simple elements into a rich, complex and even rather grand and mysterious whole. He was never to make such an elementary work again and his sculpture after 'Declaration' is in fact characterised by a strong element of fantasy which, combined with the basic formal exploration, gives it a unique character. One of his most important early series of works was a set of variations on the basic theme of the cone, one of which is the gigantic 'Genghis Khan' of 1963, a completely abstract sculpture nevertheless imbued with an astonishing presence and imaginative power.

The highly decorative, colourful, confident, optimistic sculpture of King and Caro rapidly became widely popular and was practised by a whole group of younger artists, notably David Annesley, Michael Bolus, Tim Scott, William Tucker and Isaac Witkin. With them can be associated one sculptor

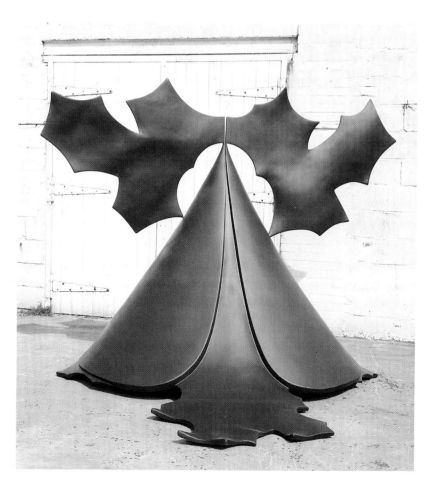

Phillip King
Genghis Khan, 1963
Fibreglass and plastic with steel supports, 84 x 108 x 144 in/
213.4 x 274.3 x 365.8 cm
Tate Gallery, London

of an older generation, William Turnbull, who had independently evolved a pure abstraction. The style became particularly associated with St. Martin's School of Art in London where Caro taught from 1953–66 and King from 1959–67. A large collection of the work of these artists with the exception of Caro was made by Alistair McAlpine and in 1971 he presented the bulk of it, sixty sculptures altogether, to the Tate Gallery.

Phillip King
Declaration, 1961
Cement and marble chippings,
33 x 82 x 33 in/83.8 x 208.3 x 83.8 cm
Leicestershire Education Authority

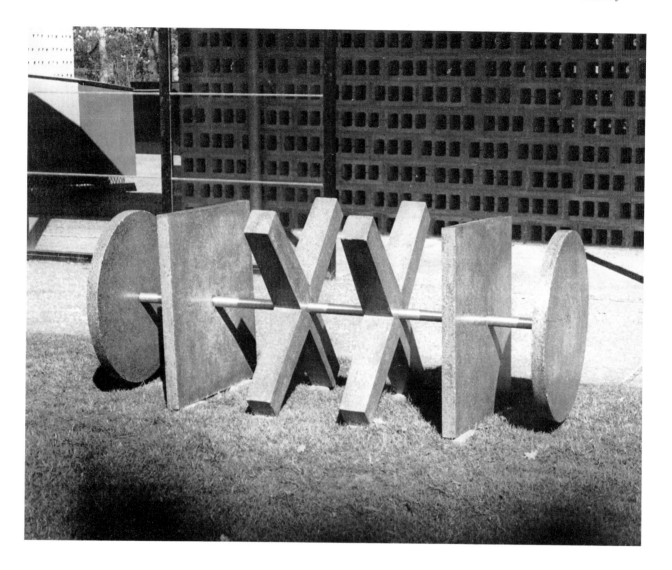

Chapter 25
Abstract Painting in the Sixties

The work of Heron and Turnbull in the late 1950s marks the beginning in Britain of a kind of painting which, having been developed in the 1950s in America, became in the decade of the 1960s an international style dominating Western painting. No really satisfactory art historical term has been coined to describe this style and it is probably best referred to simply as 'Sixties Abstraction'. Broadly speaking, Sixties Abstraction represents the ultimate extension of the whole idea of abstract painting, of a purely visual art functioning solely through the impact on the spectator of the basic elements of painting: colour, lines, form, texture, scale and so on. During the Sixties the possibilities and permutations of the idea were very thoroughly explored and worked out and a great mass of big, bold, confident and often very beautiful abstract painting was produced, ranging in Britain from the extreme simplicity of Turnbull to the often very complex works of Bernard Cohen. In its use of bright colour and large scale and in its exploration of the basic language of picture-making this painting has much in common with the sculpture of the period, and Turnbull in particular made a distinguished contribution to both sculpture and painting.

Sixties Abstraction was launched in Britain at an exhibition in London in 1960 called *Situation* to which the most important contributors were Turnbull, Bernard Cohen, Robyn Denny, John Hoyland and Richard Smith. There were no St. Ives painters, not even Heron. A thoughtful catalogue introduction by Roger Coleman explained that the conditions for selection for the exhibition were 'that the works should be abstract (that is without explicit reference to events outside the painting–landscape, boats, figures–hence the absence of the St. Ives painters, for instance) and not less than 30 square feet [2.79 sq. m]'. This last condition may seem odd but it must be stressed at this point, as Coleman went on to stress at length in his catalogue introduction, that large scale was a factor of overriding importance to the Sixties painters. Of course there had been large paintings before but, as Coleman pointed out, 'They had tended to be the careful, prepared-for exception, whereas since they have become the rule. In fact 25–30 square feet is now considered quite an average size for a painting.'

The combination of the consistent use of large scale with rigorous abstraction produced paintings which worked in a quite different way from previous abstract art. In particular, it becomes, in Coleman's word, 'environmental'–at a normal viewing distance the work fills the spectator's whole field of vision even to the point 'where in some cases a turn of the head of several degrees right or left is needed before it can be fully incorporated into his experience'. This was a complete reversal of the normal relationship of spectator to art object. A second effect was that the painting's identity as a real object in its own right, rather than as an illusionistic representation of some other reality, was very strongly asserted and this, as Coleman again emphasised, was something to which abstract artists had always attached great importance. The denial of illusion was

William Turnbull
No.1, 1962
Oil on canvas, 100 x 148 in/
254 x 375.9 cm
Tate Gallery, London

John Hoyland
28.5.66, 1966
Acrylic on canvas, 78 x 144 in/
198.1 x 365.8 cm
Tate Gallery, London

reinforced by the almost universal practice of Sixties Abstract painters of not framing their canvases–the function of the traditional frame being of course to enhance the illusion of looking through the surface of the picture to space beyond.

After the thickly painted monochromes of around 1957 Turnbull began to use thin paint, soaking it into the surface to create fields of saturated colour. He also reintroduced elements of composition, but they were kept very simple, the canvas vertically divided into two colour areas, for example, so as not to disturb the impact of the colour field. The vertical division is the basis of 'No.1, 1962', but Turnbull has given this work an added subtlety and complexity by physically dividing the work at a different point from the division of the blue and green colour field.

John Hoyland also made saturated colour fields but unlike Turnbull set forms against them to explore the resulting relationships. In '28.5.66' the upright form of contrasting green seems to throb and pulsate against the red ground, creating a visual effect of vibrant power.

The work of Robyn Denny on the other hand is intensely calm and meditational in character. In his work of the early and mid-Sixties, such as 'Garden' of 1966–7, he typically achieves this effect by the use of symmetry–an open linear form, itself symmetrical, placed centrally on the canvas–and by the use of extraordinarily beautiful colours, usually soft and muted, brought into tonal relationships of equally extraordinary subtlety. The colour is applied to an absolutely immaculate smooth matt finish so

Robyn Denny
Garden, 1966–7
Oil on canvas, 96 x 78 in/
243.8 x 198.1 cm
Tate Gallery, London

Bernard Cohen
In That Moment, 1965
Oil and tempera on canvas, 96 x 96 in/
243.8 x 243.8 cm
Tate Gallery, London

that the surface of the painting is impossible to perceive and the spectator, his attention fixed by the central motif, looks into what appears to be an infinite coloured misty space.

The paintings of Bernard Cohen are strikingly different from those of his contemporaries and this results from his highly individual approach to the making of abstract art. The nature of this approach is best appreciated by taking an actual example such as the Tate's 'In That Moment' of 1965. This painting consists of a single line starting from the bottom edge of the canvas and simply extended, crossing and recrossing itself until the whole surface is covered and the ground obliterated, at which logical point the line is brought back to the base again and the painting is finished. The colour of the line is changed at random intervals and the glowing neon-like effect is the result of it being applied over a layer of brilliant white. Thus the exact final appearance of the painting could not have been preconceived, it is largely the outcome of the process of painting it and it is this which gives Cohen's work its characteristic richness of appearance.

The work of Richard Smith, the other major member of the Situation Group, relates as much to the other principal development in British art about 1960, 'Pop', as to Situation painting and he will be discussed in the next chapter.

Two independent painters who matured through the Sixties were Bridget Riley (b.1931) and Howard Hodgkin (b.1932). Bridget Riley developed a form of pure abstraction in which systematic compositional procedures are used to create optically active works whose effects range from the uncomfortably disturbing to the poetically beautiful. In the mid-Sixties this kind of art was nicknamed 'Op' and became an international phenomenon with Riley as one of its most prominent practitioners.

Howard Hodgkin is a painter of a very different kind. Like William Scott, he has continued the European tradition of Bonnard and Matisse of sensuous, decorative, restrained painting. Among Hodgkin's favourite motifs are domestic interiors which he transforms into richly coloured and textured abstractions.

By the mid-Sixties a second, younger, generation of large-scale abstract painters was emerging in the wake of the Situation Group. Among the most prominent of these was John Walker (b. 1939).

Bridget Riley
Fall, 1963
Acrylic on board, $55\frac{1}{2}$ x $55\frac{1}{4}$ in/
141 x 140.3 cm
Tate Gallery, London

Chapter 26
Pop Art

As we have seen, in the 1940s Francis Bacon began to use photographic images as the partial basis of a new kind of figurative art. From about the same time a number of younger artists also began to interest themselves in photographic source material as a way of bringing art back into touch with the real world without in any way reverting to the traditional forms of representational art.

The interests of these younger artists were, however, much wider than, and in the end quite distinct from, those of Bacon. They rejected the heavy emotionalism and subjectivity of his and much other British art of the period and turned instead outwards and to the future, looking for their source material at the two closely connected worlds of industry, technology and commerce on the one hand and of mass communications, mass entertainment and popular culture on the other. It should be stressed at this point that in the immediate post-war period in Britain these were aspects of Western civilisation which appeared to most people, particularly of an older generation, to be utterly remote from any considerations of art or culture. But to the young artists who were beginning to look at them they seemed vital and dynamic, capable of providing powerful new inspiration for their art.

This development gathered pace throughout the 1950s and by about 1960 it had become visible as a major movement in British art and one which had its counterparts in Europe and the USA. By that time the interest in popular culture had become the most obvious characteristic of the new art and at some point around 1962 it became generally known as Pop Art.

With the new source material went a new approach. Because the source images of Pop Art were *already* pictures of some kind the artists tended to concentrate on the idea content of the work and on the formal problems of organising the images into new pictorial structures. Pop Art was thus in a sense a very abstract art: images of reality being used as the building blocks of a composition in the same way as non-representational elements in abstract art. Given this approach, it is not surprising that the procedures of collage played an important part in Pop Art. Collage involves the bringing together of separate and disparate elements to form an integrated and unified composition. It can be either two-dimensional or three-dimensional, that is to say assemblage or relief construction, and Pop artists used both these forms. They also adapted the compositional method of collage to painting, sometimes in a pure form but often making paintings with real collaged elements, either two-dimensional or relief or both.

The pioneer of interest in popular culture among British artists was the sculptor Eduardo Paolozzi who, from the start of his art education at Edinburgh College of Art in 1941, earned the disapproval of his teachers for copying pictures of aeroplanes, footballers and film stars. By the late 1940s and at a time when as we have seen his sculpture had a very different character (see p.175), he was making extraordinary collages like 'I was a

Rich Man's Plaything' of 1947, made from advertisements, packaging, lurid popular magazine covers and similar materials. This example is especially striking since it already projects the optimistic and pleasure-orientated ethos of the affluent consumer society which was not to come to Britain until a decade later in the Macmillan era but was already in full swing in the USA, symbolised above all by the Coca Cola bottle and trademark. It is also remarkable for its inclusion of the word 'Pop', probably its first appearance in art.

In 1947 these early collages were rather isolated phenomena but a few years later, in the winter of 1952–3, Paolozzi was able to alert other artists to the possibilities and significance of popular culture through his membership of the Independent Group of the Institute of Contemporary Arts in London. The Independent Group, or IG, was a ginger group within the Institute and included, besides a number of artists, the architectural and design historian Reyner Banham and the critic Lawrence Alloway. At the very first meeting of the first season of the IG, early in 1953, Paolozzi gave a now celebrated lecture which consisted of the rapid projection, using an epidiascope, of a very large number of the kind of images he used for his collages. The IG's second season did not take place until the winter of 1954–5 and it was then, according to Reyner Banham, that the beginnings of the theory of Pop Art emerged – that is, the idea that fine art could be based on or could draw on popular and commercial art sources without compromising its quality as fine art.

At this point Paolozzi ceased to play a central role and the artist who above all others first implemented this theory was Richard Hamilton, one of the original members of the IG.

In 1956 the Independent Group staged an exhibition with the title *This is Tomorrow* at the Whitechapel Art Gallery in London. It was divided into twelve sections, each to consist of an environment created by a team notionally made up of a painter, a sculptor and an architect. Hamilton worked with John McHale and the architect John Volkher to create a section which included a profusion of images from popular magazines, comics, film publicity and other advertising, with a juke-box playing continuously. All this was intended by Hamilton as the raw material from which a new kind of art could be made. However, for the poster of the exhibition, Hamilton had already made a collage which is now seen as a landmark in the development of art made from such sources. This collage, 'Just what is it that makes today's homes so different, so appealing?', is an assemblage of images that give an answer to the question posed by the title. In making it Hamilton drew up a list of the categories he thought should be covered: 'Man Woman Food History Newspapers Cinema Domestic appliances Cars Space Comics TV Telephone Information', and the appropriate images were then searched for in magazines. The list is itself a catalogue of Pop sources and the finished collage is an encapsulation of the Pop artist's view of the world. Also in 1956, shortly after *This is Tomorrow*, Hamilton produced in a letter to the architects Peter and Alison Smithson a list of the qualities defining popular art and culture and proposed a further exhibition for which works should be produced *corresponding to this definition*. The exhibition never took place but the list has become famous:

'Popular (designed for a mass audience), Transient (short-term solution), Expendable (easily forgotten), Low Cost, Mass Produced, Young (aimed at youth), Witty, Sexy, Gimmicky, Glamorous, Big Business.'

The following year, 1957, Hamilton began to produce paintings, usually with collage elements, which dealt with these qualities. One of these is '$he'

Eduardo Paolozzi
I was a Rich Man's Plaything, 1947
Collage, 14 x 9¼ in/35.6 x 23.5 cm
mounted on card, 16⅞ x 13⅞ in/
42.9 x 35.2 cm
Tate Gallery, London

Richard Hamilton
*Just what is it that makes today's homes
so different, so appealing?*, 1956
Collage, 10¼ x 9¾ in/26 x 25 cm
Kunsthalle, Tübingen

of 1958, which exemplifies the complexity and richness both of form and content of Hamilton's art. The title itself, the first letter turned into a dollar sign, signals one of the major themes of the painting, the image of woman in advertising. The main source of the picture was an advertisement for an American RCA Whirlpool fridge/freezer, but other advertisements, for toasters and vacuum cleaners, contributed, and the image of the woman is based on a pin-up photograph of a model called Vikky Dougan, known as 'Vikky the Back' because she specialised in modelling daringly low-cut backless dresses. As a glance at the painting reveals, this imagery, both painted and collaged, has been organised in a collage-like way–the separate elements brought together on the picture surface–and has been elaborately processed, using a variety of techniques. The woman, for example, is represented by a small area of bare shoulder and breast and one isolated eye, and lower down by a shape suggesting the outline of her hips. The flesh area is beautifully spray painted (air-brushed) to look exactly like female flesh in a glossy magazine advertisement or pin-up, while the hip form is a low-relief collage painted white. The interior of the fridge is represented only by the freezer compartment in the form of a collaged blown-up photograph while in the open door a Coca Cola bottle is visible, this time painted in a traditional still life style. The toaster is air-brushed

Richard Hamilton
$he, 1958–61
Oil and various media on board,
48 x 32 in/121.9 x 81.3 cm
Tate Gallery, London

again, in aluminium paint, and has been combined with part of a vacuum cleaner to form what Hamilton called a 'toastuum'. The line of dots represents the path taken by the toast when it pops up. The result is a painting in which the spectator's attention is engaged equally strongly by the imagery, of a kind quite new to art but dealing with the everyday world, and by what the artist has done to it and how he has arranged it – by the formal abstract qualities of the work, in other words. It is a classic example of what might be called the 'abstract realism' of Pop Art. It should be added that the brief description of '$he' just given does not begin to touch on the full formal and thematic complexity of the work. Hamilton himself published a detailed account of its genesis and significance in the magazine *Architectural Design* in 1962 which is too long to reprint here.

At the same time as Hamilton was producing his first Pop paintings a somewhat younger artist, Peter Blake, quite independently of Hamilton and the IG, was developing his own form of Pop Art. His painting 'On the Balcony' of 1957 is, like '$he', one of the first manifestations of the movement. It is composed like a collage and some of the elements, photographs and magazine covers, look as if they might actually be collaged, but in fact every one is meticulously painted in its entirety. A major difference between Blake and Hamilton is that Blake is not interested in elaborately processing his imagery but in presenting each element for its

Peter Blake
On The Balcony, 1955–7
Oil on canvas, 47¾ x 35¾ in/
121.3 x 90.8 cm
Tate Gallery, London

own sake as part of a pictorial structure. 'On the Balcony' contains a very wide range of Pop imagery and takes its title from the long 'photograph' of the Royal Family on the balcony of Buckingham Palace in the centre of the picture, patriotism being an important element in British popular culture.

After 'On the Balcony' Blake began to make extensive use of collage and assemblage, presenting his source' material both two- and three-dimensionally in the form of shallow relief constructions like 'Toy Shop' of 1962 with its window crowded with real toys.

The emergence of Hamilton and Blake in the late 1950s marks the first phase of British Pop Art. The second began in 1961 when a group of young artists, all students at the Royal College of Art in London, made a considerable splash with the work they showed at the *Young Contemporaries* exhibition of that year. These artists included most notably David Hockney, Allen Jones, Derek Boshier, Peter Phillips, Patrick Caulfield and Ronald Kitaj.

Two factors distinguish this Royal College Group from Hamilton and Blake. First they were primarily painters, although they also used collage and continued to use the collage system of composition. Secondly, and equally important, they were all aware of the developments in abstract painting around 1960. This led them to work with a quite different sense of scale from Hamilton and Blake both in relation to the overall picture size and the size of the image within it. Within this went an increased emphasis on the purely pictorial, abstract qualities of the painting which took some of them very close to the position of Richard Smith, an independent figure, who in the early Sixties formed a link between the new figuration of Pop and the pure abstraction of the Situation painters.

Smith looked at Pop sources, particularly advertising and packaging, but his procedure was to isolate certain qualities of the sources and use them as the basis of paintings which, in his own words 'shared scale, colour, texture, almost a shared matière, with aspects of the mass media'. The scale of Smith's paintings is often very large, larger than most other Situation painters, for example, and he has commented that 'The scale of a painting is often physically related to the hoardings or cinema screens which never present objects actual size. You could drown in a glass of beer or live in a

Peter Blake
Toy Shop, 1962
Oil and various media,
61¾ x 76⅜ x 13⅜ in/
156.8 x 194 x 34.6 cm
Tate Gallery, London

Richard Smith
Panatella, 1961
Oil on canvas, 90 x 120 in/
228.6 x 304.8 cm
Tate Gallery, London

cigarette pack.' This is perfectly illustrated by the Tate Gallery's huge painting by Smith of 1961, 'Panatella', based on a cigar band but a cigar band as it might appear on an enormous hoarding and as if seen close to so that it fills the spectator's whole field of vision and appears blurred and out of focus. In fact, so abstracted is the image that only when the source is known can the composition of 'Panatella' be recognised as being based on the cigar band – a rectangular strip broken by a circle. Similarly the very beautiful freely brushed colour has been suggested rather than directly provided by the source; it is as Smith has said 'rather tobacco and gold'.

There were, of course, considerable differences between the Royal College painters. Two of them in particular, Ronald Kitaj and Patrick Caulfield, used imagery which did not come from the world of Pop although other connections with the group have always caused them to be associated with it.

Kitaj indeed was a powerful influence on many of the others, most notably on Hockney, Jones and Boshier. An American and slightly older than his contemporaries at the Royal College, where he was a student from 1957–61, he brought with him something of the ethos and attitudes of the immensely successful post-war school of American art. He was also highly intellectual. Allen Jones and David Hockney have both acknowledged their debt to Kitaj, Jones recalling in 1965, 'I learned more about an attitude to painting merely from watching him . . . the influence wasn't one of imagery but of a dedicated professionalism and real toughness about painting.'

Much of Kitaj's imagery was drawn from high, not low, culture. His painting 'Isaac Babel Riding with Budyonny' of 1962 refers to an extraordinary range of sources, including the life and works of the Russian writer Isaac Babel, the life of the Russian Marshal Semyon Budyonny and

works by Rudolph Witthower and C. G. Jung. The denseness of philosophic, literary, historical and other reference in Kitaj's paintings makes their full meaning quite inaccessible without a key, but their richness and complexity is fully reflected in their purely visual qualities. In 'Isaac Babel' Kitaj was already master of a technique of great beauty and refinement which he has since developed even further.

David Hockney's work of the early Sixties is distinguished by a character which appears to derive from an aspect of the urban environment not looked at by his contemporaries, graffiti. This appears in his style of drawing and in the words and messages scrawled across his paintings. These early paintings deal with pop music, advertising and packaging, with aspects of Hockney's own lifestyle, particularly his homosexual interests, and with incidents in his own life. They also contain occasional references to art and literature. One of his first major works is 'We Two Boys Together Clinging' of 1961, which is typical of his work of this period in its free painterly quality and degree of abstraction. This extends to the words, which are treated as part of the pictorial structure as well as verbal messages— Hockney has explained that he wrote on his paintings at this time to make his meaning as clear as possible. The words are from a poem by Walt Whitman ('We two boys together clinging/One the other never leaving').

About 1965 Hockney's painting became less freely painted, more sharply focused, richer in colour, more refined in technique and more overtly figurative and its subject matter became exclusively autobiographical, dealing with the social world he moved in. His work in this later phase of his

R. B. Kitaj
Isaac Babel Riding with Budyonny, 1962
Oil on canvas, 72 x 60 in/
182.9 x 152.4 cm
Tate Gallery, London

career includes some of the most dazzling masterpieces of modern figurative painting. One of these is his 1971 double portrait of his close friends, the fashionable clothes designers Ossie Clark and Celia Birtwell.

Allen Jones and Derek Boshier were closest to Richard Smith in their

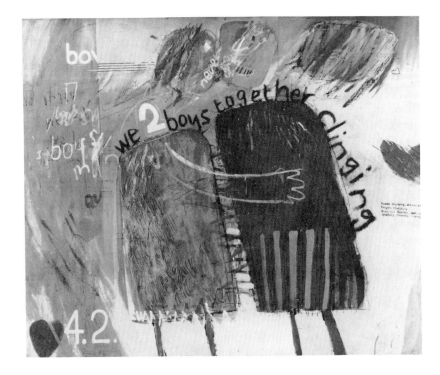

David Hockney
We Two Boys Together Clinging, 1961
Oil on board, 48 x 60 in/
121.9 x 152.4 cm
Tate Gallery, London

David Hockney
Mr and Mrs Clark and Percy, 1970–1
Liquitex on canvas, 84 x 120 in/
213.4 x 304.8 cm
Tate Gallery, London

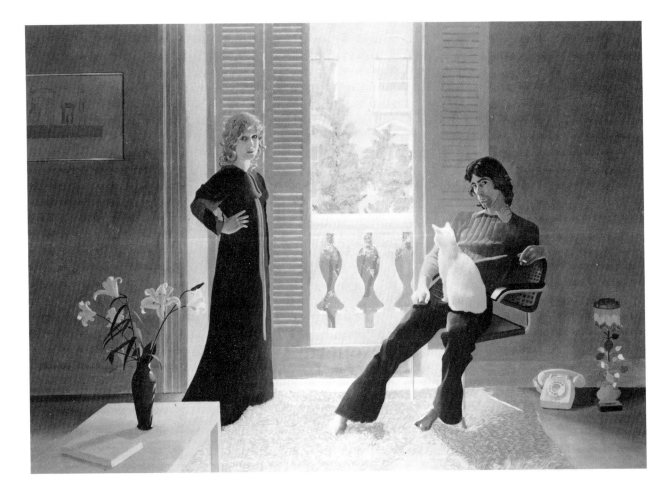

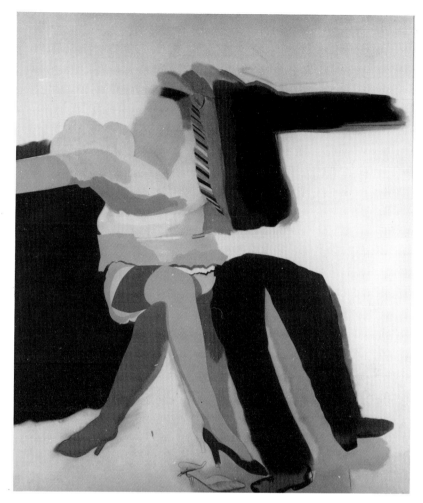

Allen Jones
Man Woman, 1963
Oil on canvas, $84\frac{1}{2}$ x $74\frac{1}{4}$ in/
214.6 x 188.6 cm
Tate Gallery, London

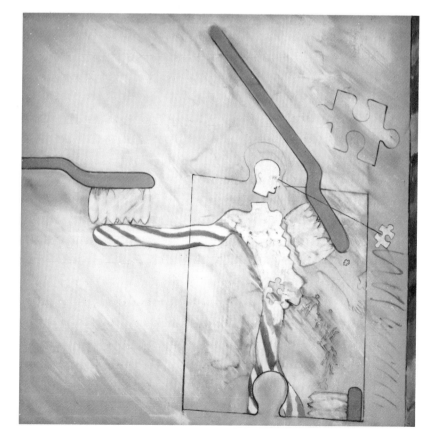

Derek Boshier
Identi-Kit Man, 1962
Oil on canvas, 72 x 72 in/
182.9 x 182.9 cm
Tate Gallery, London

Peter Phillips
Gravy for the Navy, 1963
Oil on canvas with inserts of wood
and glass, 95 x 64 in/241.3 x 162.6 cm
Art Gallery and Museum, Oldham

larger-scale painterly work in which the image is used as the basis of a
'colour field' type of painting. However, the image always remains im-
mediately recognisable as it does not in Smith, and in paintings like Jones's
'Man Woman' of 1963 and Boshier's 'Identi-Kit Man' of 1962 these two
artists achieved a very successful marriage of the figurative image to the
striking, purely visual qualities of large-scale abstraction. 'Man Woman' is
an early example of what has ever since been Jones's main subject, sex and
pin-ups. Boshier was preoccupied with advertising. 'Identi-Kit Man' is based
on a toothpaste advertisement and as the title suggests he is making a
comment about the way in which advertisers manipulate us to create mass
markets in which everyone has identical tastes.

 Peter Phillips's imagery is drawn from juke boxes, pinball machines, one-
armed bandits, motor cycles, advertising, and film star pin-ups. Unlike Jones
or Boshier, he paints in a tight, glossy, sharply focused way which directly
reflects the character of these sources and he sets the images into bold
heraldic abstract frameworks whose form and colour derive from the same
sources. In 'Gravy for the Navy', 1963, the star shapes are appropriate to
the film star pin-up, and the geometric ray forms at the top derive from
cinema decoration.

 As has already been mentioned, Patrick Caulfield did not take his imagery
from the usual Pop sources. What he had in common with his
contemporaries was an interest in an art that was both figurative and
abstract and it is this concern, rather than any particular kind of imagery,
that is central to his art. Usually Caulfield chooses very familiar and
unassertive objects and treats them in such a way as to make the spectator
very conscious of the relationship, especially the differences, between the
real thing and what he sees on the canvas. It should perhaps be added that it

[195]

Patrick Caulfield
Vases of Flowers, 1962
Oil on board, 48 x 48 in/
121.9 x 121.9 cm
Tate Gallery, London

is a very common concern of modern artists to make the spectator think about the nature of art, the relationship between art and reality, as part of the subject matter of their work. In 'Vases of Flowers' of 1962 he does this by painting different parts of the picture with different degrees of naturalism: the flowers are painted from a careful drawing of real chrysanthemums but the vases are invented and rendered as simplified shapes. The rest of the painting is entirely abstract, although the enclosure of double black lines probably ultimately represents the table top on which the vases are standing.

Chapter 27
Art Since Pop

In the late 1960s a distinct new phase of modern art began more or less simultaneously in Europe, Britain and America. This has become generally known as Conceptual Art although a great variety of tendency exists within this broad category. Conceptual Art is characterised perhaps above all by an increasing emphasis on the idea content, the mental aspect, of the work; by a further extension of the emphasis on process already seen in for example the work of Richard Hamilton or Bernard Cohen and by an increasing freedom in the use of media. In this last respect artists have both extended the possibilities of traditional painting and sculpture and turned to non-traditional media for fine art such as photography, film, video, words and the artist's own body.

Among those artists who seem most fruitfully to have extended the traditional media in different ways are Tom Phillips (b.1937), Ian Hamilton Finlay (b.1924), Michael Craig-Martin (b.1942) and Keith Milow (b.1945).

Tom Phillips is a painter whose primary source material is the modern, photographically based, coloured picture postcard of which he is an obsessional collector. Postcards present an image of the world which has been transformed, often very considerably, by the mechanical processes of postcard manufacture and the accidents and errors of those processes. These transformations render the postcards often highly suggestive to the artist, both thematically, that is in terms of extra meaning given to the scene depicted, and formally, that is in terms of the purely pictorial or abstract possibilities they present.

Using such suggestions as a basis, Phillips typically develops some specific human or social theme and then submits the source image to an elaborate painting process so devised that the theme is embodied in a visual scheme of maximum richness and subtlety.

One of Phillips's major works is 'A Treatise on Colour Harmony' of 1975. This has its origin in his first visit to southern Africa made in 1973. He was struck by the way in which the ideal of apartheid from the white point of view was reflected in the picture postcards he collected. These tended to show on the one hand only very 'European' looking scenes of white people enjoying themselves on beaches and on the other only emphatically tribal 'native' images of black people in traditional costume. These postcards became the basis of a group of works dealing with apartheid of which 'A Treatise on Colour Harmony' is the largest and most elaborate. The main formal basis of the painting lies in the extraordinary range of colours found in the skins of the figures in the postcards, due to the vagaries of the colour reproduction process. The work consists of sixteen separate square canvases hung in a block. Thus arranged they form a narrative sequence which also operates as a unified visual whole. The first two canvases are painted with texts, lettered and arranged, so that the words also form an image as for example they do, in a different way, in the early work of Hockney. This gives the spectator all the information he needs to extract the

full meaning of the work and to understand its formal structure.

The first canvas reads around its edge: 'The greatness of a nation consists not so much in the number of its people or the extent of its territory as in the extent and justice of its compassion.' The irony of the statement becomes apparent with the additional information that it was transcribed from the equestrian statue at Port Elizabeth, South Africa. In the centre of the canvas is the title, date and artist's name.

The second canvas explains that the work is 'Based on excerpts of skin from postcards of South Africa and Rhodesia and South West Africa and of their land and skies' (other parts of the postcards from which colours were extracted for the work) and also carries the titles and/or explanations of all sixteen canvases.

The third canvas is titled 'Black is Beautiful' and consists of twenty-five squares of colour derived from black skins in the postcards. This arrangement is a literal visual embodiment of the title since it forms a stunningly beautiful abstract painting, a glorious harmony of extra-ordinary dusky oranges and mauvish or purplish pinks.

Canvas Four, also of twenty-five squares, looks completely different in colour from Canvas Three but it is in fact a mutation of Three, each of its squares being made from a mixture of all the colours in the equivalent square in the preceding canvas. These mixtures are called by Phillips terminal greys or TGs and his use of them originally arose from his wish not to waste the paint left over at the end of a day's work: he would mix them all up to form a grey and use that to paint part of another work. The greys are in fact muted and often very beautiful colours which vary according to the balance of pigments in them. Canvas Five, ironically titled 'White is somewhat lovely too', introduces white skin extracts and is a blond parallel to Three. It too is followed by its TG mutation. Then, in Canvases Seven and Eight Phillips *combines* the black and white skin TGs to form two abstract harmonies of fifty squares (half-size) which are now rich visual metaphors for the idea of racial harmony. In the remaining canvases he continues systematically to explore and develop the visual possibilities of the combination of the black and white skin colours from the postcards. The total result is a painting which is simultaneously a beautiful abstraction on the theme of colour relationships, a powerful visual metaphor for a political ideal and a specific comment on the frustration of the ideal in the State of South Africa. The title precisely describes all these functions.

Throughout the history of art, poetry and painting have frequently come very close together–in the works of William Blake for example. In the twentieth century a movement grew up known as 'Concrete' poetry in which the shapes of words and their layout on the page played an important part in expressing the poem's meaning–it was as much visual as verbal. Ian

Ian Hamilton Finlay
Starlit Waters, 1967
Various media $12\frac{1}{4}$ x $94\frac{1}{2}$ in/
31.1 x 240 cm
Tate Gallery, London

Tom Phillips
A Treatise on Colour Harmony, 1975
Oil on canvas, 14 panels
each 24 x 16 in/61 x 40.6 cm
Artist's collection

Hamilton Finlay is a Concrete poet who since about 1964 has increasingly made his poems in a three-dimensional, sculptured form so that they become in fact art objects. Finlay's work, like that of Phillips, is extraordinarily rich, varied and complex and only a brief introduction is possible here. One of his central concerns is with the sea and with ships and boats of every kind, and the critic, Stephen Bann, has written that 'The fishing boat becomes the chosen receptacle for "the whole notion of Beauty and Freedom".'

One of Finlay's many works relating specifically to fishing boats is 'Starlit Waters'. It consists of the two words of the title made of solid wooden letters standing on a base, about 12 inches high and 8 feet long (30.5 cm x 2.4 m). It is painted green, the colour of the sea and covered with orange fishing-net. In themselves the words form a short poem in that they set up all kinds of echoes and associations in the spectator's mind. These might have nothing to do with fishing – romance for example – but add to the words the net and the idea of fishing becomes specific. The spectator might then

realise, what is in fact the case, that 'Starlit Waters' is the name of a boat, a real working fishing boat, and this realisation adds a whole further dimension of poetic association and reference to the work.

Since 1967 Finlay and his wife have created an extensive garden called 'Stony Path' at their home in Lanarkshire, Scotland, in which a large number of Finlay's object poems are integrated into the garden setting. This garden, still in progress, is already a place of pilgrimage for poets and art lovers and seems destined to become one of the great gardens of Britain.

Keith Milow is basically a painter, but the processes used in making his paintings often result in a relief object such as the Tate Gallery's work 'I 2 3 4 5 [6] ..B' of 1970. The title is purely a reference; the work is the sixth and last in a group called 'Improved Reproductions' and comes from the second of the two series, A and B, within the group. Its basis is a previous work by Milow done in 1969 and that in turn is based on a photograph of a sculpture by Anthony Caro. In 'I 2 3 4 5 [6] ...B' Milow is thus re-using both his own work and that of another artist and his is typically an art that grows out of art.

The Tate Gallery work is a variant on the one of 1969, the difference being that the Caro sculpture is drawn, not painted, on to the canvas and is in monochrome, not colour. Milow refers to it as a 'ghost' version. After drawing the image the artist cut the canvas from its top edge into sixteen vertical strips of equal width, the cuts terminating as far from the bottom as the width of the strips. Each strip was then carried leftwards and attached by its top right corner to the right edge of the preceding strip to produce a parabolic curve. Before being folded each strip was coated with translucent resin so the painting took on its final relief form.

Michael Craig-Martin's '4 Identical Boxes with Lids Reversed' of 1969 is one of a number of works in which he explored the sculptural possibilities of boxes, in themselves fascinating and mysterious things as well as being, from a modern sculptor's point of view, highly satisfying abstract forms. '4 Identical Boxes' is the outcome of the artist's desire to make a work of maximum visual richness and complexity out of four identical boxes while retaining intact their original identity. The meaning of the work resides as much in the spectator's appreciation of the intellectual elegance of the process by which he has achieved this end as in its visual beauty. As the title implies – it gives the essential clue to the process involved – Craig-Martin cut a lid from each box, itself a completely logical thing to do to a box without a lid. Each lid was cut from halfway down the front edge but sloping towards the back and each one was cut progressively larger until in the last box lid and box were identical. The lids were then switched, the largest to the smallest, and then the remaining two. The result is a work which appears at first glance to consist of utterly disparate elements in an apparently random and puzzling arrangement. Furthermore the work has an almost infinite number of different possible configurations since the lids can be either open or closed or in any combination of those states. At the same time, knowledge of the title plus a few moments' contemplation reveals its true, simple and logical nature. Whatever the arrangement, the work looks quite unlike any other sculpture ever before, it has no stylistic affinities whatsoever. This is also true of Milow's 'I 2 3 4 5 [6] ...B' and is because the form is determined by the internal logic of the procedures involved, not by external references.

Among the leading British artists who have gone beyond traditional painting and sculpture are Victor Burgin, Gilbert and George, and Richard Long.

Victor Burgin is one of those Conceptual artists whose work has

sometimes taken a purely verbal form. His piece of 1969 called 'Room' consists of eighteen standard-size A4 (11¾ x 8¼ in, 29.7 x 21 cm) sheets of paper on which instructions to the participant are printed. The sheets are normally arranged around the walls of a room at eye level so the spectator proceeds around the room, following the sequence, which tends to get more and more complex as the work proceeds. The first sheet of 'Room' bears the message, 'All substantial things which constitute this room'. Reading this, the spectator at once becomes aware of all the physical features of the room, and the piece goes on to heighten, develop and structure this awareness and to expand it to include the people in or passing through the room and the spectator's own role in performing the process. Burgin is thus working with

Michael Craig-Martin
4 Identical Boxes with Lids Reversed,
1969
Painted wood, 24 x 96 x 36 in/
61 x 243.8 x 91.4 cm
Tate Gallery, London

Keith Milow
1 2 3 4 5 [6]...B, 1970
Resin, crayon and fibreglass,
42 x 84 x 4 in/106.7 x 213.4 x 10.2 cm
Tate Gallery, London

Gilbert and George
*Balls: the evening before the morning
after – Drinking Sculpture*, 1972
114 monochrome photographs
mounted between glass and card, the
edges sealed by passe-partout, overall
size 83 x 172½ in/210.8 x 438.2 cm
Tate Gallery, London

an existing reality, that of the spectator and his environment, as the medium for his art and in particular, as he has said, asserting 'the primacy of the observer's act of observation' in the art process. Burgin in fact makes very heavy demands on the spectator; 'Room' if properly experienced requires at least half an hour of intense mental activity stretching the spectator's powers of concentration and memory to their limits. The experience is analogous to strenuous physical exercise and correspondingly beneficial.

The two artists who are invariably known simply as Gilbert and George are among those Conceptual artists who have chosen to act out or perform their art and they call themselves 'The Living Sculptors'. They are unique, however, in the ranks of such artists in that not only their specific action pieces but their whole lives constitute their art and, in addition to public performances, they reach their audience through a variety of printed, photographic, video-tape and even drawn and painted works based on their lives and expressing their feelings about life and art.

Their first major piece was the 'singing sculpture', 'Underneath the Arches', in which the artists, neatly dressed in conservative but unexceptional business suits, their faces made up with metallic paint, repeatedly sang the old music-hall song from which the work takes its title. They performed it in various venues from 1969 onwards and when they did so at the Nigel Greenwood Gallery in London they did it continuously during the gallery's normal opening hours, thus becoming literally living sculpture. Their attitude during the singing was of an extraordinary immobility with occasional highly stylised movements, and their faces always remained quite impassive. Their actions and the words of the song combined to express a sense of indefinable pathos, of the sadness and even the tragedy of life, one of the most characteristic themes of their art: in 1971 in their first 'book sculpture', 'Side by Side', they wrote, 'And so here we must recognise sadness as the key to our past and future.'

In their suits and boots they are quintessentially modern urban men and, while much of their work, like 'Underneath the Arches', deals with the

situation of urban man they have a strong sense of the pastoral and have consistently made works in which they appear, incongruous in their suits, wistfully contemplating the natural world from which modern civilisation has alienated us.

Although they continue to give occasional live performances, most of Gilbert and George's work now consists of photographic pieces which embody their art in a more permanent and easily exhibitable form. One of the finest of these is 'Balls: the evening before the morning after–Drinking Sculpture' of 1972, one of a number of their sculptures dealing with a common traditional subject for art. It consists of 114 monochrome photographs of varying sizes simply mounted in glass with passe-partout showing the artists drinking in one of Balls Brothers chain of London wine bars. The photographs have been processed to produce effects of increasing distortion and blurring, vividly conveying the experience of increasing drunkenness. The inability to think logically and coherently when drunk and the tendency to stagger is directly reflected in the apparently random non-linear staggered arrangement of the photographs. Somewhere near the middle one of the frames contains the title.

Richard Long has become the most internationally celebrated of the younger generation of British artists. He is a landscape artist, a sculptor who roams all over the globe working directly in and with the landscape, communing with it, carrying on what the art historian Anne Seymour has characterised as 'a philosophical dialogue between the artist and the earth'. His art is the outcome of this dialogue, the expression of his poetic response to nature.

His works fall into three basic categories: those in which he physically interferes with the landscape in some way; those in which he undertakes a formalised and ritualised journey through it (walking sculptures); and those in which he brings portable elements of the landscape into the museum or art gallery and arranges them into a formal sculptural structure.

The final physical form of the first category of Long's works is a simple photograph such as 'A line made by Walking', 1967, and of the second a map or section of map indicating the location and form of the walk. The map pieces often have photographs and texts as well, as in the case of 'A Hundred Mile Walk', 1971–2, now in the Tate Gallery. The gallery sculptures are made from such things as twigs, fallen branches, stones of various kinds and

Richard Long
A Line made by Walking, 1967
Photograph, $14\frac{3}{4}$ x $12\frac{3}{4}$ in/
37.5 x 32.4 cm
Tate Gallery, London

Richard Long
River Avon Driftwood, 1976
Eighty pieces of driftwood, approx.
diameter 240 in/610 cm
Tate Gallery, London

driftwood. 'River Avon Driftwood' of 1976 is one of a number made from this material.

In structuring both his walks and his physical works Long uses a vocabulary of simple forms – lines, circles, spirals, which relate his art to the idea of pure abstract beauty found in, for example, Ben Nicholson's white reliefs of the 1930s (see p.145). However, he is also deeply fascinated, like Paul Nash before him, by the stone circles and lines of stones at Avebury, Stonehenge and elsewhere and in general by the evidences which occur in the landscape of the presence and ritual practices of ancient man, and these provide a more direct inspiration for his work. He is a romantic seeking to assert in the face of industrial civilisation that man was once an integral part of the natural world and cuts himself off from it at his peril.

Books for Further Reading

This is not a full or comprehensive bibliography but a selective list of works which may be useful to the reader who wishes to read in more detail about particular artists and periods. It is arranged in chronological sequence.

WATERHOUSE, ELLIS, *Painting in Britain 1530–1790*. London, Penguin Books, 1953

STRONG, ROY, *The English Icon: Elizabethan and Jacobean Portraiture*. Published for the Paul Mellon Foundation for British Art by Routledge & Kegan Paul, London. New York, Pantheon, 1969

STRONG, ROY, *The Elizabethan Image: Painting in England 1540–1620*. Catalogue of exhibition at the Tate Gallery. London, 1969

REYNOLDS, GRAHAM, *Nicholas Hilliard and Isaac Oliver*. Catalogue of exhibition at the Victoria and Albert Museum, London. Published by Her Majesty's Stationery Office, London, 1971

MILLAR, OLIVER, *The Age of Charles I: Painting in England 1620–1649*. Catalogue of exhibition at the Tate Gallery, London, 1972

VAUGHAN, WILLIAM, *Endymion Porter by William Dobson*. Tate Gallery Publications, 1970

PAULSON, RONALD, *Hogarth: his Art, Life and Times*. 2 vols. Published for the Paul Mellon Centre for Studies in British Art by the Yale University Press, London and New Haven, 1971

PAULSON, RONALD, *The Art of Hogarth*. London, Phaidon Press, 1975

HERRMANN, LUKE, *British Landscape Painting of the Eighteenth Century*. London, Faber, 1973

TAYLOR, BASIL, *Stubbs*. London, Phaidon Press, 1971

NICOLSON, BENEDICT, *Joseph Wright of Derby*. 2 vols. Published for the Paul Mellon Foundation for British Art by Routledge & Kegan Paul, London, 1968

KLINGENDER, FRANCIS, *Art and the Industrial Revolution*. London, Paladin, 1972

HAYES, JOHN, *Gainsborough*. London, Phaidon Press, 1975

WATERHOUSE, ELLIS, *Reynolds*. London, Phaidon Press, 1973

BINDMAN, DAVID, *William Blake as Artist*. Oxford, Phaidon Press, 1977

REYNOLDS, GRAHAM, *Constable the Natural Painter*. London, Cory, Adams and Mackay, 1965

REYNOLDS, GRAHAM, *Turner*. London, Thames & Hudson, 1969

BUTLIN, MARTIN and JOLL, EVELYN, *The Paintings of J.M.W. Turner*. 2 vols. Published for the Paul Mellon Centre for Studies in British Art and the Tate Gallery by the Yale University Press, 1977

MAAS, JEREMY, *Victorian Painters*. London, Barrie & Rockliff, 1969

HILTON, TIMOTHY, *The Pre-Raphaelites*. London, Thames & Hudson, 1970

SUTTON, DENYS, *Nocturne: the Art of James McNeill Whistler*. London, Country Life, 1963

ROTHENSTEIN, JOHN, *Modern English Painters*. 3 vols. London, Macdonald & Jane's, 1976

CORK, RICHARD, *Vorticism and Abstract Art in the First Machine Age*. 2 vols. London, Gordon Fraser, 1976

SHONE, RICHARD, *Bloomsbury Portraits*, London, Phaidon Press, 1976

SHONE, RICHARD, *The Century of Change: British Painting since 1900*. Oxford, Phaidon Press, 1977

READ, HERBERT, *A Concise History of Modern Sculpture*. London, Thames & Hudson, 1964

SEYMOUR, ANNE, *Henry Moore to Gilbert and George*. Catalogue of exhibition at Palais des Beaux Arts, Brussels. Tate Gallery Publications, 1973

Index

Note: numbers in italics refer to illustrations